W9-CAY-560

# The Art of Basic
# Oil Painting

© 2014 Quarto Publishing Group USA Inc.
Published by Walter Foster Publishing, a division of Quarto Publishing Group USA Inc.
All rights reserved. Walter Foster is a registered trademark.

Artwork on front cover (center) and pages 30–33 © 2012 Marcia Baldwin. Artwork on front cover (bottom right) and pages 1, 58, and 60–89 © 2014 Glenda Brown. Artwork on front cover (top right) and pages 90 and 92–105 and photograph on page 92 ("Tortoiseshell Cat") © 2013 Lorraine Gray. Artwork on back cover, photographs on pages 8–9 ("Paintbrushes," "Palette," "Easel"), and artwork on pages 12, 13, 16, and 18–29 © 2012 Vanessa Rothe. Artwork on pages 4, 46–51, and 134–141 © 2014 Varvara Harmon. Photographs on pages 6 and 7 © 2014 Elizabeth T. Gilbert. Photographs on pages 8 and 9 ("Paints," "Palette & Painting Knives"), 92 ("Tabby Cat"), 94, 98, and 102 © Shutterstock. Photographs on page 9 ("Supports," "Mediums & Solvents") and artwork on pages 10, 11, 14, and 15 and  © WFP. Artwork on pages 34–45 © 2013 James Sulkowski. Artwork on pages 106–119 © 2014 Jason Morgan. Artwork on pages 120 and 122–133 © 2014 Jim McConlogue.

Authors: Marcia Baldwin, Glenda Brown, Lorraine Gray, Varvara Harmon, Jim McConlogue, Jason Morgan, Vanessa Rothe, James Sulkowski

Publisher: Rebecca J. Razo
Art Director: Shelley Baugh
Project Editor: Stephanie Meissner
Associate Editor: Jennifer Gaudet
Assistant Editor: Janessa Osle
Production Artists: Debbie Aiken, Amanda Tannen
Production Manager: Nicole Szawlowski
Production Coordinator: Lawrence Marquez

This book has been produced to aid the aspiring artist. Reproduction of the work for study or finished art is permissible. Any art produced or photomechanically reproduced from this publication for commercial purposes is forbidden without written consent from the publisher, Walter Foster Publishing.

Walter Foster

www.walterfoster.com
3 Wrigley, Suite A
Irvine, CA 92618

Printed in China
10 9 8 7 6 5 4 3 2
18712

# The Art of Basic
# Oil Painting

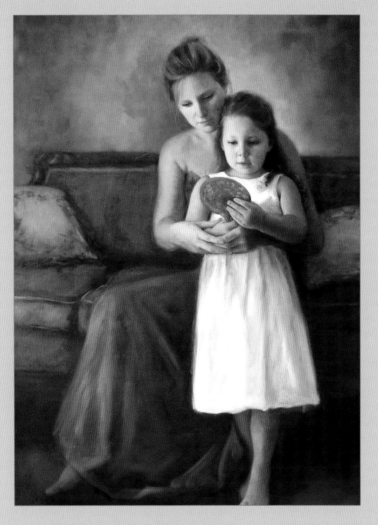

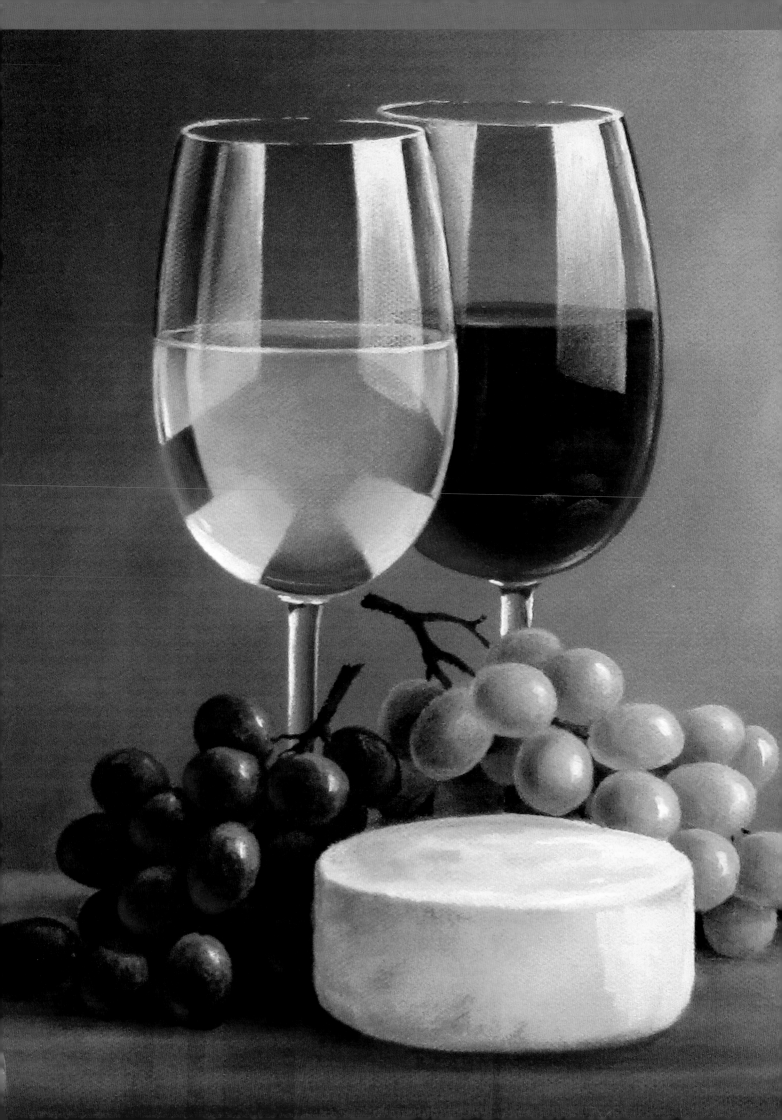

# Contents

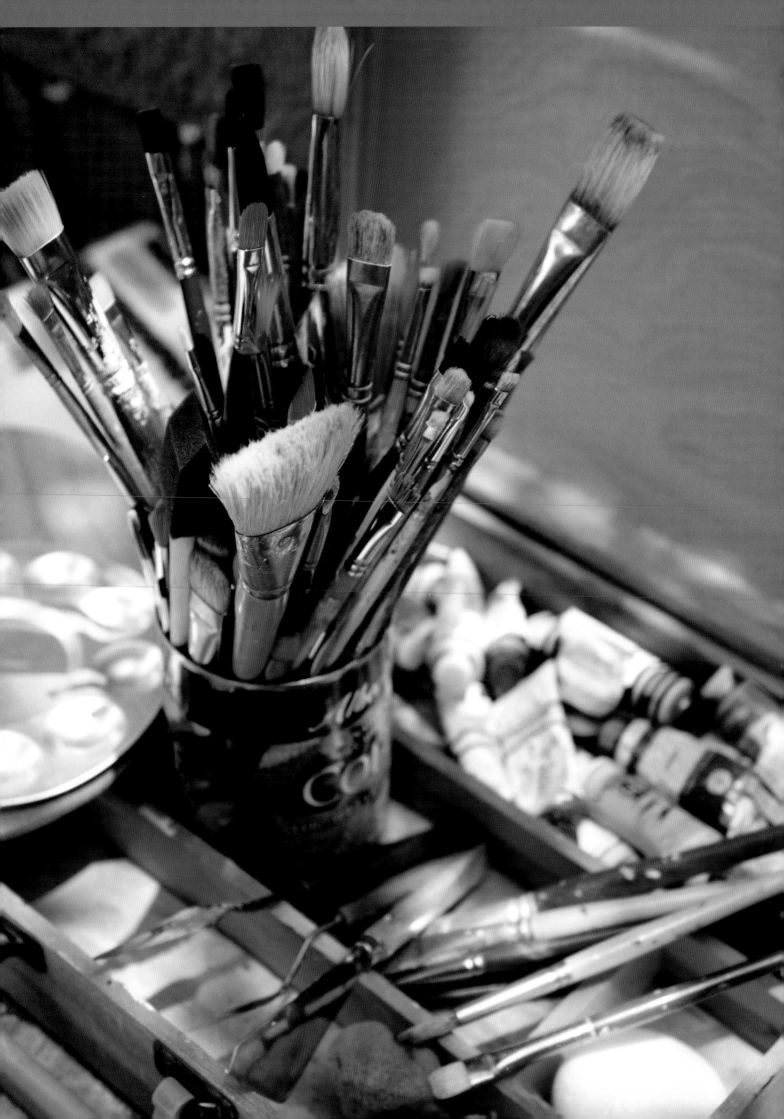

# Introduction

Often described as rich and buttery, oil painting is a classic medium that has captivated artists for centuries. This versatile medium lends itself to many painting styles—from the precision of photorealism to the freedom of expressionism. Its slow drying time allows artists to create smooth blends and rework a painting over multiple sessions. The projects in this book cover a wide range of styles and subject matter. Along the way, you'll find techniques and insights for mastering the medium from professional artists. Follow along as these talented and experienced artists guide you from initial sketches to final, finished paintings. Practice and paint daily, and you'll be a master of oil painting in no time.

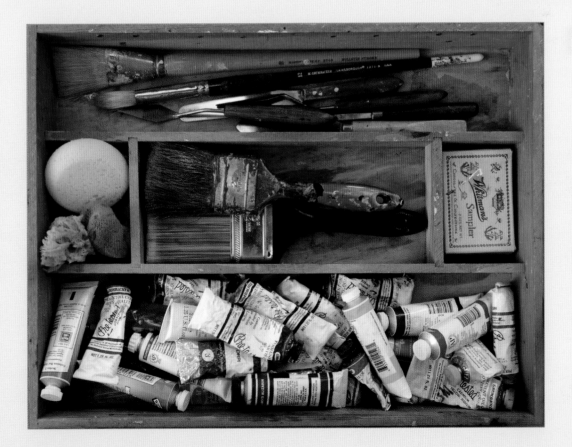

# Tools & Materials

## Paints

Oil paints are made up of pigments suspended in oils (such as linseed oil) with additives for durability and consistency. Paint is available in two main qualities: student grade and artist grade (or studio grade). Artist-grade paints contain a higher quality of pigment and fewer additives. Although they are slightly more expensive, they tend to last longer. Colors and consistency vary slightly from brand to brand, and there are many quality options available. Experiment with different brands to see which you prefer. Each of the lessons in this book lists the colors you need to complete the painting.

## Paintbrushes

Brushes vary greatly in size, shape, and texture. Some are sized by number, and others are sized by inches or fractions of inches. Natural-hair brushes, as opposed to synthetic, work best for oil painting. There are four main brush shapes: round, filbert, flat, and bright. Round brushes taper to a thin point and are good for detail work and fine lines. Filbert brushes are slightly flattened with long bristles that taper gently at the tip, making them good for blocking in large areas and rounding out forms. Flat brushes have long, rectangular bristles. These versatile brushes can hold a lot of paint and are great for creating corners. Bright brushes are similar to flat brushes but have shorter bristles, allowing for more control. The sharp corners are great for painting thin lines. Special brushes such as hake and fan brushes are good for blending or creating feathery textures. Clean your brushes after each use to keep them in good condition. Remove as much paint as you can with turpentine. Then wipe the bristles with a paper towel, following the direction of the bristles, and clean with warm water and mild dish soap.

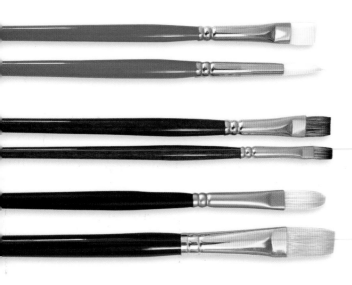

Pictured above from top to bottom: synthetic bright, synthetic round, natural bright, natural flat, hog-hair filbert, and hog-hair flat.

## Palette & Painting Knives

Palette knives are mainly used for mixing colors on your palette and come in various sizes and shapes. Some knives can also be used for applying paint to your canvas, creating texture in your work, or even removing paint. Palette knives are slightly rounded at the tip. Painting knives are pointed and a bit thicker, with a slightly more flexible tip.

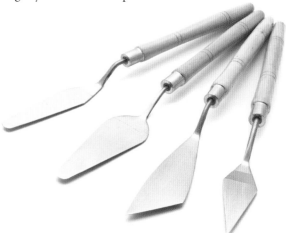

## Palette

Whatever type of palette you choose—glass, wood, plastic, or paper—make sure it is easy to clean and large enough for mixing your colors. Glass is a great surface for mixing paints and is very durable. Palette paper is disposable, so cleanup is simple, and you can always purchase an airtight plastic box (or paint seal) to keep your leftover paint fresh between painting sessions.

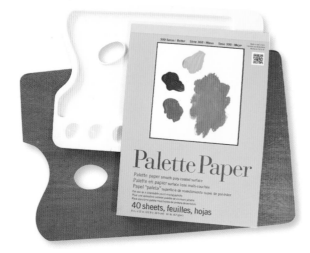

## Easel

The easel you choose depends on where you plan to paint. You can purchase a studio or tabletop easel for painting indoors, or you can buy a portable easel if you are going to paint outdoors.

Table easel

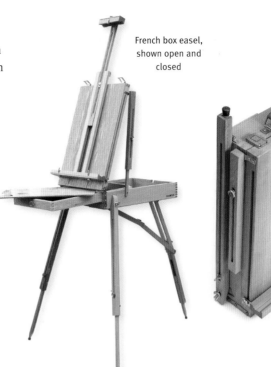

French box easel, shown open and closed

## Supports

The surface on which you paint is called the "support"—generally canvas or wood. You can stretch canvas yourself, but it's simpler to purchase prestretched, preprimed canvas (stapled to a frame) or canvas board (canvas glued to cardboard). If you choose to work with wood or any other porous material, apply a primer first to seal the surface so that the oil paints adhere to the support instead of soaking through.

## Mediums & Solvents

There is a variety of mediums available for oil paint. Different mediums can be used to thicken or thin paint, speed up drying time, etc. Solvents such as turpentine can also be used to thin oil paint or wipe it from the canvas. You can also use turpentine to clean your equipment. Turpentine and mineral spirits are toxic, so take precautions when using these products. Avoid direct contact with these liquids, and always paint in a well-ventilated area or room. There are many types of solvents on the market, including odorless varieties. To keep your brushes clean, you can get a special jar to hold your turpentine with a coil strainer inside. Simply stoke your brushes along the coils to dislodge the paint. Avoid leaving your brushes in the jar with bristles down.

## Additional Materials

Oil paint can be messy so it's a good idea to keep paper towels or rags close by to clean both your brushes and your painting area. You should also have some drawing tools on hand, such as drawing paper to practice your sketch first and a drawing pencil. You'll want a spray fixative to protect your drawing before you begin applying paint.

# Color Theory & Mixing

Knowing a little about color theory will help you tremendously in mixing colors. All colors are derived from just three *primary* colors—red, yellow, and blue. (The primaries can't be created by mixing other colors.) *Secondary* colors (orange, green, purple) are each a combination of two primaries, and *tertiary* colors (red-orange, red-purple, yellow-orange, yellow-green, blue-green, blue-purple) are the results of mixing a primary with a secondary. *Hue* refers to the color itself, such as red or green, and *intensity* means the strength of a color, from its pure state (straight from the tube) to one that is grayed or diluted. *Value* refers to the relative lightness or darkness of a color. (By varying the values of your colors, you can create depth and form in your paintings.)

## Color Wheel

A *color wheel* (or *pigment wheel*) is a useful reference tool for understanding color relationships. Knowing where each color lies on the wheel makes it easy to understand how colors relate to and react with one another. Where colors are in relation to one another determines how they react in a painting—which is an important part of evoking mood in your art.

## Color Psychology

Colors are referred to in terms of "temperature," but that doesn't mean actual heat. An easy way to understand color temperature is to think of the color wheel as divided into two halves: The colors on the red side are warm, while the colors on the blue side are cool. As such, colors with red or yellow in them appear warmer. For example, if a normally cool color (like green) has more yellow added to it, it will appear warmer; and if a warm color (like red) has a little more blue, it will seem cooler. Temperature also affects the feelings colors arouse: Warm colors generally convey energy and excitement, whereas cooler colors usually evoke peace and calm. This explains why bright reds and yellows are used in many children's play areas and greens and blues are used in schools and hospitals.

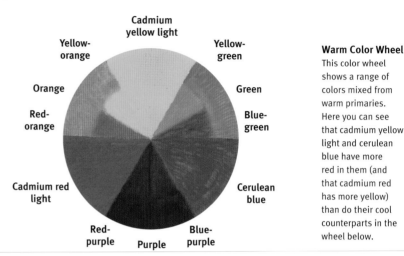

**Warm Color Wheel**
This color wheel shows a range of colors mixed from warm primaries. Here you can see that cadmium yellow light and cerulean blue have more red in them (and that cadmium red has more yellow) than do their cool counterparts in the wheel below.

**Cool Color Wheel**
This cool color wheel shows a range of cool versions of the primaries, as well as the cool secondaries and tertiaries that result when they are mixed.

## Complementary and Analogous Colors

*Complementary* colors are any two colors directly across from each other on the color wheel (such as purple and yellow). When placed next to each another in a painting, complementary colors create lively, exciting contrasts, as you can see in the examples at right. *Analogous* colors are those that are adjacent to one another (for example, yellow, yellow-orange, and orange). Because analogous colors are similar, they create a sense of unity or color harmony when used together in a painting.

**Complementary Colors** Here are three examples of complementary pairs. Using a complementary color in the background will make your subject seem to "pop" off the canvas. For example, place bright orange poppies against a blue sky, or enliven some yellow sunflowers by placing them in a purple vase.

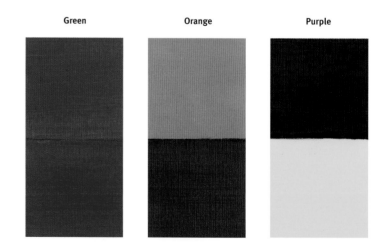

## Mixing Neutrals

There are very few pure colors in nature, so it's important to learn how to neutralize your oil colors. Direct complements can "gray" each other better than any other colors. For example, mixing equal amounts of two complementary colors results in a natural, neutral gray. To simply mute a color, making it more subtle and less vibrant, just mix in a bit of its complement. But there are so many neutrals that you'll need to go beyond using only complements. The chart below shows how to create a range of grays and browns.

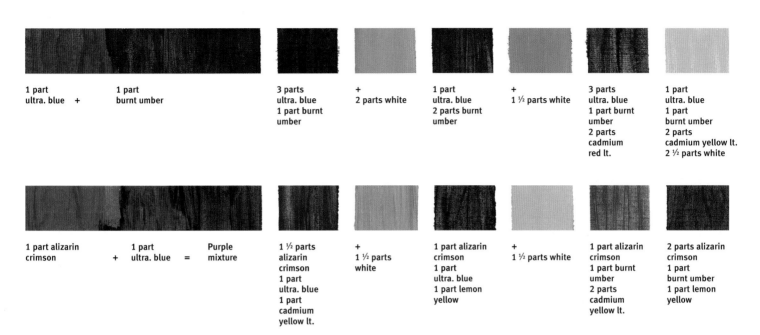

1 part
ultra. blue    +    1 part
burnt umber

3 parts
ultra. blue
1 part burnt
umber

+
2 parts white

1 part
ultra. blue
2 parts burnt
umber

+
1 ½ parts white

3 parts
ultra. blue
1 part burnt
umber
2 parts
cadmium
red lt.

1 part
ultra. blue
1 part
burnt umber
2 parts
cadmium yellow lt.
2 ½ parts white

1 part alizarin
crimson    +    1 part
ultra. blue    =    Purple
mixture

1 ½ parts
alizarin
crimson
1 part
ultra. blue
1 part
cadmium
yellow lt.

+
1 ½ parts
white

1 part alizarin
crimson
1 part
ultra. blue
1 part lemon
yellow

+
1 ½ parts white

1 part alizarin
crimson
1 part burnt
umber
2 parts
cadmium
yellow lt.

2 parts alizarin
crimson
1 part
burnt umber
1 part lemon
yellow

## Tinting and Shading

You can also mix a great range of values by simply adding white to a color (creating a *tint* of that color) or by adding black (creating a *shade* of that color). This chart demonstrates some of the tints and shades you can create by adding varying amounts of white or black to a pure color. To avoid mixing muddied colors, here are some simple tips: When adding white to any color, also add a touch of the color *above* it on the color wheel. For example, when you add white to red, also add a tiny bit of orange. This creates a more fresh and lively tint. When adding black to any color, also add a touch of the color *below* it on the color wheel. For example, when you add black to green, also add a small amount of blue-green, which makes a richer and more vibrant shade.

**Diluting and Toning** Another method for lightening your colors is to dilute the color with a solvent, such as turpentine. You can also add gray to a color, creating a **tone** of that color.

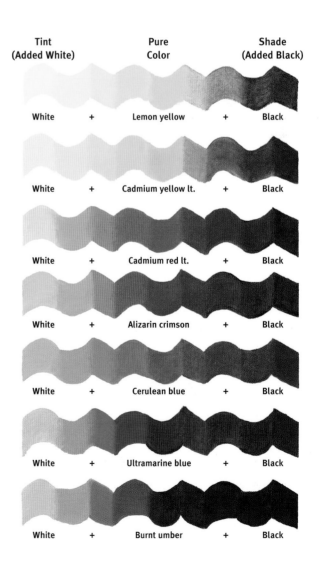

| Tint (Added White) | | Pure Color | | Shade (Added Black) |
|---|---|---|---|---|
| White | + | Lemon yellow | + | Black |
| White | + | Cadmium yellow lt. | + | Black |
| White | + | Cadmium red lt. | + | Black |
| White | + | Alizarin crimson | + | Black |
| White | + | Cerulean blue | + | Black |
| White | + | Ultramarine blue | + | Black |
| White | + | Burnt umber | + | Black |

# Drawing Techniques with Vanessa Rothe

While the focus of this book is on painting, it's important to hone your drawing skills so you can set yourself up for a successful painting from the start.

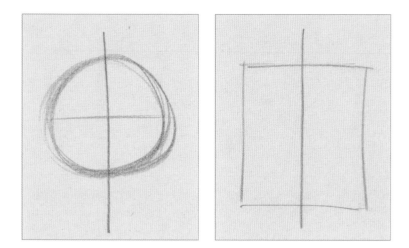

## Using a Centerline

Using a centerline when drawing shapes can help you achieve accurate measurements and symmetry. Before sketching a basic shape, draw a vertical and/or horizontal line; then use the guideline to draw your shape, making sure it is equal on both sides. Remember: Drawing straight lines and uniform circles takes practice and time. As you progress as an artist, these basic skills will improve.

## Establishing Proportions

To achieve a sense of realism in your work, it's important to establish the correct proportions. Using centerlines, as shown above, will provide starter guidelines. From here, you must delineate the shape of the object. To do this accurately, measure the lengths, widths, and angles of your subject. Examine the vertical, horizontal, and diagonal lines in your subject and make sure they relate properly to one another in your drawing. You can check proportions and angles by using your pencil as a measuring tool. Use the top of your thumb to mark where the measurement ends on your pencil (A, B), or hold it at an angle to check your angles (C, D).

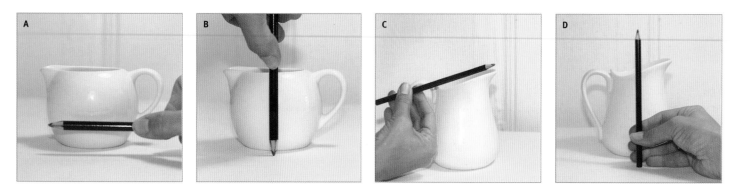

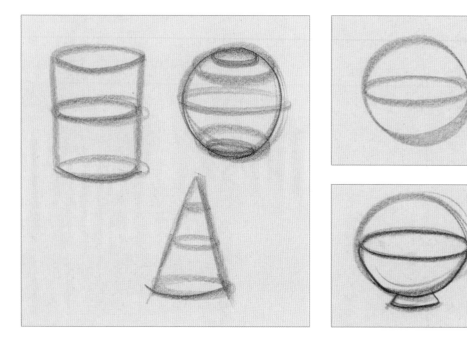

## Drawing Through

You can transform basic shapes into forms by "drawing through" them. Imagine the form is transparent, and then suggest the surface of the backside with your sketching strokes. This process will help you acknowledge the volume of your object as you add the surface shadows in later stages. It will also help you understand your object as it relates to its surroundings.

## Values & Shadows

There are five main aspects of value that are used to create the illusion of volume. As mentioned previously, value refers to the tones of lightness or darkness, covering the full range of white through shades of gray to black. The range of lights and darks of an object can change depending on how much light hits the object. With practice, you will develop a keen eye for seeing lights, darks, and the subtle transitions between each value across a form. The five main values to look for on any object are the cast shadow, core shadow, midtone, reflected light, and highlight, as illustrated at right.

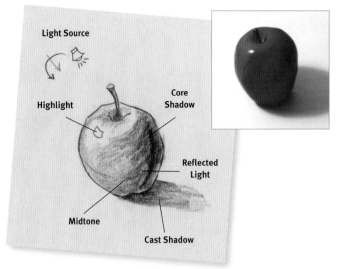

1. **Cast shadow:** This is the shadow of the object that is cast upon the other surface, such as the table.

2. **Core shadow:** This refers to the darkest value on the object, which is located on the side opposite the light source.

3. **Midtone:** This middle-range value is located where the surface turns from the light source.

4. **Reflected light:** This light area within a shadow comes from light that has reflected off of a different surface nearby (most often from the surface on which the object rests). The value of this depends on the overall values of both surfaces and the strength of the light, but remember that it's always darker than the midtone.

5. **Highlight:** This refers to the area that receives direct light, making it the lightest value on the surface.

## Focusing on Cast Shadows

Every object casts a shadow onto the table, chair, or surface that it sits upon (called the "cast shadow" as explained above). The shadow will fall to and under the dark side of the object, away from the light source. Including this shadow is very important both in depicting the illusion of form and in grounding your object, which gives the viewer a sense of weight and space. Note that these shadows are the darkest at the point where they meet the object (often beneath the object) and lighten as they move away from the object. Also, generally the shadow edge is sharpest at the base of the object, softening as it moves away from the object.

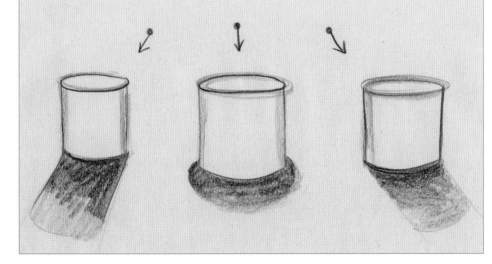

# Basic Painting Techniques

Most oil painters apply paint to their supports with brushes. The variety of effects you can achieve—depending on your brush selections and your techniques—is virtually limitless. Just keep experimenting to find out what works best for you. A few of the approaches to oil painting and brushwork techniques are outlined below.

## Approaching Your Painting

There are three basic approaches to oil painting; you may want to try each approach to see which you prefer. In the first approach, you begin by toning the entire canvas with a layer of transparent color (an *imprimatura*) and then build up the painting with a series of thin layers of color (*glazes*) on top of the initial color. For the second approach, you build the painting from dark to light or light to dark; for example, you may start by blocking in the darkest values, then add the mid-values, and finish with the lightest values. The third approach is called *alla prima*, which is Italian for "at once." This means that you apply all the paint in a single painting session. In this approach, you are not applying a series of layers but laying in the opaque colors essentially the way they will appear in your final painting. Artists also refer to this method as a *direct approach*.

**Painting Thickly** Load your brush or knife with thick, opaque paint and apply it liberally to create texture.

**Thin Paint** Dilute your color with thinner, and use soft, even strokes to make transparent layers.

**Drybrush** Load a brush, wipe off excess paint, and lightly drag it over the surface to make irregular effects.

**Blending** Use a clean, dry hake or fan brush to lightly stroke over wet colors to make soft, gradual blends.

**Glazing** Apply a thin layer of transparent color over existing dry color. Let dry before applying another layer.

**Pulling and Dragging** Using pressure, pull or drag dry color over a surface to texturize or accent an area.

## Artist's Tip

When you're learning a new technique, it's a good idea to practice on a separate sheet first. Once you're comfortable with the technique, you can apply it with confidence to your final work.

**Stippling** Using the tip of a brush or knife, apply thick paint in irregular masses of small dots to build color.

**Scumbling** Lightly brush semi-opaque color over dry paint, allowing the underlying colors to show through.

**Scraping** Use the tip of a knife to remove wet paint from your support and reveal the underlying color.

**Wiping Away** Wipe away paint with a paper towel or blot with newspaper to create subtle highlights.

**Sponging** Apply paint with a natural sponge to create mottled textures for subjects such as rocks or foliage.

**Spatter** Randomly apply specks of color on your canvas by flicking thin paint off the tip of your brush.

## Painting with a Knife

With painting knives, you can apply thick textures or render intricate details. Use the side of your knife to apply paint thickly. Use the fine-point tip of your knife for blending and drawing details. Below are some examples of effects you can achieve with a painting knife.

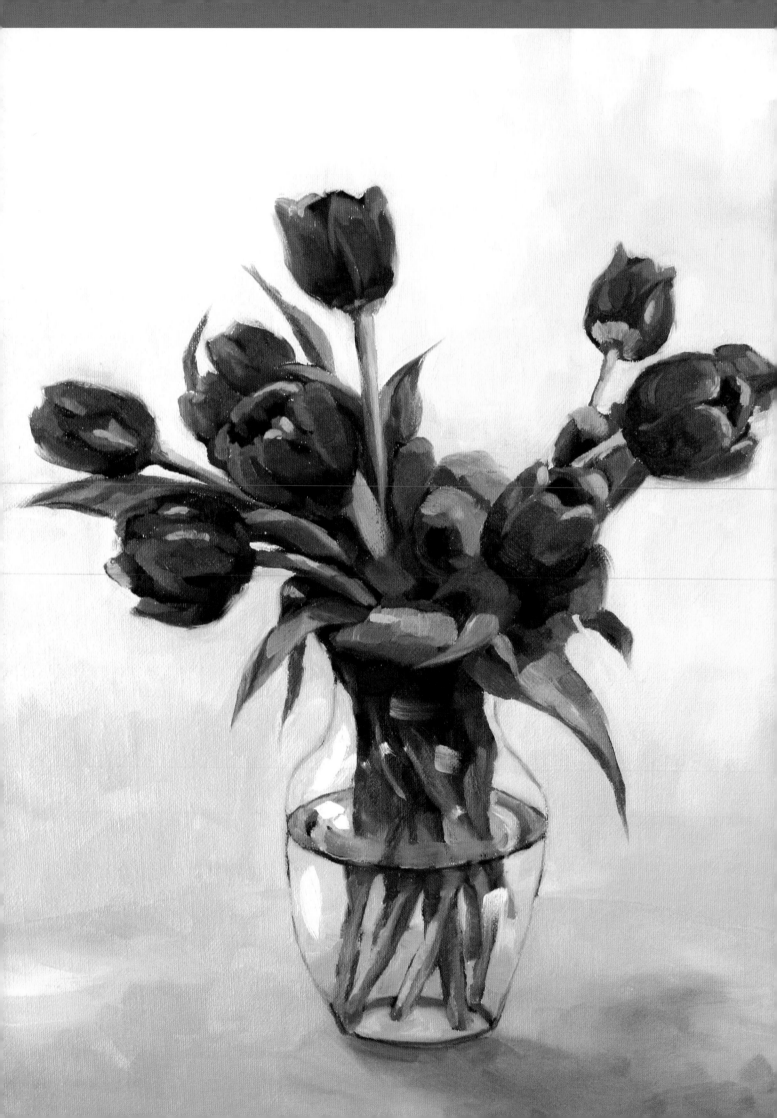

# Chapter 1
# Painting Still Lifes & Florals

**with Marcia Baldwin, Varvara Harmon,
Vanessa Rothe, and James Sulkowski**

Still lifes and florals are a great place to start on your journey
to becoming an expert oil painter. Because they are completely
stationary, these subjects offer you the opportunity to really study
the composition, shapes, shadows, and colors. In this chapter you'll
find nine beautiful and unique still life and floral projects to paint
step by step. Along the way you'll learn how to render glass,
porcelain, petals, and wood texture.

# Tulips in a Glass Vase

## with Vanessa Rothe

Reflective surfaces can be intimidating, but simple glass is much easier than it looks. Tulips make a great subject for focusing on glass, as the flowers are made up of simple shapes and the stems are clean and long, which will show clearly through the glass. For this painting, I'm using a 12" x 16" canvas. Keep an extra palette or canvas panel on hand; we will be mixing many colors for this painting.

### Palette

alizarin crimson • black • burnt sienna
cadmium red • cadmium yellow • Naples yellow
titanium white • ultramarine blue

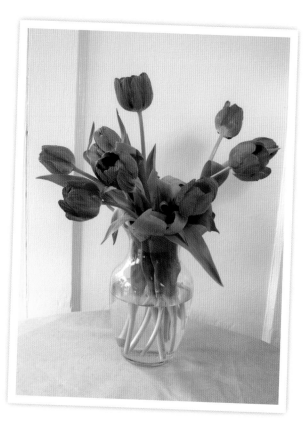

▲ Set up your still life with direct lighting that creates a white highlight on your glass, as shown here. Arrange your flowers so they face different directions and so there are no holes in the arrangement. It's a good idea to have some leaves drop down and to the side.

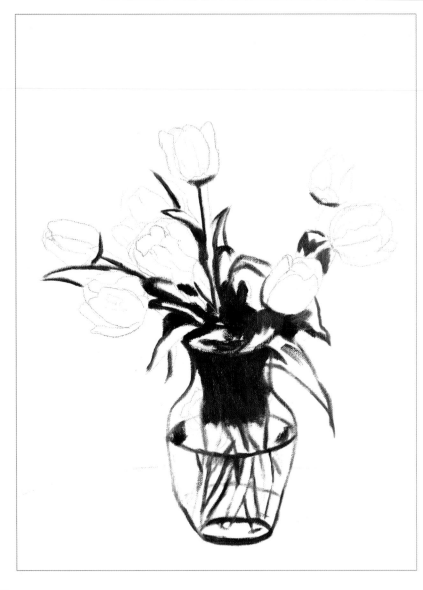

**1.** First I sketch the composition on my canvas. I block in the darkest values with a blue-green mix of ultramarine blue and cadmium yellow. You can put more than you feel is necessary on this layer. You can also outline some of your leaves to create a nice undercolor and shadow for the leaves. I also outline the glass vase to help make it stand out.

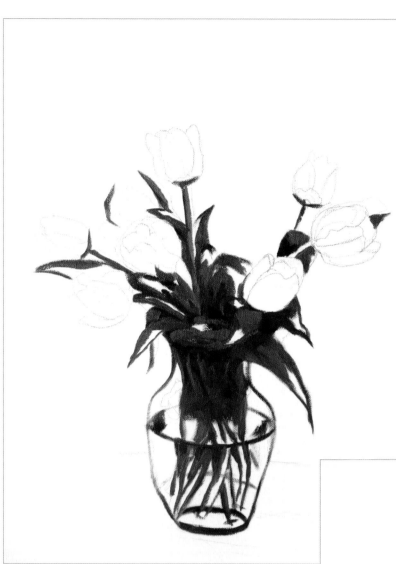

**2.** I stroke a slightly lighter second green mix of cadmium yellow and ultramarine blue, on the leaves. Pay close attention to how the leaves curl and follow them with your brushstrokes. Leave the dark blue-green where the shadows fall. I blend the lower stem area lightly into the darks.

**3.** I mix a light green, using Naples yellow, titanium white, and a bit of ultramarine blue and cadmium yellow, and paint the lighter values on the leaves and stems. Look closely at the direction of the leaves. Note that there is a good amount of lighter green on the lower stems in the glass vase.

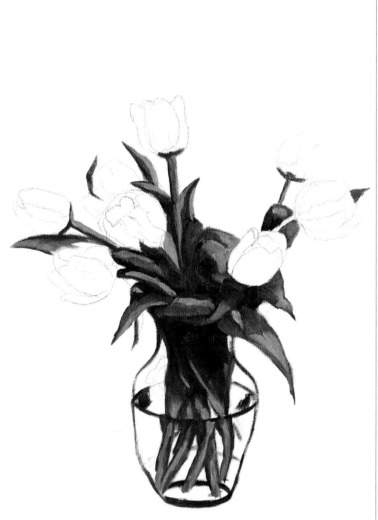

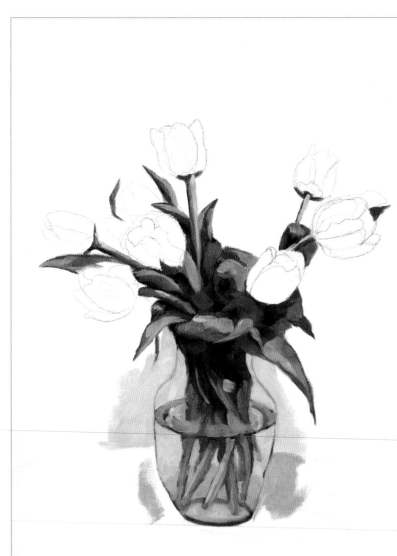

**4.** I add a light blue-gray mix of ultramarine blue, Naples yellow, and titanium white to the leaves where the light hits. Then I add lime-yellow highlights to the leaves and stems, using a mix of Naples yellow, titanium white, and a bit of ultramarine blue. I block in the tan colors on the wall with a dark mix of black, burnt sienna, Naples yellow, and titanium white and a lighter mix of Naples yellow, burnt sienna, and mostly white. I add a light blue mix of titanium white, ultramarine blue, and a bit of cadmium yellow to the light tan mix and paint the wall through the glass vase. Then I add some of the blue table background around the vase, using a mix of ultramarine blue, cadmium yellow, and lots of titanium white. Note that the blue in the glass starts lower due to some distortion in the glass shapes. You can see this clearly in the photo.

**5.** I add the white highlights to the glass to make it shine, loading my brush with pure white and marking where the lightest highlights hit the vase. I continue adding more of the blue table around the vase.

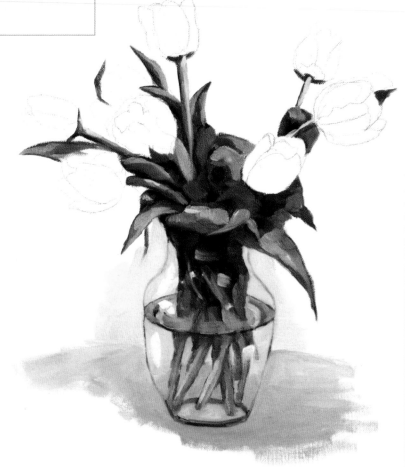

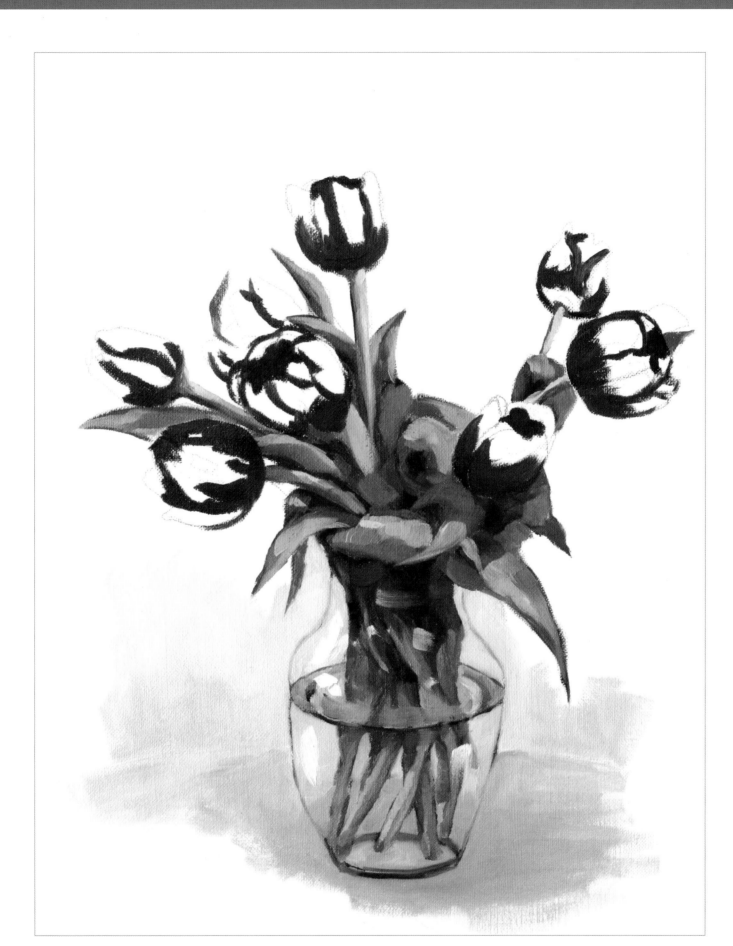

**6.** I mix a cool, dark purple, using ultramarine blue, alizarin crimson, and a bit of cadmium red. I paint the base of each tulip and a little inside the flowers to define them. I also define the darkest areas between petals. Then I mix a second dark purple value, using less ultramarine blue and more alizarin crimson, cadmium red, and titanium white. I build up the darks on top of the previous purple and further define the edges of the petals where they meet.

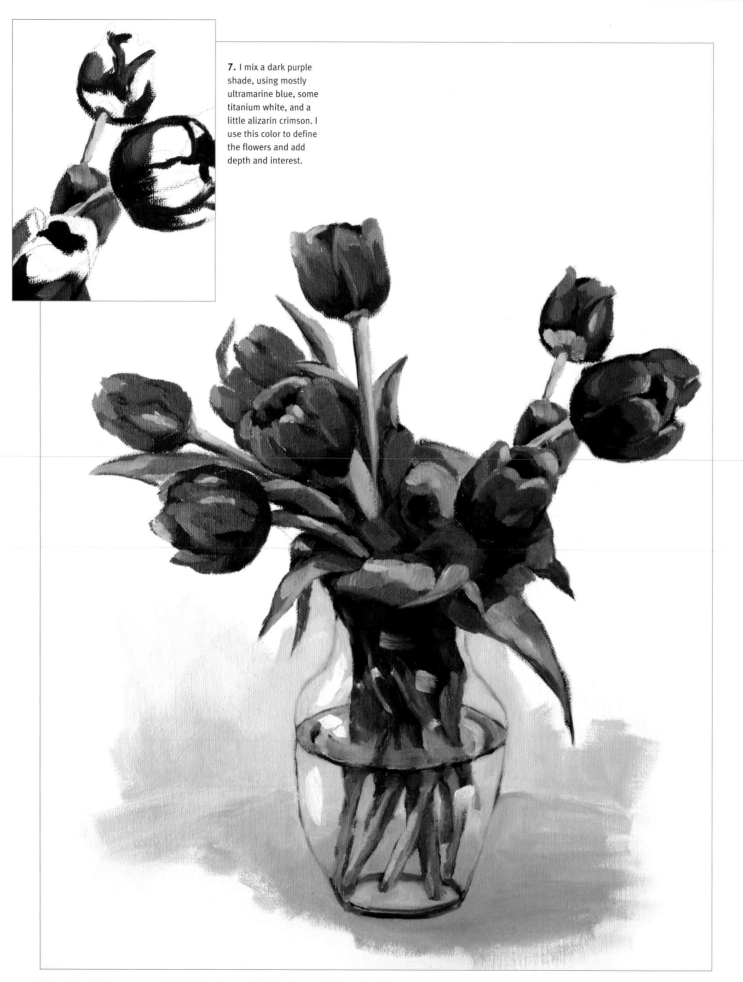

**7.** I mix a dark purple shade, using mostly ultramarine blue, some titanium white, and a little alizarin crimson. I use this color to define the flowers and add depth and interest.

**8.** I apply a slightly warmer purple mix of equal parts alizarin crimson and ultramarine blue, some titanium white, and a bit of cadmium red to the tulips. Be sure to paint in the direction the petals go. I add light purple to the tops of the tulips, using a mix of alizarin crimson, titanium white, and cadmium red. Look at the photo reference and then add the final highlights to the tops of the tulips with a mix of titanium white, alizarin crimson, and cadmium yellow. Not all the tulips will receive this final light color at the top, as not every one is hit by strong light. You can also add a little purple to the leaves and stems for color harmony. Don't add too much—just a hint of warmth in the leaves.

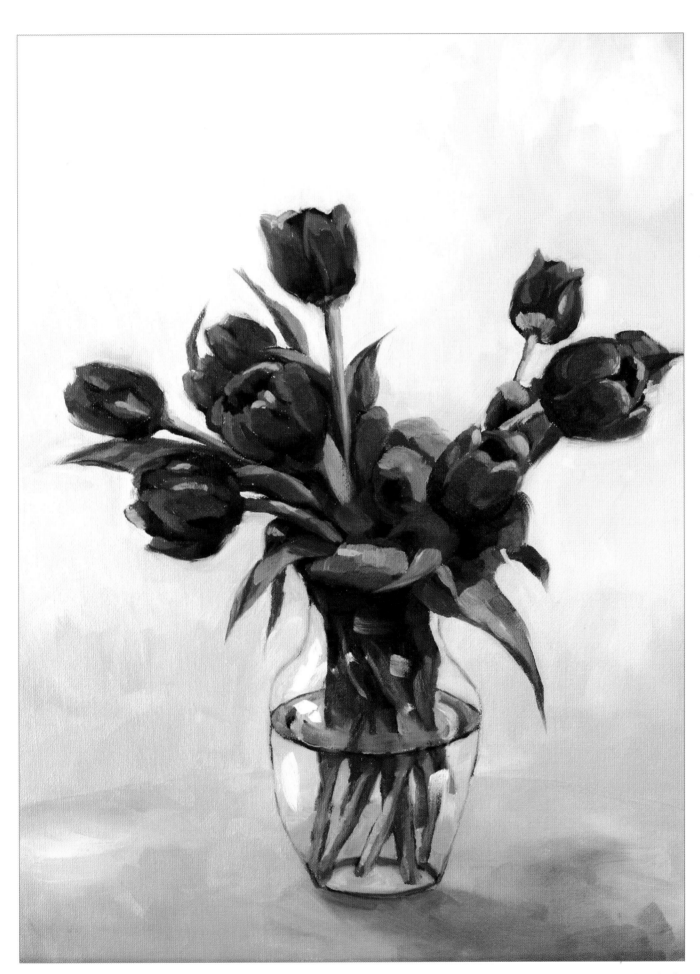

**9.** I paint the subtle cast shadow on the table, using one of my light purple mixes on the darker part of the table, and paint the shadow directly under and to the right of the vase. I build the tans on the wall and add a bit of my blue table mix too. As I work up the canvas I add titanium white to my mixes to lighten them. I check the edges where the background meets the flowers and soften them a little more. I stroke a midtone green on the tips of the leaves, right over the background. If you make a mistake with your green stroke, simply apply the peachy tan wall mix over it and try again.

# Bowl of Lemons

## with Vanessa Rothe

In this vibrant still life painting, I focus on composition and color harmony. Although I plan to mix many different colors for each element in the painting, the work needs to look cohesive. I paint each element separately as I go, noting and representing any color interactions for dynamic results.

### Palette

alizarin crimson • burnt sienna • cadmium yellow
cerulean blue • lemon yellow • Naples yellow
permanent green light • titanium white • ultramarine blue
Winsor violet • yellow ochre

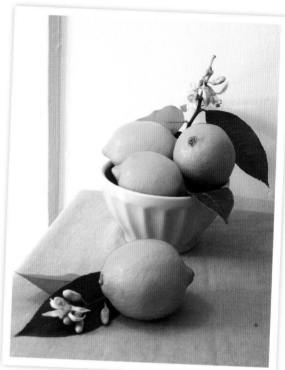

▲ Work both from the photo and from my final painting on page 29. Alternatively, you can set up your own still life with lemons similar to the one pictured. Notice that the lighting is coming from the left and slightly behind, and the shadows are cast to the right and forward.

**1.** I sketch the composition on newsprint, placing the largest object first—in this case, the bowl of lemons. Once I'm satisfied with the layout, I draw it on the canvas. I draw first in pencil and then outline the sketch with a thin layer of paint, adding a bit more paint in the darkest shadows. For this I used a mix of 90% yellow ochre and 10% ultramarine blue, lightened with a speck of titanium white.

**2.** I start on the lemons, moving from dark to light. First I lay down the core shadow, a mix of cadmium yellow and burnt sienna. Always put down a little more dark on the canvas than you see, and remember to preserve your darks throughout the process.

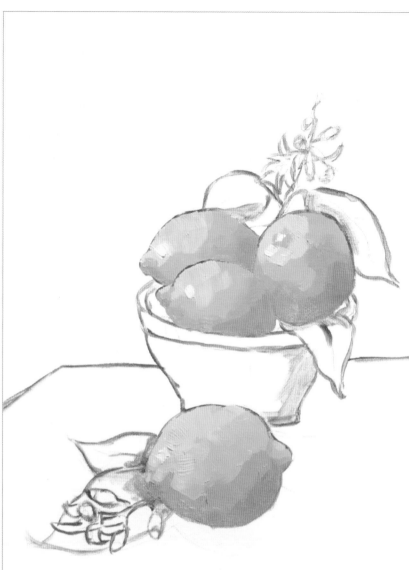

**3.** I paint the midtone yellow with a mix of cadmium yellow, titanium white, and lemon yellow. Then I paint the lightest yellow values—a mix of mostly titanium white with some cadmium yellow and a bit of lemon yellow. I add touches of cadmium yellow and lemon yellow to white to paint the highlights. You can blend the values a bit if needed. To give the lemons more weight, I stroke a darker mix of cadmium yellow and burnt sienna along the bottom areas. Then I add a small stroke of pure lemon yellow—straight from the tube—over each for interest. I also stroke some pure lemon yellow over some of my light lemon values to add to the overall feel of the lemon.

## Artist's Tip

Reminder: Clean the brush thoroughly every time you switch to a new color.

**4.** Next I cover a generous portion of the leaves with a dark green mix of ultramarine blue and cadmium yellow.

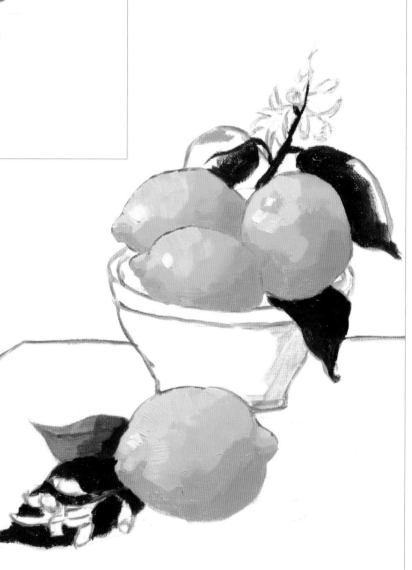

**5.** I use the same colors to create a midtone green, but use more cadmium yellow and less ultramarine blue. I also mix a light green by adding a little less cadmium yellow and a bit of Naples yellow. Next I work on the lemon blooms. In addition to the values, note the variety of purples and warm lavenders. I work from dark to light to build volume in the flowers. I start with a dark value at the base of the blooms, using a mix of Winsor violet, alizarin crimson, and titanium white. For the midtone purple I add more white to the dark mix. I add even more white for the lightest purple value.

**6.** For the turquoise bowl I use a rich combination of blues, yellows, and greens and work from dark to light, using minimal blending. I use a light blue mix of cerulean blue, titanium white, and a little ultramarine blue and cadmium yellow and a lighter mix of just cerulean blue, titanium white, and cadmium yellow to block in the main values. Then I use a dark blue-green mix of cerulean blue with equal parts permanent green light and titanium white, with a bit of cadmium yellow, to stroke under the rim at the top of the bow. I also outline the sides and bottom of the bowl. Then I create an even lighter blue value of mostly titanium white with some cerulean blue and a tiny bit of cadmium yellow. I use this to add a light stroke along the top rim of the bowl.

**7.** I mix a rich dark for the cast shadow of the leaf onto the bowl, using mostly ultramarine blue with small amounts of cerulean blue, titanium white, and burnt sienna. Then I mix a bright green with cerulean blue and equal parts of permanent green light and titanium white, and add some strokes to the bowl.

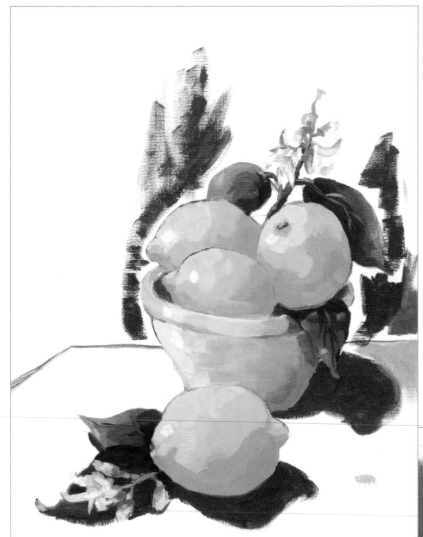

To develop the color harmony in the work, I add one of my yellow values for the lemons at the ends of the blooms.

◄ **8.** I begin building the background, starting with a few marks on the wall and the lemons. I use a mix of ultramarine blue, burnt sienna, and titanium white and also use this value to block in shadows on the table. I mix equal parts ultramarine blue and titanium white with a bit of burnt sienna for a medium blue value and paint some strokes on the light chambray tablecloth.

**9.** I continue painting the table and wall. The light on the back wall is coming from the top left, so keep this in mind as you develop the light pattern of the background. As you fill in the dark and light blues, feel free to work in previously mixed blue colors from the bowl for interest and color harmony. I also add burnt sienna to the tabletop in the lower right and a light yellow to the upper left of the table for light and warmth.

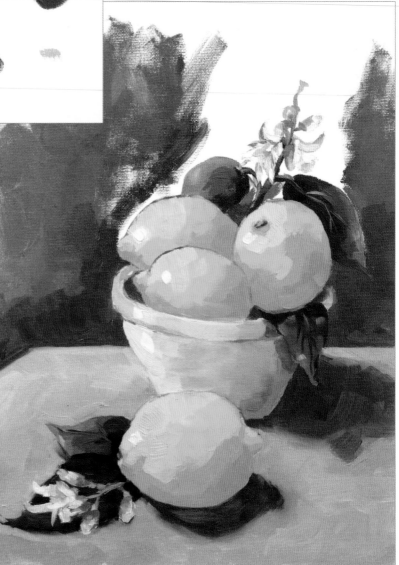

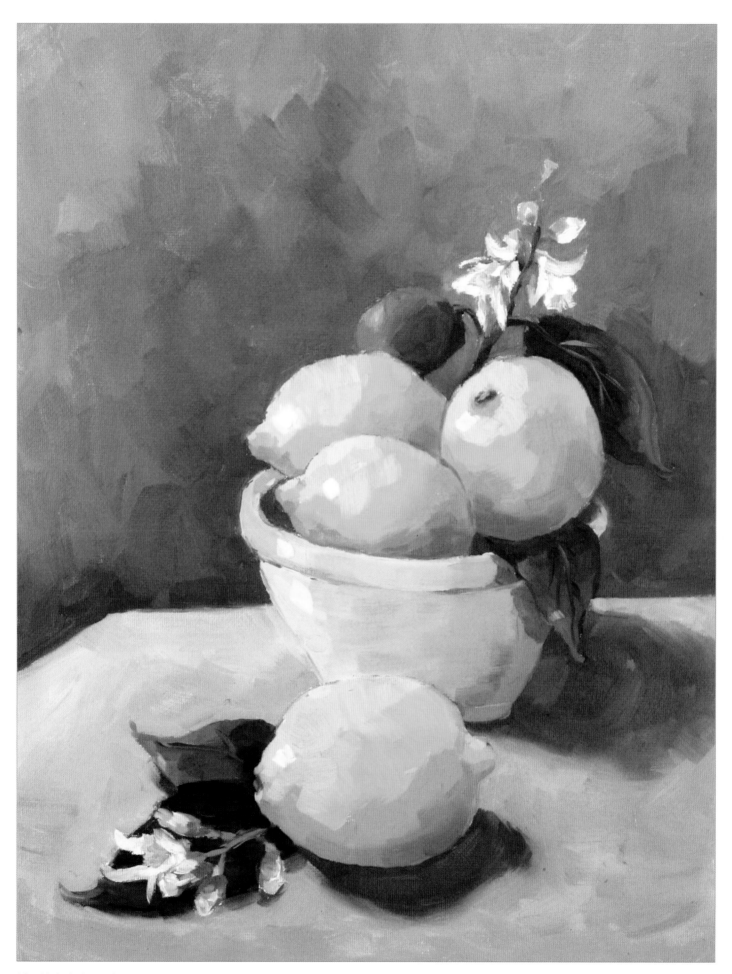

**10.** With the background in place I use a dry brush to smooth the strokes to suit my taste. You can return to various areas of the painting to blend and make areas appear to recede. *Voilà*, my piece is done!

# Applying an Underpainting

## with Marcia Baldwin

Although I drew a very rough sketch of my planned composition, my underpainting, which consists of almost all of the colors in my project palette, offers me a visual color reference, which proves extremely useful as I layer in more and more paint.

## Palette

### Oil Colors

blue violet • cadmium orange • emerald green
lemon yellow • phthalo rose red • phthalo violet
red deep • red medium • titanium white • yellow ochre

### Oil Pastels (optional)

rose red • violet • yellow ochre

**1.** I start by laying down the underpainting, consisting of lemon yellow, yellow ochre, cadmium orange, and phthalo violet. I load my brush with the darkest color first, plus medium. Using soft, broad brushstrokes, I apply color to the support. I continue this process, working from dark to light, making sure to clean my brush between each new color. Once I have generously covered the canvas, I let it dry for about 30 minutes. Then I use a soft dry brush to gently blend the colors into each other.

**2.** Using quick, loose strokes, I draw the dahlia petals using an oil pastel or the tip of a round paintbrush. Use yellow ochre for the petal outlines over the yellow areas of the underpainting, and use rose red or red deep for the outlines you draw over the reds, violets, and oranges. Keep your lines loose and free of detail, but strive to create the overall basic shape to help you form the general composition.

◄ **3.** Following the outlines, I begin filling in the dahlia. I use blue violet for the darkest, shaded areas. For the tips of the muted petals, I apply a mix of phthalo violet and cadmium orange.

▲ **4.** Next I lay in the various reds. For the brighter red petals, I mix a bit of quick-drying medium with phthalo rose red and apply it over the yellow underpainting. For the darker petal areas, including the shadows, I add a bit of emerald green to the red mix. I begin applying the color to the petals, making sure to stop and blend them occasionally with a flat sable brush.

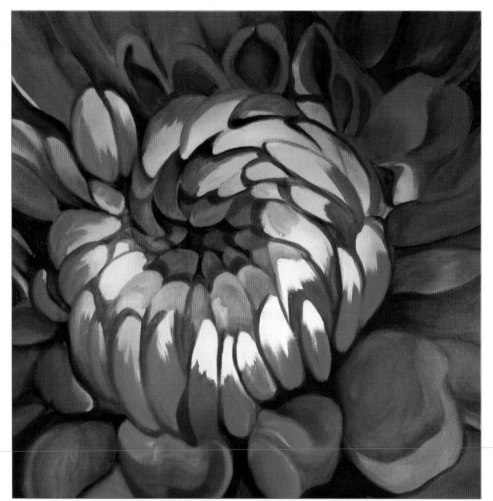

**5.** I continue layering in the reds, making sure that my brushstrokes curve with the shape of the petals. When I am finished applying the reds, I go back over and fill in the deepest shadows with my emerald green/red mixture. I use phthalo violet to add shading in areas.

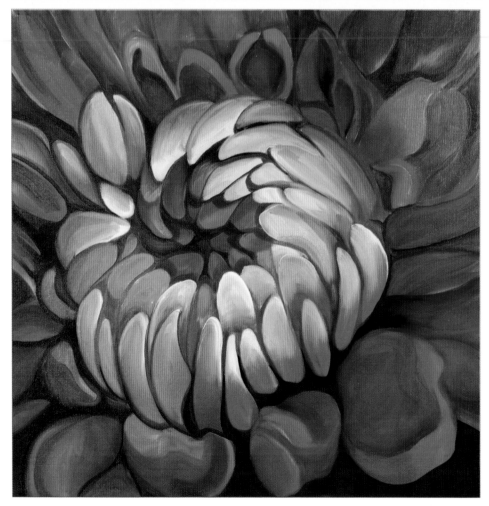

**6.** I mix a dab of red rose with titanium white and another dab of cadmium orange with white. Then I add highlights to the petals in select areas. I softly blend the hues into the darker tones using a clean, dry brush and enhance any shadows, edges, or darker areas with strokes of red deep or phthalo violet.

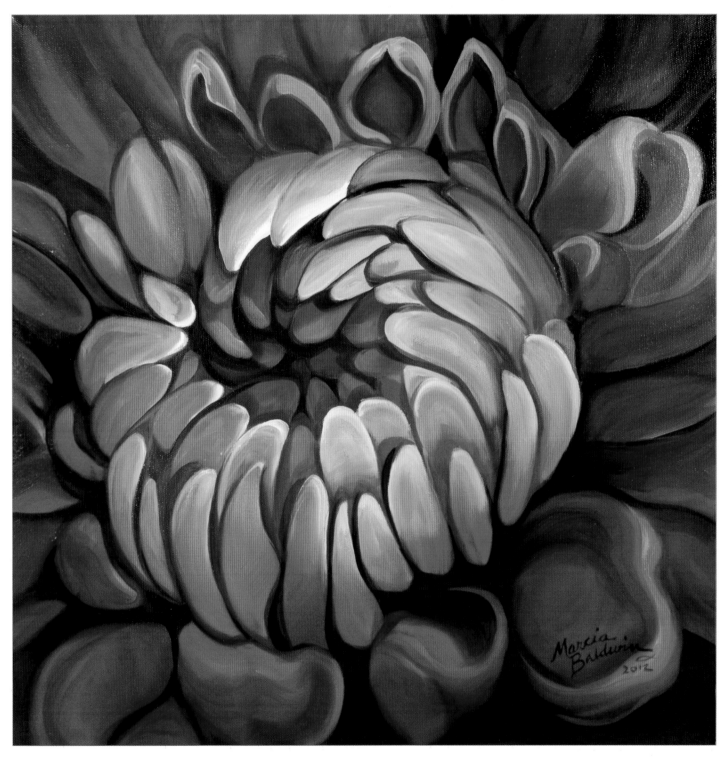

**7.** I finish darkening the deepest shadows with red deep and phthalo violet. When I am satisfied with the painting, I sign my name and date the piece.

# Teacup & Lemon
## with James Sulkowski

This still life incorporates the idea of lost and found edges. Generally your paintings should include a variety of edges— from sharp and distinct to blurred and subtle—to create a feeling of atmosphere and space. For example, you can direct the viewer to the focal point by using solid edges against contrasting values. You can also create subtlety and depth by keeping some edges less defined, allowing objects and the background to move into each other and connect visually. As you paint this teacup and lemon, note how each edge relates to this painting's clarity and message.

▶ I set up a teacup, lemon, and white lace napkin on a flat wooden surface and place a box over the scene to focus the light. I make sure to place my lightest objects in the strongest light, which is coming from the left.

## Palette
alizarin crimson • cadmium lemon yellow • cadmium yellow light • cadmium red • cadmium red light
cobalt blue • ivory black • phthalo green • raw umber • titanium white • transparent gold ochre
terra rosa • ultramarine blue • yellow ochre

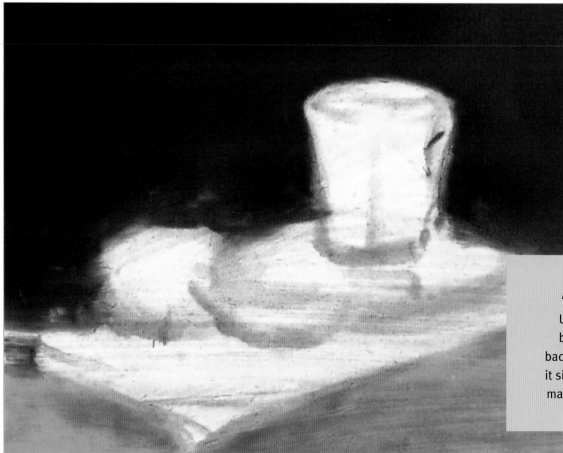

**1.** I tone a 9" x 12" gessoed panel with thinned cadmium red medium or terra rosa. Once dry, I use a No. 2 filbert bristle brush to sketch the scene, using a medium gray mix of white and ivory black. Next I move to the background and apply a mix of phthalo green, dark gray, and a touch of cadmium lemon yellow. Notice how the background moves subtly from dark (left) to light (right). Then I wash in the table using a mix of transparent gold ochre and a bit of cadmium red light.

### Artist's Tip

Use large bristle brushes to paint backgrounds, making it simple and quick to mass in broad areas.

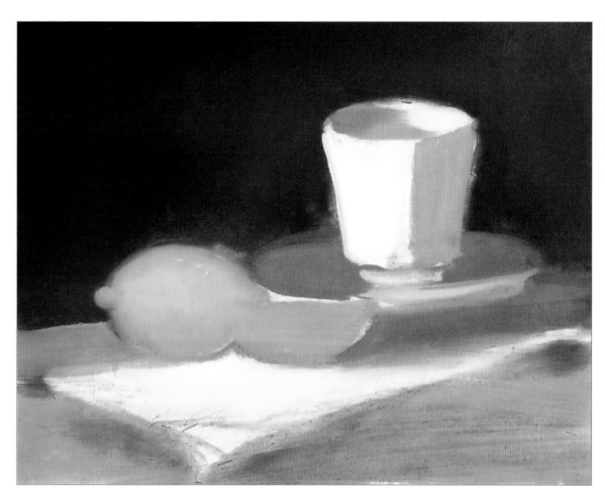

**2.** I block in all of my forms with their local colors. I block in the lemon with cadmium yellow light mixed with a bit of yellow ochre. I also divide the teacup into light and shadow using gray mixes, allowing the distant edge of the saucer to remain soft against the background. Then I indicate the shadows on the napkin.

**3.** Now I build the light effect, keeping in mind that the napkin and lemon wedge are the focus. I use pure white for the front of the napkin, and I mix cadmium lemon yellow and white for the lemon wedge. I also indicate the shadows on the lemon and wedge with a red-leaning mixture of cadmium red light and cobalt blue. This mixture creates a vibrant, warm, rich shadow.

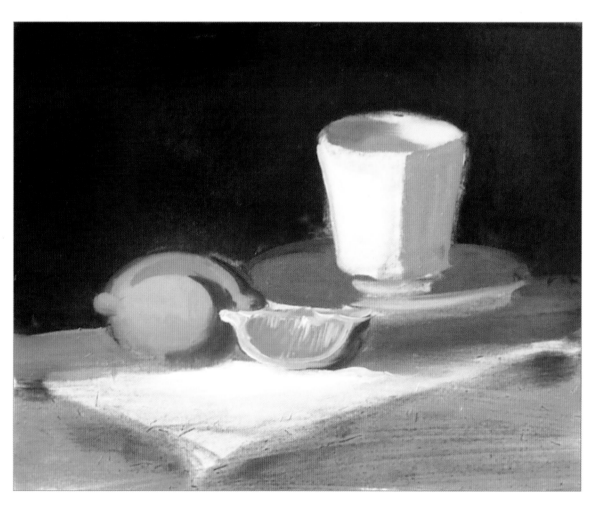

## Artist's Tip
A shadow mixture of cadmium red light and a bit of cobalt blue creates a warm violet.
This mixture is similar to English red, Venetian red, chrome oxide red, and Indian red.

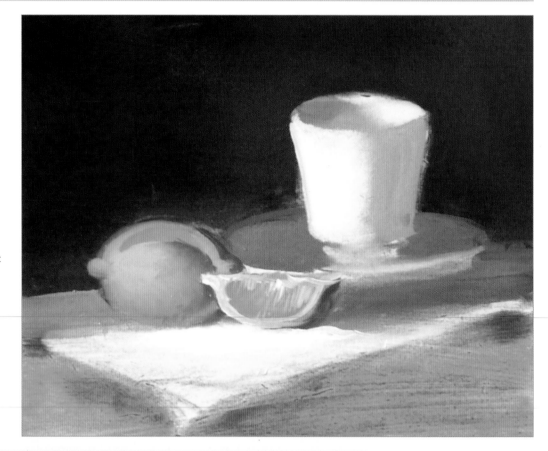

**4.** I mix a cool halftone of gray plus yellow ochre and use it as a transition from the light of the lemon to its shadow. This application begins to create the illusion of form. I keep the outer edges of the lemon soft, especially the edge that recedes into the background. I also begin to blend the area where light and shadow meet on the teacup, which suggests its cylindrical shape.

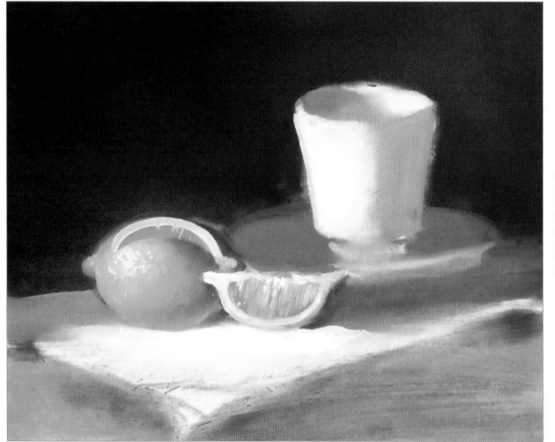

**5.** I continue increasing my forms by building up the highlights on the lemon to white. The pith of the lemon is fairly bright, so I use a mix of cadmium yellow light and white. For the pulp, I use a mixture of lemon yellow and gray.

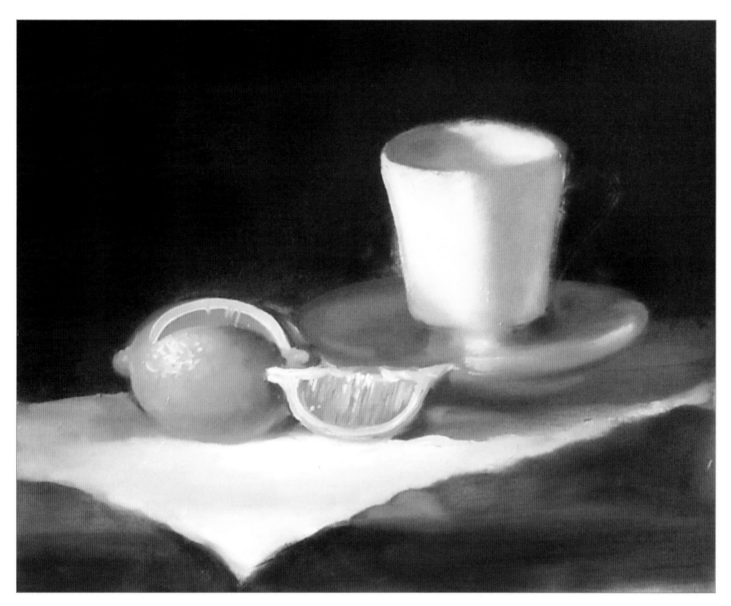

**6.** Next I turn my attention to the table. As I move away from the light effect, my colors become darker and richer. I add more cadmium red light and raw umber to the yellow ochre, indicating a table ledge with raw umber to give more dimension to the scene. Then I develop and smooth the values on the napkin and refine the teacup a bit.

## Artist's Tip

Remember to use your largest bristle brushes while building a painting. This keeps the surface fresh and lively while preventing you from becoming too tight too early. Save the smaller brushes for the final stages.

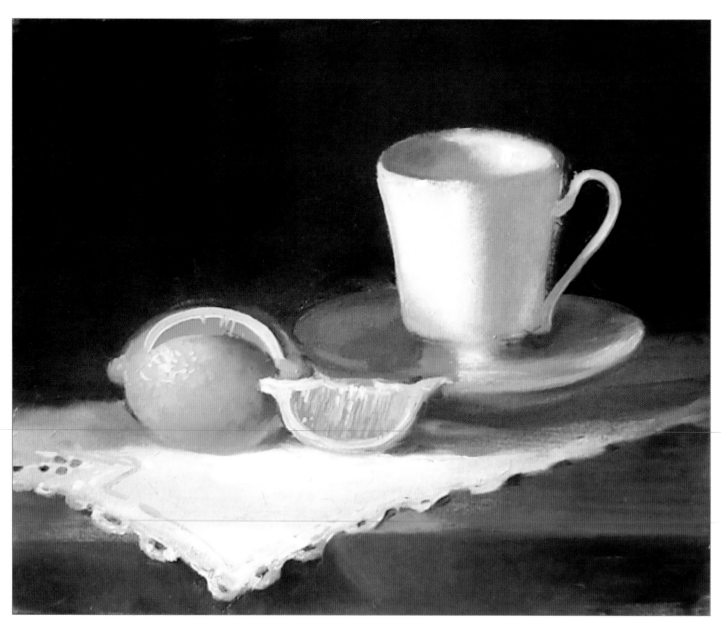

**7.** I add the handle of the teacup and build up the cup's highlights to white. (See "Teacup Detail," page 39.) I paint the lace around the edges of the napkin using gray values, applying white highlights carefully and sparingly. I include a shadow cast from the napkin on the table ledge, and I increase the light on the table ledge with yellow ochre under the lemon wedge. Notice the lost and found edges, particularly where the lemon and the saucer begin to disappear in shadow.

## Artist's Tip

When painting lights and building highlights, load your brush with more paint
than in previous steps to create thick impasto strokes.

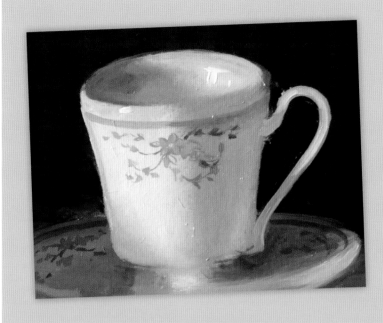

## Teacup Detail

When painting white porcelain, I always use a series of light gray mixtures to build the form. This leaves room for impact when I add the final pure white highlights. In this case, there are four small white highlights on the teacup: one on the outside lip, one on the inside lip, and two near the base. As you add the final highlights, place them precisely according to your light source.

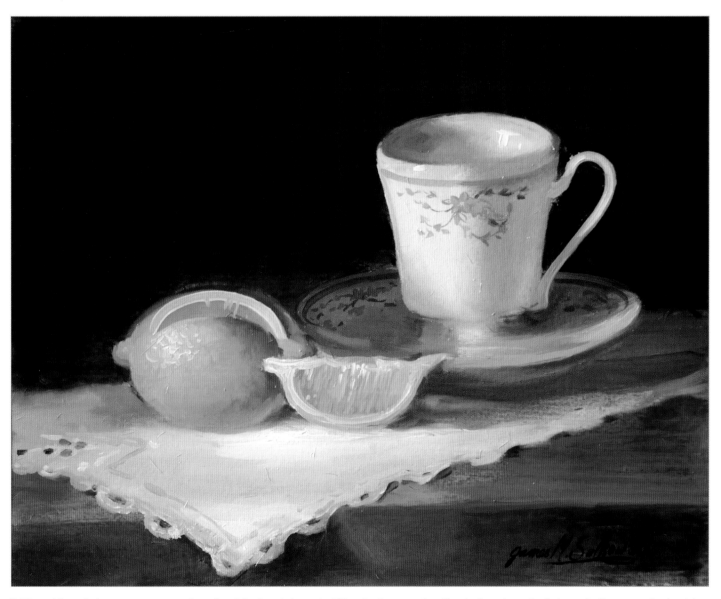

**8.** When adding a design to a teacup or vase, I usually wait for the painting to dry. This makes it easy to wipe off a mistake and start the design again, if necessary. For the pink flowers, I use a mix of alizarin crimson and white, adding gray to alizarin crimson for the darker values. For the greens I mix cadmium lemon yellow, ultramarine blue, and white for the lights, adding gray for the darker values. I paint the lightest areas of the cup first and then make my way to the areas in shadow.

# Lilacs in a Brass Pot

## with James Sulkowski

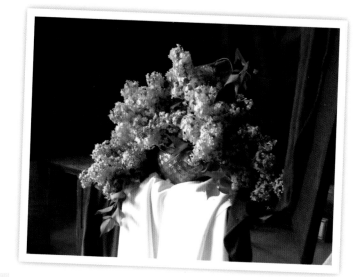

Lilacs are some of my favorite flowers to paint. In particular, I love the texture and delicate color variations in the flowers, ranging from blue-violets and red-violets to white. As with any still life painting, I intentionally use one main light source on my floral setup. Natural light from a north-facing window is best because it is consistent and even, and it allows you to see the truest color of any object. In this project, pay particular attention to how the light falls across the objects to define their forms.

### Palette

alizarin crimson • cadmium lemon yellow • cadmium red medium • cadmium yellow medium • ivory black phthalo green • titanium white • ultramarine blue yellow ochre

▲ I prefer to paint from life, so I set up my floral still life to view as I work. I place my subject on a table with a three-sided, black-draped background. Painting from life allows me to see the effects of the light moving in, through, and across the subject. Because my light source is coming from the left, the focus of light in my painting will be on the right.

**1.** I tone a gessoed panel with pink by wiping a mix of cadmium red medium (or terra rosa) and turpentine across the surface, using a soft cloth. For a quicker drying time, you can use watercolor paint for this step. Once dry, I use soft vine charcoal to sketch the subject with loose, gestural marks that indicate the position of the objects and suggest the flow of the composition. I always try to create compositions that feature a sense of movement, which I call "dynamic action."

## Artist's Tip

If you don't have a three-sided background, try setting up a floral scene in a cardboard box. This will concentrate the light on the subject, while eliminating reflected light from the room. You can paint the inside of the box black or dark green—or you can add two holes in the upper corners and pull fabric through for different colored backgrounds.

**2.** I always begin painting the background first. With my light source coming from the left, the background shows a horizontal movement of light from left (dark) to right (light). There is also a vertical movement from the top (light) to bottom (dark). I replicate these transitions of value in my painting. I create a dark green mixture of phthalo green, ivory black, and cadmium lemon yellow. Using a 1- to 2-inch flat bristle brush, I apply this mixture on the far left and add white as I move to the right toward the lighter areas.

**3.** Next I block in the shadows of the lilacs with filbert bristle brushes and dark violet mixtures of alizarin crimson, ultramarine blue, and titanium white. I allow for variation within the masses of color, reserving the cooler, darker tones for the shadowed area at right. I also stroke a few warm shadows on the pot and tablecloth using yellow ochre darkened with ultramarine blue.

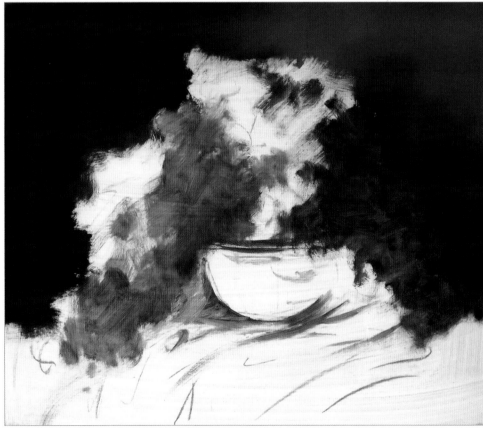

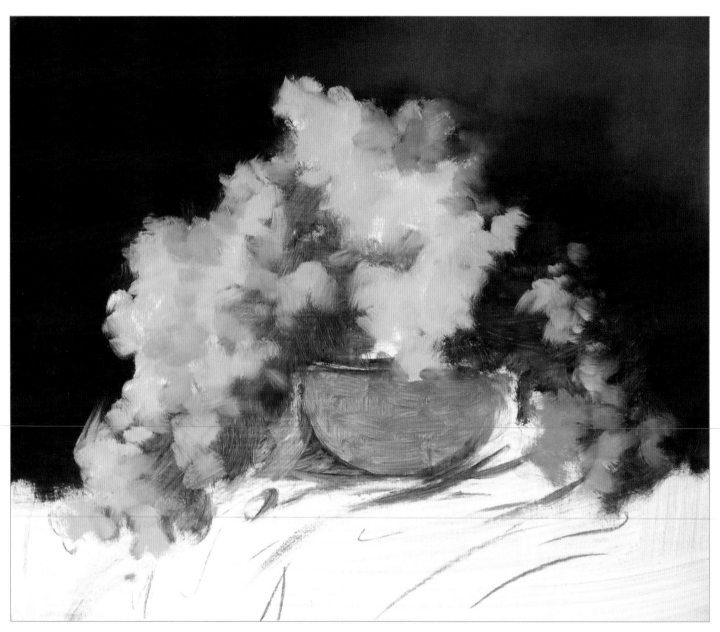

**4.** Next I block in the light masses of the flowers using a lighter value of my violet mixture from step 3, adding more white as needed. I continue blocking in the brass bowl with a mixture of yellow ochre and ultramarine blue.

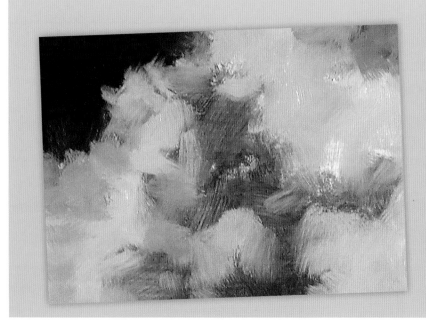

### Flower Mass Detail

As you mass in areas of a painting, use large brushes and keep your strokes loose and energetic. Notice the difference in opacity between the deep, transparent shadows and the opaque lights, which communicates depth even in this early stage.

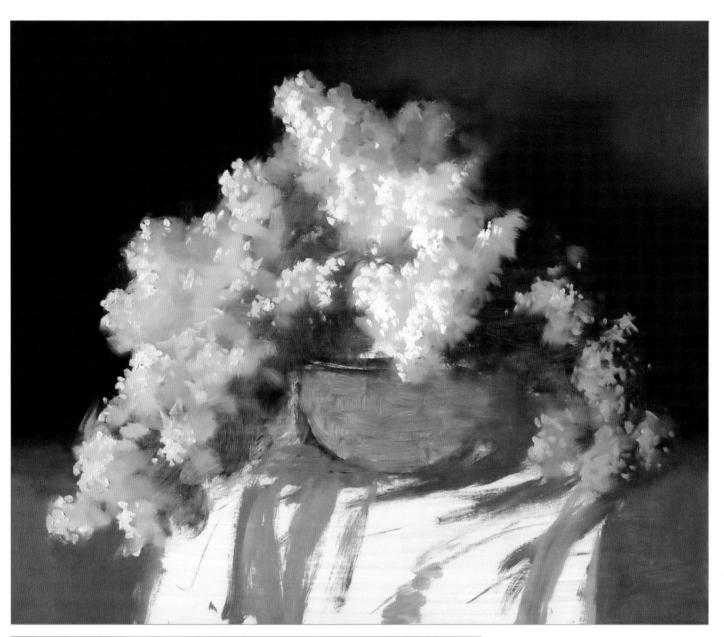

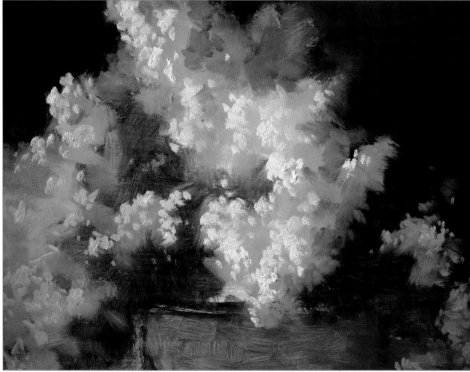

▲ **5.** I block in the darkest shadows of the white tablecloth with gray, using a mix of titanium white and ivory black. Then I create a green mix of ultramarine blue and lemon yellow toned down with gray and apply it to the green tablecloth. Next I return to the flowers and build the lightest values, using ultramarine blue, alizarin crimson, and plenty of titanium white. This is an important step for achieving the dramatic effect of light in the painting.

◄ **6.** With a bristle brush loaded with paint, I further develop the texture of the flowers. I follow the rhythm and shapes of the petals using a small filbert brush loaded with paint. Remember that lilacs are made up of egg shapes.

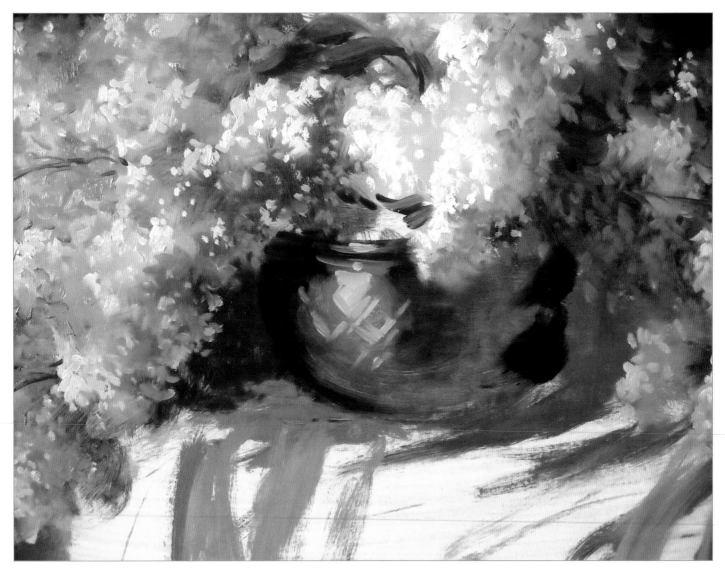

7. I begin working on the brass bowl by establishing the darks with a mixture of ultramarine blue and alizarin crimson. I paint the design of the bowl with my lights, which is a mixture of yellow ochre, cadmium yellow medium, and white.

## Brass Detail

For a more luminous painting, keep the darks transparent and build the lights with opaque layers of paint. Make each stroke count by following the form as you pull the brush.

## Flower Detail

I like to break down every object into three ideas or values: light, middle, and dark. In the final step, add the highlights and reflected lights. Think of this as you develop the lilacs.

## Artist's Tip

I stand about 4 to 5 feet away from my still life setup while painting, and I occasionally back up 10 feet or more from my canvas to study the progress of my work. A painting should look good from 10 to 20 feet away.

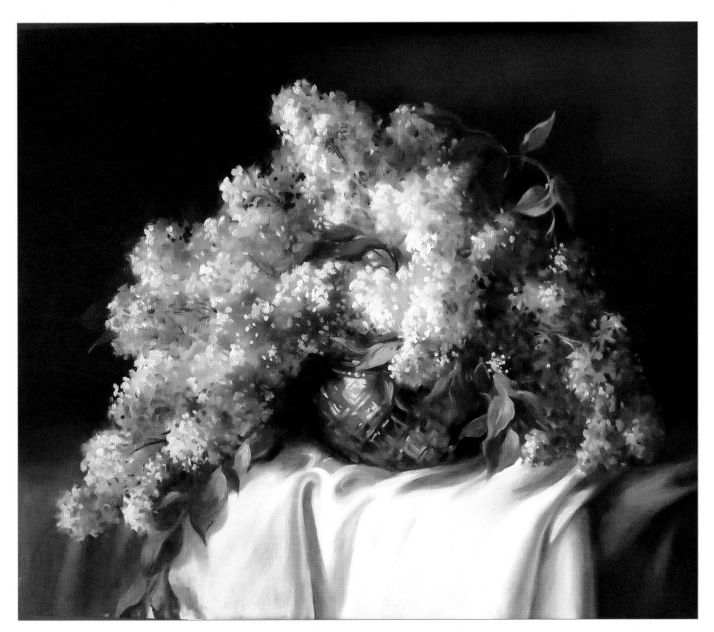

**8.** As I begin the finishing stages, I continue to develop the details with a round Kolinsky sable brush. I paint the white tablecloth with my grays, building up the light to pure white. Then I paint the texture of the rest of the lilacs as I move away from the light. Remember: Objects in the light are brighter and lighter, and objects moving away from the light are darker and cooler. I am also aware of the reflected light coming from the right as it hits the flowers and the bowl. For these areas, I use yellow ochre.

# Wine & Cheese

## with Varvara Harmon

In this painting of a classic still life setup of wine and cheese, I use underpainting to help me get started on the right foot. An underpainting is an initial layer of paint that blocks in shapes or values for subsequent layers. Applying an underpainting early on can help you determine that your composition works and allow you to see and plan for proper values.

### Palette

alizarin crimson • burnt sienna
cadmium yellow deep • sap green • titanium white
ultramarine blue • Winsor lemon • yellow ochre

**1.** First I place the composition on the canvas using paint in a color similar to the planned color of the background. I combine alizarin crimson, burnt sienna, and ultramarine blue to create the reddish-brown color for my outline.

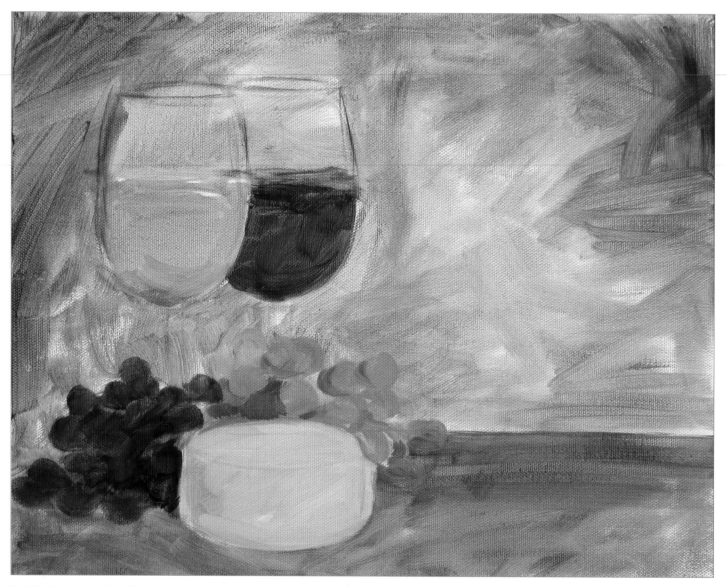

**2.** I fill in the painting with a thin layer of underpainting to help me see the values. I want to confirm that I am still satisfied with the composition of the painting and see if anything needs to be changed. This thin layer of paint will dry quickly; you will be able to continue working soon. Note that these colors do not have to precisely match the final colors; you just want them to be close enough to get an idea of what the future painting will look like.

## Artist's Tip

Generally, it takes a few days for oil paint to dry. I mix oil paint with walnut alkyd medium because it gives me a consistency I like, and it dries faster than walnut oil.

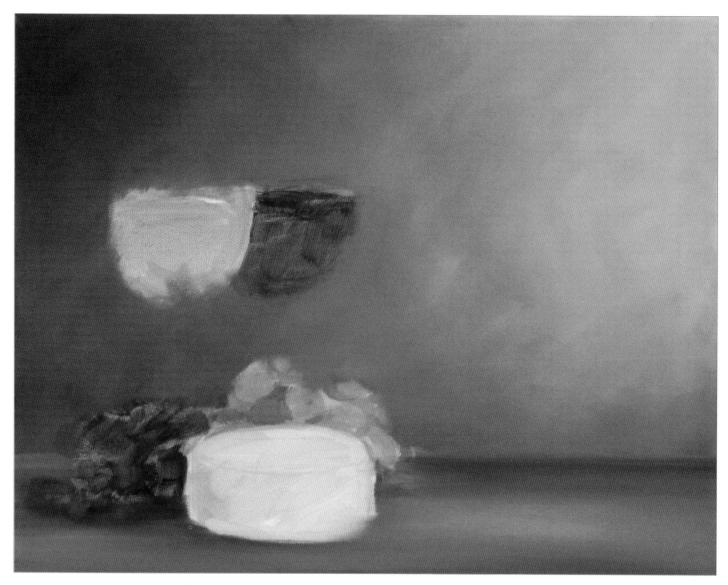

**3.** Using my underpainting as a guide, I decide to use deeper colors on the left side of the background wall in order to bring out more contrast with the wine glasses. Bringing more light to the top right corner will better indicate the source of light. For the background wall I mix yellow ochre, burnt sienna, ultramarine blue, and alizarin crimson. I mix a cooler, darker color for the left side by using more ultramarine blue and a warmer, lighter color on the right side by using more yellow ochre. I paint the table using the same colors, but less ultramarine blue and alizarin crimson.

## Artist's Tip

When you are using paint (rather than pencil) to plot the composition on canvas, try to avoid using heavy strokes. That way if you want to make changes to your first outline, you can paint right over it without seeing lines from the previous composition.

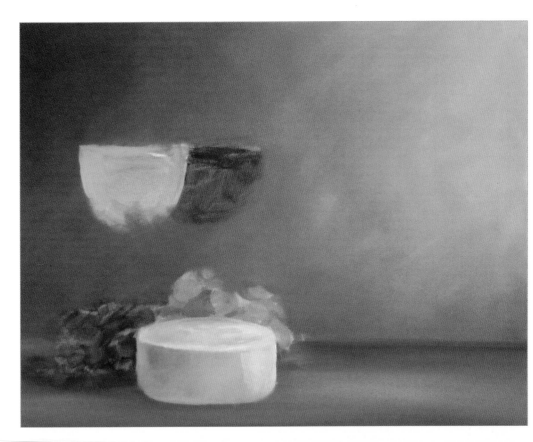

**◄ 4.** At this point the background is almost complete, and it's time to start working on the focal subjects. I start with the cheese, using yellow ochre, burnt sienna, and titanium white as the major colors. Then I add ultramarine blue and alizarin crimson in the shaded area near the red grapes. As a final touch I add highlights to the side of the cheese in the light.

**▼ 5.** The next few steps involve placing a few layers of paint in order to finish each subject. In this step I put down the first layer for the wine in the glasses. The glasses are still not visible, but the wine provides their shape. For the white wine I mix cadmium yellow deep hue and titanium white with a bit of burnt sienna. For the red wine I use ultramarine blue, alizarin crimson, and burnt sienna.

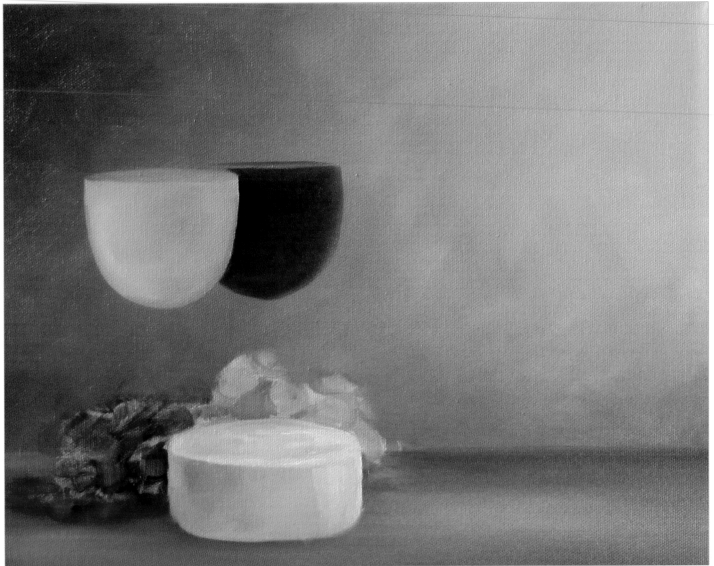

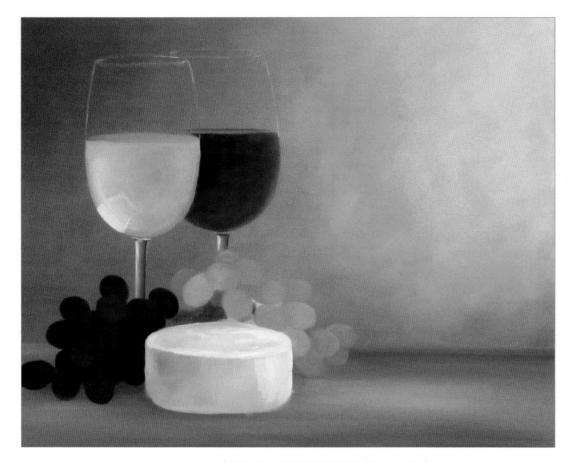

**6.** I place a layer for the grapes. I use a mixture of sap green and cadmium yellow deep for the green grapes, using a slightly darker mix of these colors for the shadowed grapes. For the red grapes I use ultramarine blue, alizarin crimson, and burnt sienna. While the paint is still wet, I continue to work on some smaller details. Using very thin white paint, I finish outlining the shape of the wine glasses. Because glass is transparent, I use the same color combination from the background to paint the stems of the wine glasses, adding a white-yellow mixture to create the highlights.

**7.** When the first layers are dry I continue to work on the wine glasses. Glass is transparent, but also it reflects all surrounding light sources and other subjects. For example, the white wine glass has a dark reflection from the red wine, but it also reflects a few light objects, which are not visible in this composition. To show the depth and reflection of the red wine in my white wine glass, I add alizarin crimson and burnt sienna along the edge of the glass. I start dark at the edges and gradually lighten as I move to the center. I add titanium white to my yellow wine mixture from step 5 for the highlights. I use a similar color palette as I did in step 5 to paint a deeper shade of the red wine in the glass. I show some reflections near the edge of the glass and on the top surface of the wine and also add shadows on the top of the wine glasses with a thin layer of ultramarine blue mixed with alizarin crimson. Don't use too much paint here, or you will lose the transparency of the glasses.

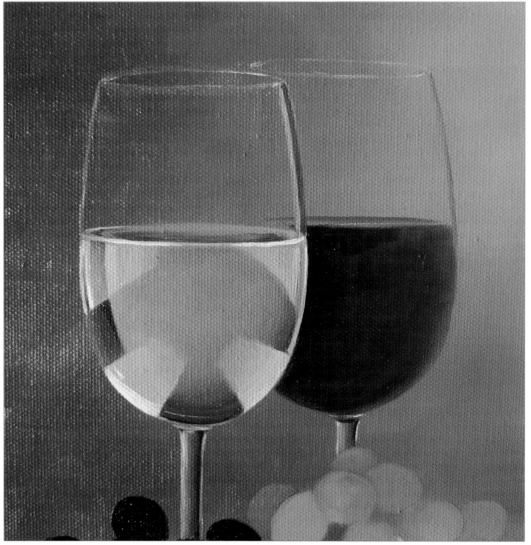

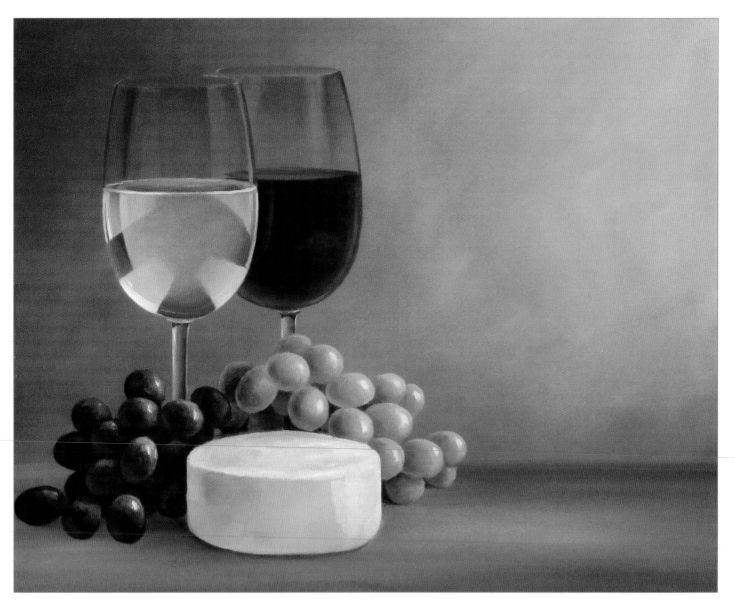

**8.** Now I work on shaping the grapes. In addition to the green grape mix I used in step 6, I create a darker mix for the shadows by adding ultramarine blue and burnt sienna. I create a lighter mix for highlights by adding Winsor lemon and titanium white. I prefer to work on one grape at a time. I add touches of white highlights and darker tones to the grapes in shadows with a thin layer of sap green and ultramarine blue. For the red grapes I use ultramarine blue and alizarin crimson. To show light coming through the grapes, I use a lighter mixture of alizarin crimson, titanium white, and cadmium yellow deep. The white coating on the skin of the red grapes is more visible on the light sides. For this part, I mix ultramarine blue, alizarin crimson, and white, using more blue in darker areas and more white in lighter areas. I add highlights with titanium white and then add little branches and stems on both bunches of grapes.

## Details

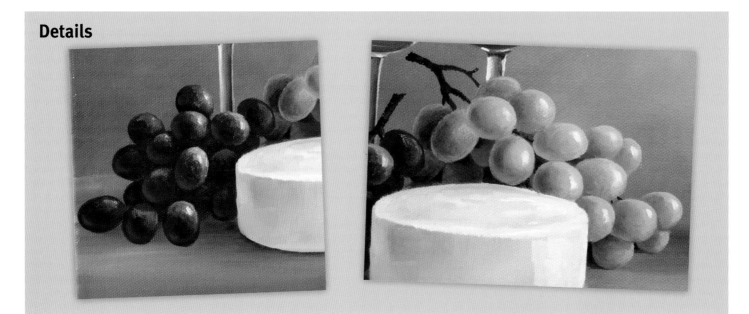

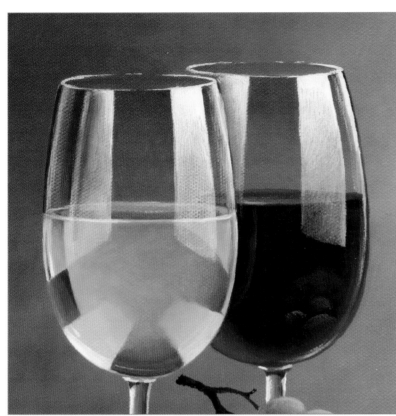

**9.** I add highlights on the wine glasses, using a mix of titanium white and a bit of ultramarine blue, putting down just a very thin layer of paint to still show the transparency of the glasses. I finish painting light reflections on the wine glasses and add more color closer to the top of the glasses where the reflections are brighter. I also use the color palette from the green grapes to add a very light layer of paint showing the reflection of the green grapes on the bottom of the red wine glass.

▼ **10.** To complete the painting I add shadows from the grapes and cheese on the table and a bit more texture to the wood.

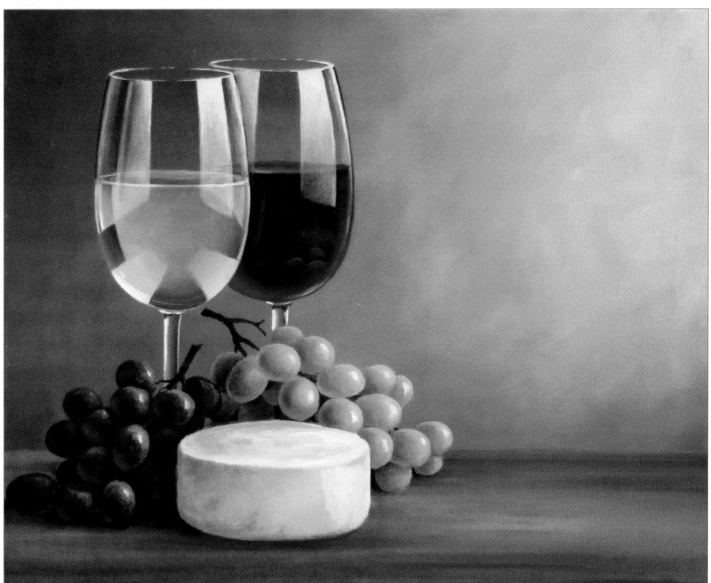

# Oil & Vinegar

## with Varvara Harmon

In the previous lesson I demonstrated how to start with an underpainting layer, which provides guidance regarding the color values. However, in this piece I am painting on a white canvas without an underpainting. In this approach to the painting process, some parts will be done in a few steps, but the majority is completed in one step from start to finish.

## Palette

alizarin crimson • burnt sienna
cadmium yellow deep • sap green
titanium white • ultramarine blue
vert olive • Winsor lemon
yellow ochre

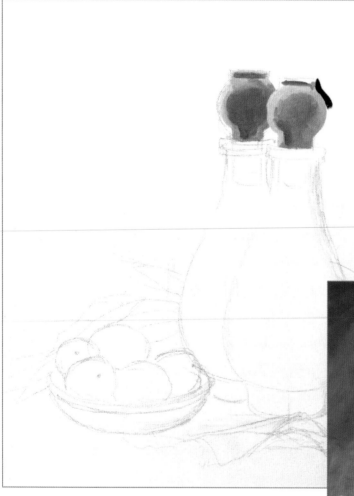

**1.** First I lightly draw my composition. Then I start with the glass bottles. Because glass is transparent, the bottles will have similar colors as the background; I use ultramarine blue, burnt sienna, and titanium white.

**2.** In any still life it is good practice to see the color relation of the main subjects with the background, especially if the subject is transparent, as in this case. For this reason, I paint the background before I finish the bottles. I use a combination of ultramarine blue and burnt sienna in the shaded areas, and I add yellow ochre to paint the lighter areas of the background.

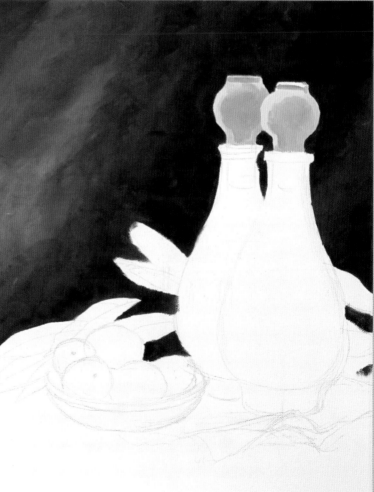

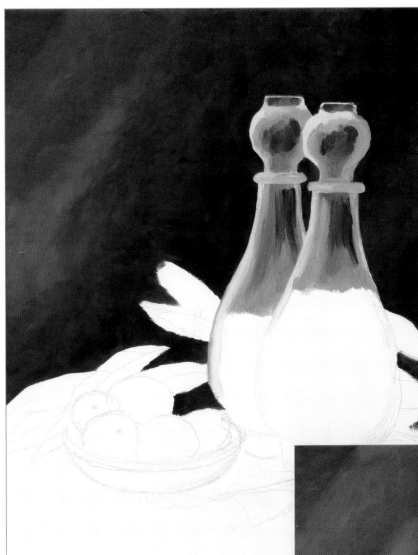

**3.** Knowing the color of the background, I use a similar palette to continue painting the bottles, but I add some titanium white to create the glass effect. When completing this step, I place big, bold strokes of color first.

**4.** I blend the paint strokes I placed in step 3. I let this blended base layer dry while I work on other areas. I paint the leaves with vert olive and sap green mixed with a yellow palette of yellow ochre and cadmium yellow deep. To create the light lines for the leaf veins I add a touch of titanium white to my mixture. For the shaded parts of the leaves, I cool down the mix by adding ultramarine blue.

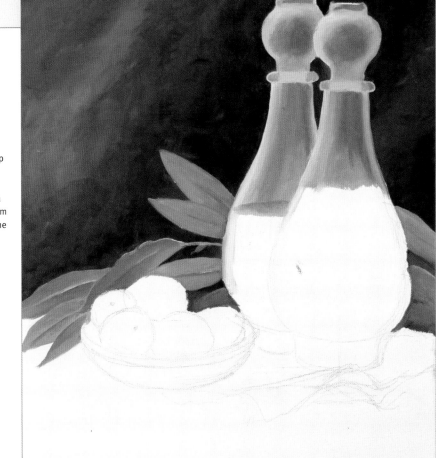

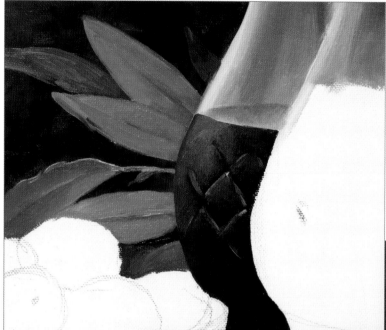

**5.** I finish the bottle filled with vinegar. I mix ultramarine blue, burnt sienna, and a bit of alizarin crimson. To show the subtle reflections of light in the design I add titanium white to my mix.

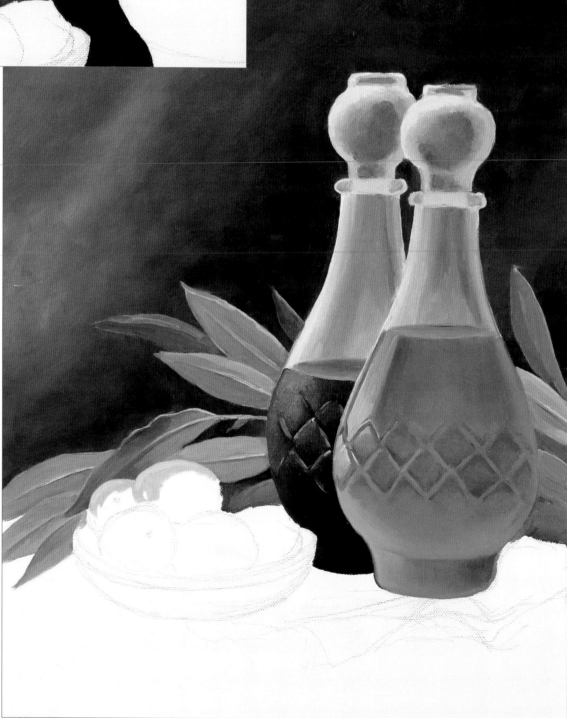

**6.** I paint the bottle filled with oil, using cadmium yellow deep, Winsor lemon, vert olive, and sap green. I avoid using any white here because I don't want to lose the transparency of the glass bottle and oil. I add the details of the design on the bottle using the same colors in a slightly darker mix.

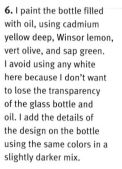

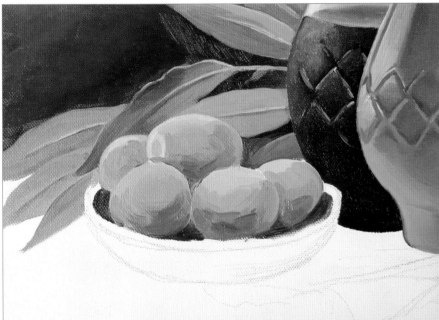

**7.** To paint the olives I use the same color combination as for the olive oil, but I add a little bit of white for the lighter parts. I place my strokes carefully to map both the color and value of the olives.

**8.** I finish working on the olives by refining the strokes I placed in step 7 and adding smaller details, such as the dark spots at the tops and highlights on the surface of the olives. Then I work on the wooden bowl holding the olives by placing big, bold strokes first and then developing smoother transitions. I use ultramarine blue and burnt sienna in the shaded portions of the bowl, and I add yellow ochre and titanium white to this mix for the lighter areas of the rim and sides that show reflection from the table and bottles.

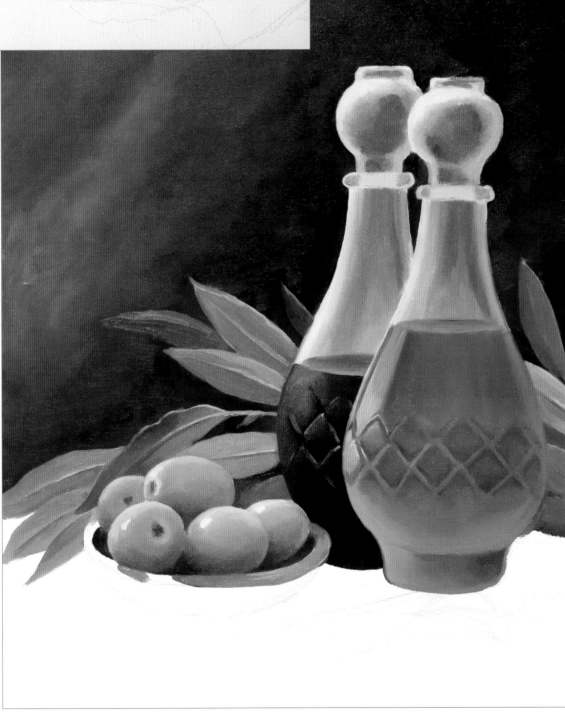

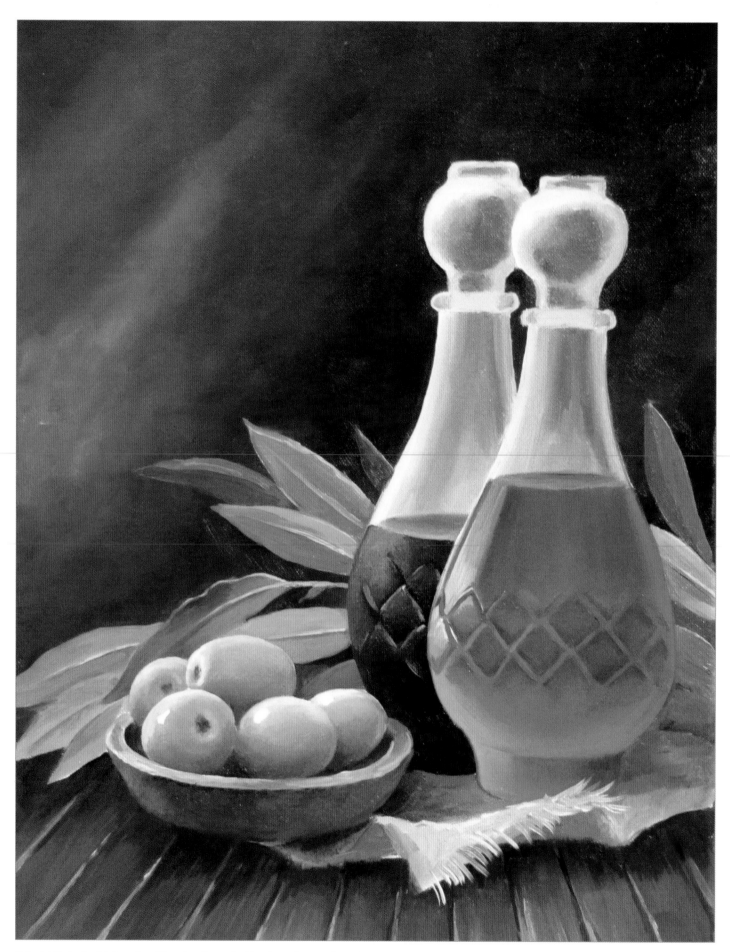

**9.** I paint the burlap fabric on the table, using ultramarine blue, burnt sienna, yellow ochre, and titanium white. I use darker, cooler color mixtures in the shaded areas to contrast with lighter, warmer mixtures in the lighter areas. Notice how the shape of the fabric folds begin to take place using the variety of color values. For the table I use the same color combination, but I create much darker shades of color.

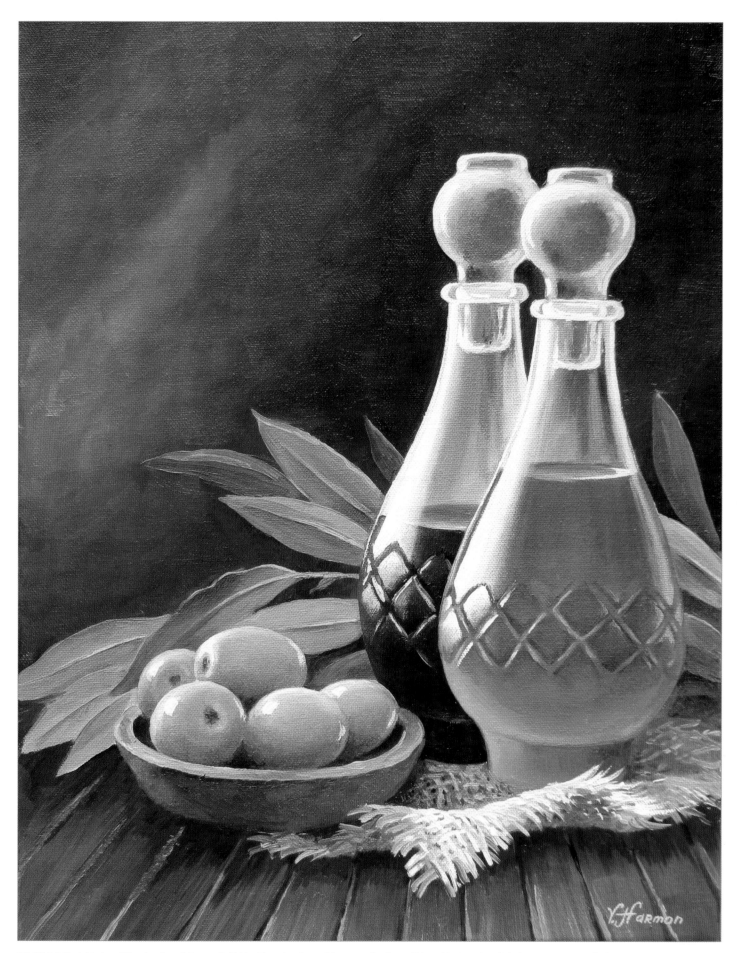

**10.** I finish the table by adding details to bring out individual boards, along with some reflections off the table. Keep in mind where your source of light is shining from while placing light and shadows in the cracks between these boards. I add light reflections to the glass bottles. The major source of light is on the left, so I place warmer light reflections with a mixture of titanium white and cadmium yellow deep on the left sides of the bottles. In the shaded areas, I add cooler light reflections with a mixture of titanium white and ultramarine blue. The cooler reflections on the right are not as bright as the primary reflections on the left. Finally I finish by adding the weaving details on the burlap.

# Chapter 2
# Painting Portraits

**with Glenda Brown**

There are many different ways to paint portraits,
and there are no exact rules to follow for each style.
However, there are some good guidelines in classical portraiture.
The projects in this chapter are in the classical style, but
you should feel free to explore your own preferred style.
Each painting process has it's own unique approach and personality.
This chapter includes five step-by-step projects, and in them
you will explore how to paint children, group portraits,
and formal portraits, as well as how to paint from life.

# Cayden

Cayden is an angelic toddler with curly blond hair and flawless porcelain skin. On this hot summer day he was learning to ride his tricycle. In his portrait I want to try to capture the intense, sweet expression of learning on his baby face before he starts to mature into a little boy. As Cayden was trying to ride his tricycle, I noticed the way the natural light bounced and fell beautifully across one side of his face, creating a Rembrandt effect.

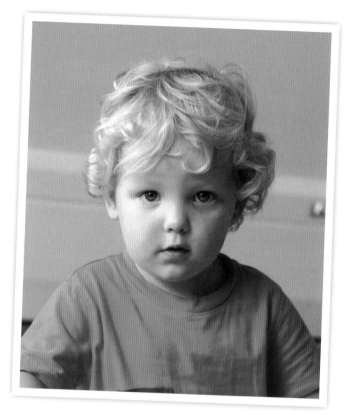

### Palette

alizarin crimson • burnt sienna • cadmium orange
cadmium red light • cadmium scarlet (or pyrrole red)
cerulean blue • perylene red • phthalo turquoise
raw sienna • raw umber • sap green
transparent red oxide • ultramarine blue
viridian green • titanium white • yellow ochre

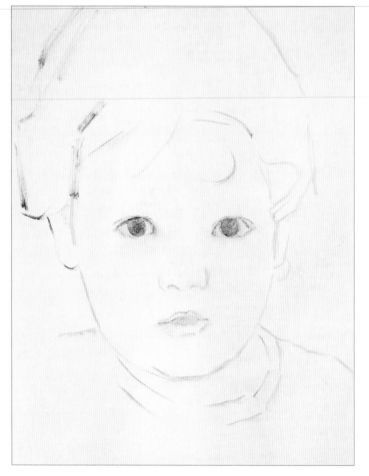

**1.** When working from a photograph, I begin with a pencil drawing on paper first. This helps me get my placement right. Because I don't want to use dark ink on Cayden's delicate face, I decide to just transfer my drawing and spray with a fixative.

### Mixing Colors

- Use small amounts of pure pigment to mix other colors. I don't follow formulas for my colors. Take the time to learn your colors and how they mix. I suggest you start by laying out each color on your palette and mixing in a small drop of white to see how the color changes.
- If you are a beginner, start by practicing mixing with your primary colors and work into the secondary colors.
- Always mix your paint with a palette knife, not a brush. After mixing several puddles of color you may use your brush to pull into another color.

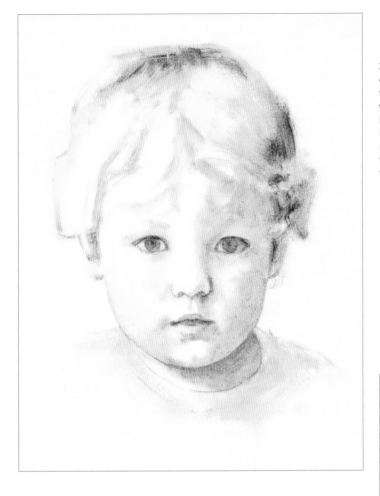

**2.** I clean the surface with turpentine and a soft cloth to remove any extra residue. Then I tone the canvas with a light yellow ochre wash. I begin working paint over the soft lines with a #4 filbert bristle brush and a light wash, using transparent red oxide with a touch of ultramarine blue to neutralize the color. I like to start by working with transparent paint and building for darker areas as the painting continues.

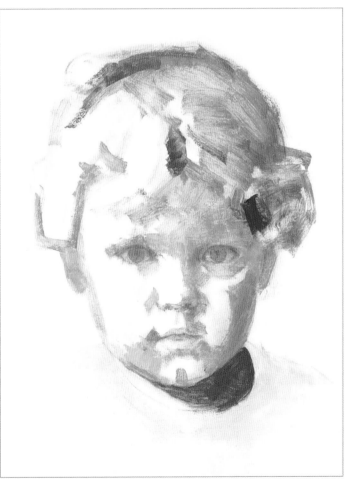

**3.** I start by carefully blocking in the darker areas of the face, using a mid-value flesh tone of cadmium red light, viridian green, very small amounts of phthalo turquoise and titanium white, and a touch of raw sienna. I mix a little at a time, making several different dollops of mixed paint. After making a dollop, I use white to start lightening color, and if it becomes too light, I can go back to my base color and add yellow ochre and/or raw sienna. Next I mix perylene red with viridian green to make a darker, richer flesh brown and add a bit of yellow ochre or raw sienna. Keep in mind that the more red you add, the warmer the flesh tone; likewise, the more viridian green or phthalo turquoise you add, the cooler the flesh tone. I turn my attention to his golden hair and begin blocking it in, using yellow ochre, raw sienna, burnt sienna, and titanium white. In the darker parts of the hair I add ultramarine blue or a little cerulean blue to raw sienna or burnt sienna.

## Artist's Tip

To achieve a luminous appearance, I can't lay down all my paint in one or two sessions. Instead, I work each day until I feel I've come to a stopping point. I let it dry, and then I come back and continue building one layer at a time. Each person is different, and every time I sit down at my easel I look for ways to make a better painting.

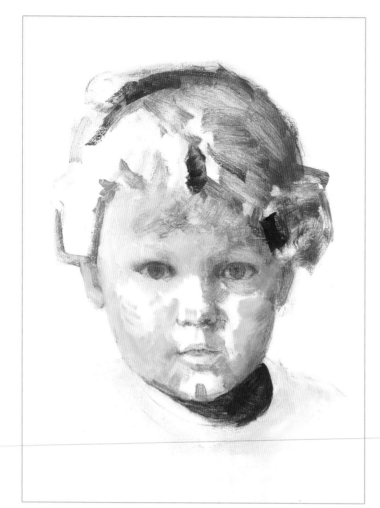

**4.** I start painting the delicate pink undertone of Cayden's cheeks, using a dab of perylene red, pyrrole red or cadmium scarlet, and titanium white. I add more flesh tone across the face and darken the eyes with my flesh colors. I am not concerned about the eye color yet.

**5.** I softly blend the skin, using a flat natural-hair brush (No. 4 or No. 6) and alternating with a No. 6 cat's tongue brush. I paint with basic brushstrokes and crosshatch strokes and, when needed, I use my finger to soften or blend. I paint the lips with a darker mix of the same color I used on the cheeks. Then I go back to the hair, painting the golden blond curls on the lighter side with yellow ochre and titanium white. I return to the darker hair and paint with raw sienna and a little white. Where the darkness increases I begin to use cerulean blue or ultramarine blue with a bit of burn sienna. Notice I am not painting each individual hair, but rather the mass, or larger shapes. Next I start to block in the orange shirt, which I want to be softer than in the photo. I use a mix of cadmium orange, yellow ochre, and titanium white. I also block in the background with a little cerulean blue, white, and a few little paint strokes of my soft orangey color.

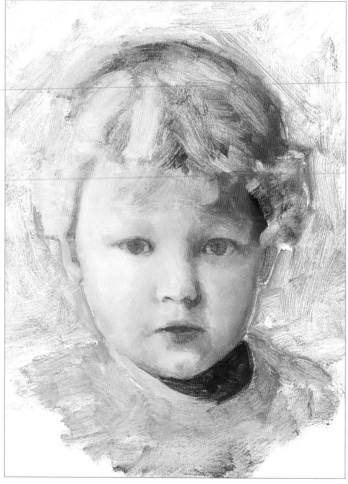

## Artist's Tip

You can save your mixed colors for future sessions of portraits. Rake together similar mixes of flesh tones in the center of your paint box and store in the refrigerator or freezer. You can prevent the paint from drying out with a drop of clove oil.

## Artist's Tip

The "whites" of the eyes are never really white; they are yellow, grayish, or slightly orange in color. Each person's coloring is different.

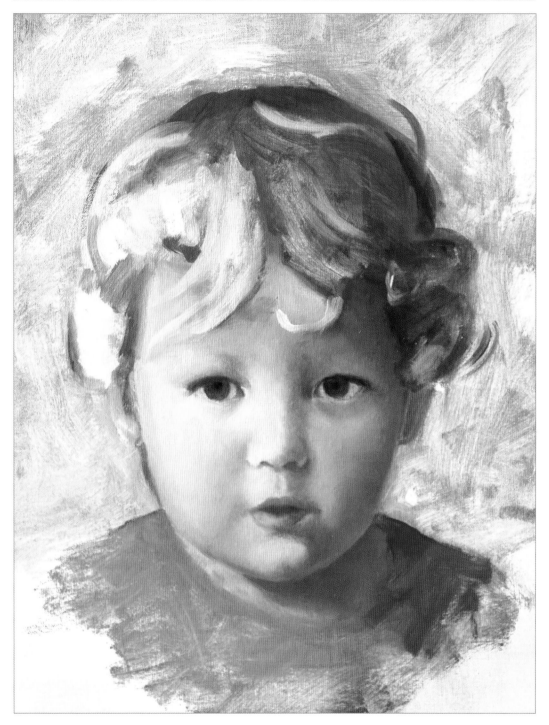

**6.** Next I work on the eyes. Instead of using pure black, which can look flat, for the pupils, I make a nearly black mix of ultramarine blue, alizarin crimson, and sap green. I work around the eyes and paint the lashes with a very dark brown mix of ultramarine blue, alizarin crimson, sap green, and a tiny drop of titanium white and raw umber. I drybrush lightly to help the eyes set back into the face. For the whites of the eyes I mix a small amount of cadmium red light and cerulean blue and slowly mix into titanium white. Using very small strokes, I start to apply to the white of the eyes. I go back into the light parts of the hair with yellow ochre mixed with titanium white. Then I go back to the darker parts of the hair with raw sienna and a little cerulean blue, burnt sienna, and ultramarine blue. I blend again on top with the lighter colors.

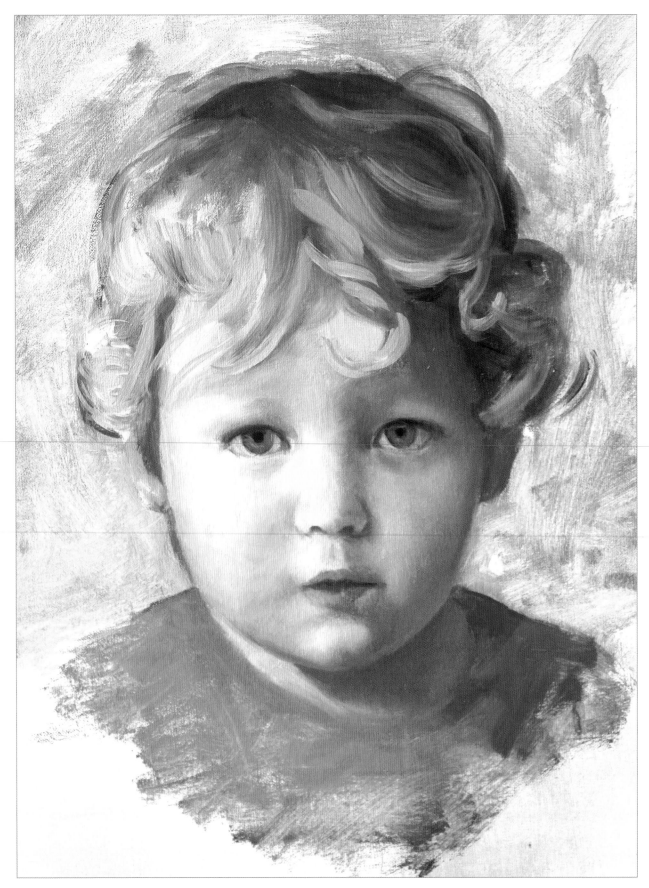

**7.** I paint the blue irises with cerulean blue, ultramarine blue, titanium white, and a tiny drop each of cadmium red light and yellow ochre to tone the intensity. Then I add more highlights in the hair and start blending my dark and light shapes gently into each other for a soft appearance. I refine the shapes of the ears a bit.

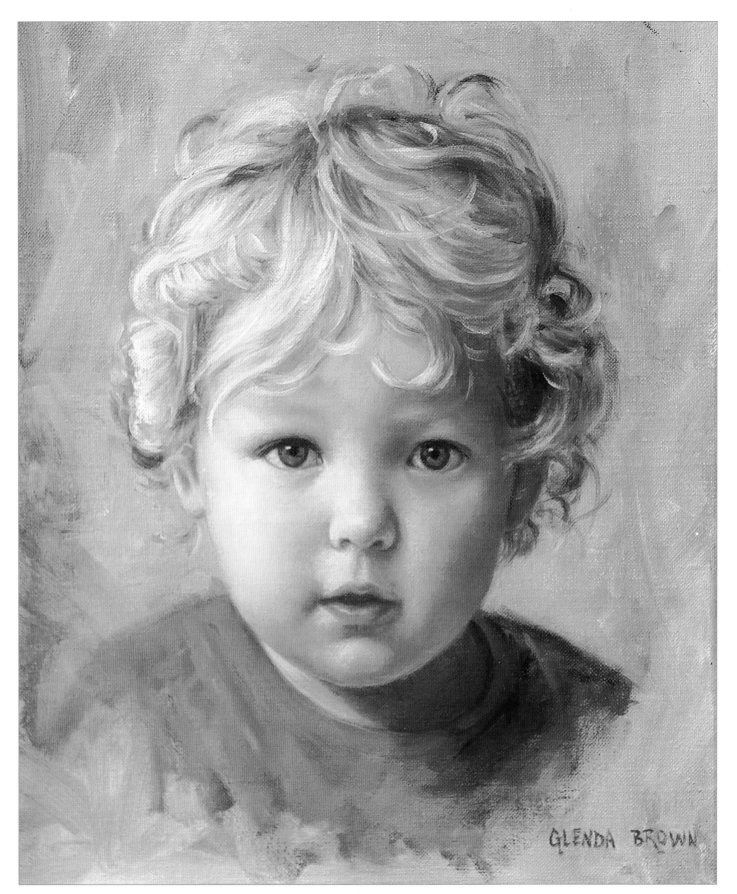

GLENDA BROWN

**8.** I go over the eyes again, and then I paint the catch light in each the same color as the whites of the eyes. I use my finger to blend. Using my light and dark blond mixes, I place various strokes in Cayden's hair to develop the soft curls. I use titanium white in some parts to add highlights. I also add some white highlights on the end of the nose and on the lips. I finish my background, drybrushing with my blond hair mixes. I make a final pass around the painting, looking for any hard edges that need to be blended. Then I sign my name, and my portrait is complete!

# Family Ties

These three siblings arrived for their photo session on a beautiful, sunny winter day. I took several photos in natural lighting, using the sunlight from the front window. It's a challenge to photograph three young children with the perfect expression from each child at once, so I selected several photos to work from for the final painting. This composition was the most pleasing, with the triangle of body language and the way the faces are placed together.

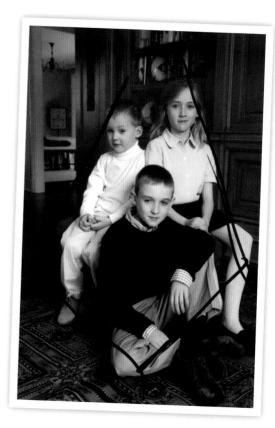

## Palette

alizarin crimson • burnt sienna • cadmium red light
cerulean blue • raw sienna • sap green
titanium white • transparent red oxide • ultramarine blue
viridian green • yellow ochre

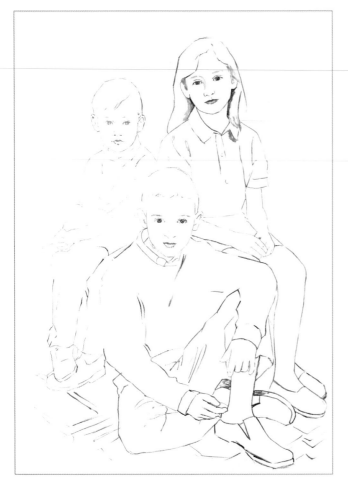

**◀ 1.** Before beginning, I created a color study and a scaled drawing for my client's approval. Then I transferred the drawing onto Belgium linen canvas by taping the drawing to the canvas and using transfer paper to trace over the drawing. I go over my lines with india ink diluted with alcohol. India ink fades over time, making it a good choice for projects like this.

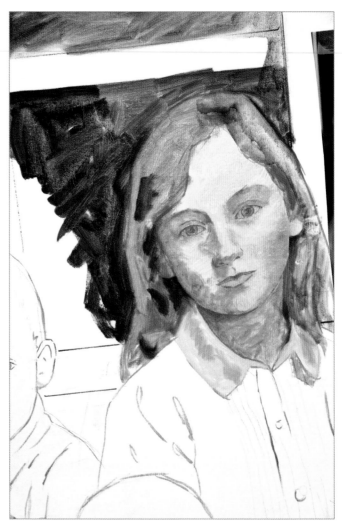

**▶ 2.** I begin blocking in, starting with mostly browns. Then I add additional layers of color to block in masses.

## Artist's Tip

When I rub colors into canvas I use turpentine on my cotton rag, which helps the paint dry faster.

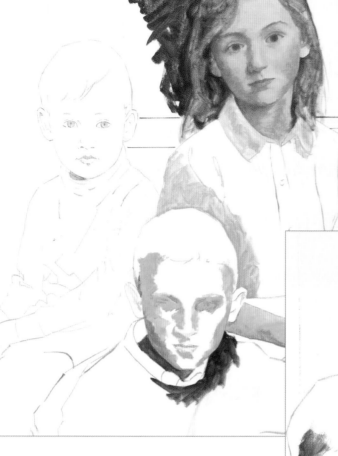

**3.** As I start to block in the dark colors on the white canvas it is very stark. I begin working on the background, using a mix of burnt sienna, ultramarine blue, and raw sienna. I don't use any white in the dark background, but I will rub this intense dark color down soon.

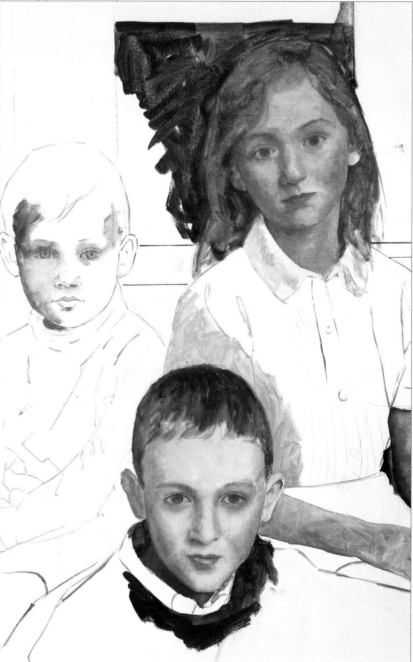

**4.** I start adding the darker colors of the skin with a mixture of transparent red oxide, raw sienna, a bit of viridian green, and a bit of titanium white with a touch of yellow ochre. For the lighter skin colors I use yellow ochre, cadmium red light, and white.

## Artist's Tip

When you're commissioned to do a portrait, ask your client to keep the clothing and colors simple. The colors should be subdued and flow together in multiple-person portraits. Avoid bright or trendy styles, stripes, checks, flowers, and anything that distracts or draws attention from the face.

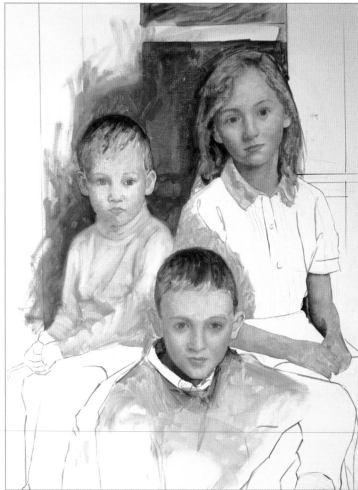

**5.** I begin to rub my dark colors into the canvas, toning the white and neutralizing it for further applications. For the young man's dark, navy blue sweater I mix ultramarine blue, burnt sienna, raw sienna, and a bit of viridian green. At this point I am not concerned about getting the exact colors; this is only an underpainting.

▶ **6.** I work from the top down, trying to work all over the painting. Now that the background is blocked in, I work a little more on the faces, using the same color mixes from step 4. I paint the girl's blue shirt with a mix of cerulean blue, ultramarine blue, and touches of cadmium red light and white.

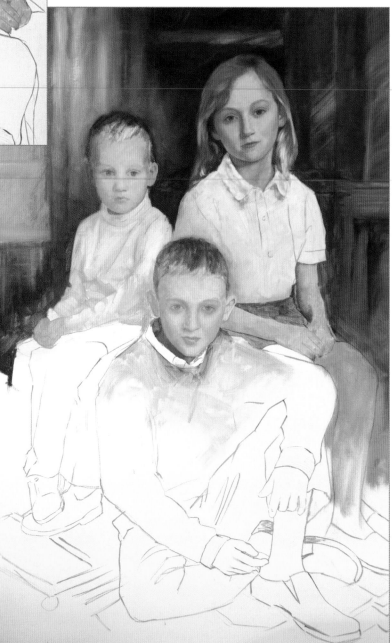

## Detail

Adding cadmium red light to the mix grays down the blue so that the color of the blouse isn't too intense.

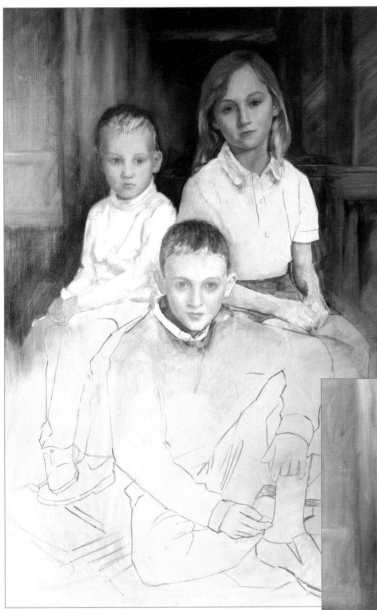

**7.** I tone the bottom of the canvas with some of the colors I used at the top and begin to reinforce the background colors, making sure all the edges are soft. I soften and knock down any edges with a 2-inch soft-hair brush by just by lightly touching the paint where I see it rising.

**8.** I continue working down by blocking in the dark blue sweater, using ultramarine blue, alizarin crimson, burnt sienna, and sap green. I am keeping most of the colors semi-transparent for now.

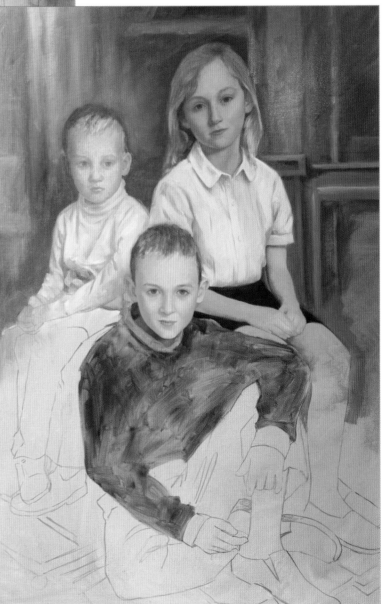

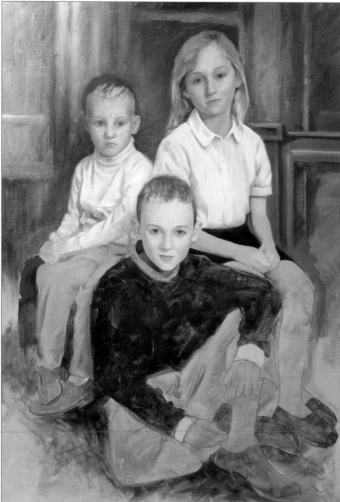

**9.** While I'm still toning the canvas, I start to add values to my painting, looking at the masses of shape and striving for a unified painting. I paint the boys' pants with raw sienna, cerulean blue, and a little cadmium red light and white. I use my 2-inch brush to soften edges, and then I let the whole painting dry.

▶ **10.** I paint over the flat color values, adding the low, dark values and touches of a lighter value to my mid-value colors. I slowly build the values and colors in layers, working my way around the whole painting and not just one area at a time.

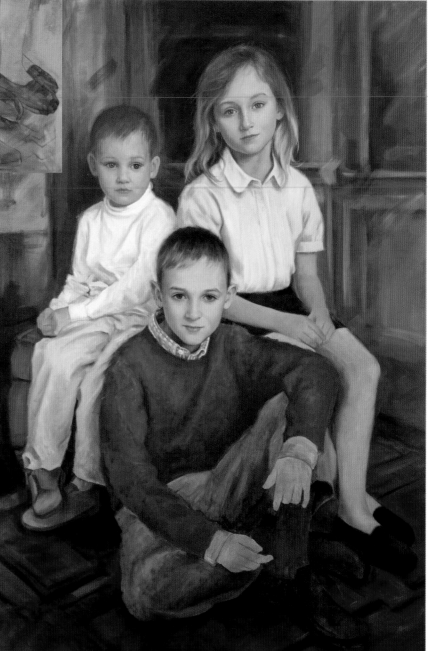

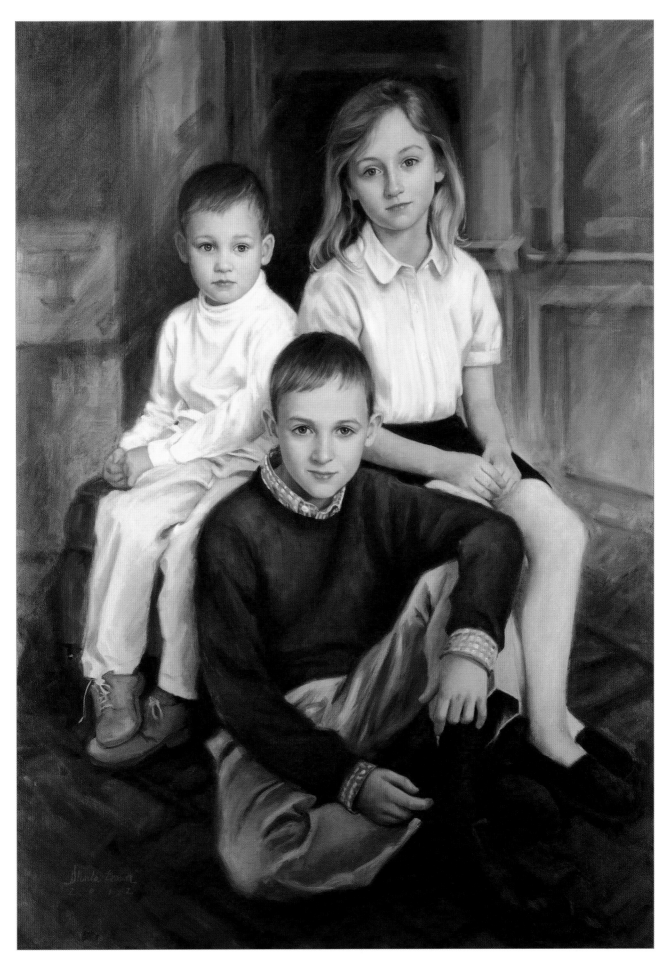

**11.** Towards the end the painting needs rich, deep color. I use transparent colors and paint in a thin wash. Going back over the faces I use ultramarine blue, sap green, and transparent red oxide or alizarin crimson. Where the faces need just a little highlight, I scumble a lighter value of color. If I see areas where the colors need to slightly change in value, I use transparent colors to achieve the desired look. Remember that the smallest amount of color goes a long way; resist the temptation to add too much when you're finishing up your painting.

# Like Mother, Like Daughter

This photo was taken with natural lighting. I used no flash and opened the doors to bring in the natural glow of the warm, sunny afternoon. In this painting of a mother and daughter I want to simulate a classic, timeless feel of togetherness. The setting for this scene is in the little girl's grandmother's home, with her great-grandmother's antique mirror in her hands. Each item in the photo has a special meaning to this family, and my goal is to emulate the feeling of love among several generations.

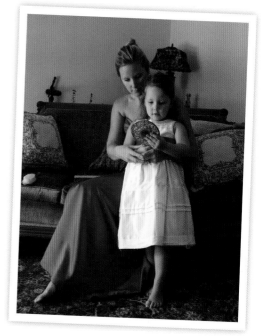

## Palette

alizarin crimson • burnt sienna • burnt umber • cadmium red light cadmium scarlet • cerulean blue • dioxazine purple • Indian yellow perylene red • phthalo turquoise • raw sienna • raw umber sap green • titanium white • transparent red oxide • ultramarine blue • ultramarine red • Venetian red • viridian green • yellow ochre

## Artist's Tip

If areas of a photo are too dark to see detail, you can lighten the photograph (or have a lab do so) so you can see the details. These lighter areas will be too light to use but you can look for details in the darker areas. I usually have my color lab make three or four different photos, changing the color and value for more information.

**1.** After drawing my initial sketch I enlarge it for placement and transfer my drawing to the canvas, using carbon paper. I go over the lines with india ink diluted with alcohol to keep the lines thin and light gray, instead of black. After the ink dries I use turpentine and a soft cloth to wipe the canvas and remove any residue.

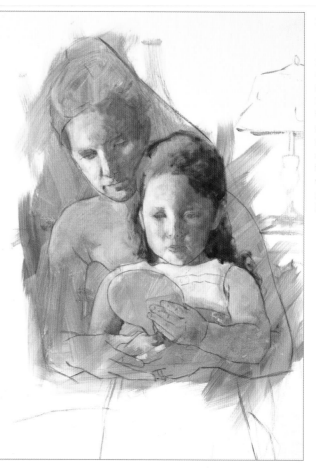

**2.** Next I loosely paint a thin wash of burnt umber over the mother and daughter. Using turpentine and a soft cotton cloth, I lift out the wash to leave a beautiful golden stain on the canvas. I paint the darker areas around the little girl's head with thinned burnt umber mixed with a little raw umber.

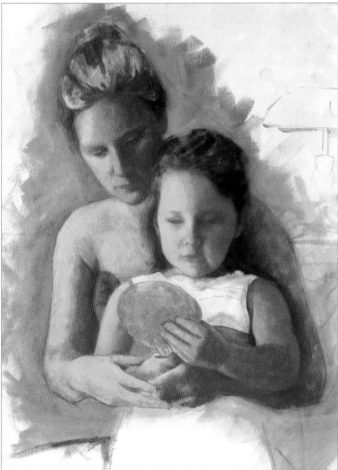

**3.** I let my painting dry completely before working on the skin tones. Then I start with the face and work out, letting each layer dry before going back. I keep my paint semi-transparent so that each layer builds on the next for luminous skin tone. Caucasian skin always starts with a red undertone, with more red across the nose, cheeks, and lip. The lips aren't really red, but an extension of the flesh with more color. For the skin I use titanium white, yellow ochre, raw sienna, cadmium red light (or cadmium scarlet), a little perylene red and viridian green, and a tiny bit of phthalo turquoise. I paint four to six layers on the face. For the hair I use a mixture of burnt sienna, ultramarine blue, raw umber, and yellow ochre. I paint the base color of the mother's dress and the girl's sash with Venetian red. I add viridian green, ultramarine blue, burnt umber, cadmium scarlet, and a bit of titanium white to the red to paint another layer. Be careful with the white, as it can turn the dress a cool pink—a little goes a long way!

**4.** I tone down the background with raw sienna, burnt sienna, and a little ultramarine blue. Then I paint over the background with yellow ochre, raw sienna, and burnt sienna mixed with ultramarine blue, cerulean blue, and a small amount of viridian green. I mix different-colored pools of paint for variation and texture, and I add the colors in different layers so the background doesn't look flat. I paint the sofa cerulean blue and then use different shades of mixes of ultramarine blue, burnt sienna, phthalo turquoise, and alizarin crimson to create dimension. I let the painting completely dry before evaluating what it needs with fresh eyes—the background is too light, the lamp is distracting, the sofa is too bright, and all the colors in general are too raw. These are the things I'll address in the next step.

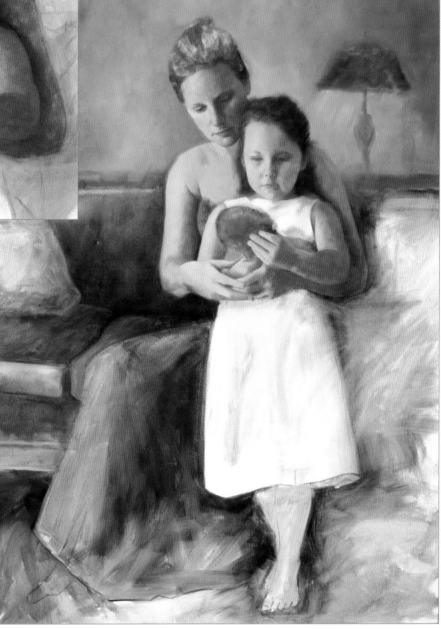

## Artist's Tip

To save time when I start a project, I always lay out my colors in the same order. Before I begin, I mix the colors I plan to use with my painting knife, not the brush. If I'm working on a face, I mix different flesh tones from light to dark.

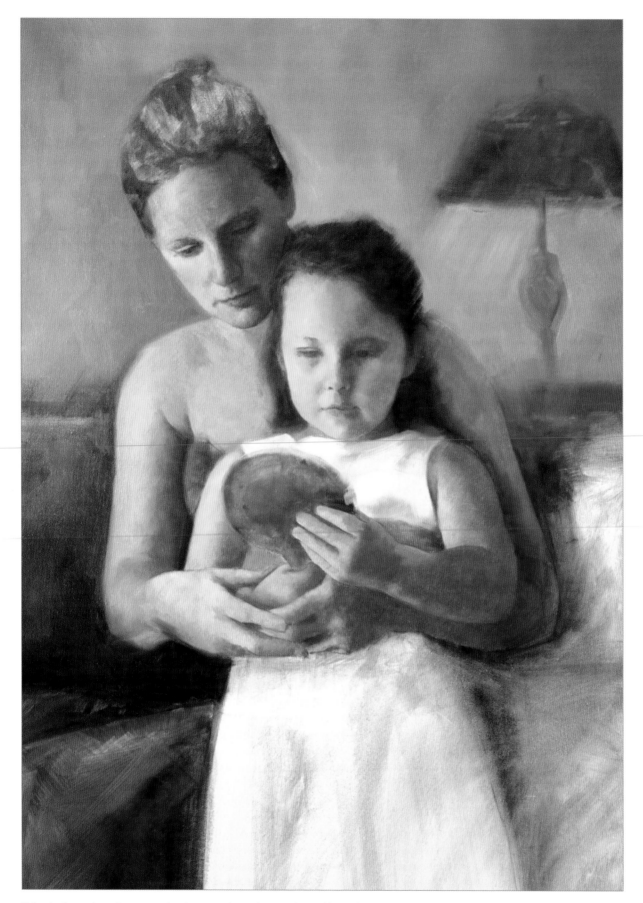

**5.** I go back over the entire scene, using the same colors as in step 4, but I add a touch of Venetian red to balance the painting. Using touches of this color throughout helps bring harmony to the painting, ensuring that nothing is one single color. I move all over the painting, adding touches of burnt umber and ultramarine blue to create darker layers toward the edges, thinking about how the light falls. I paint the lamp with the same colors as the background, using a flat No. 16 bristle brush. I add more yellow ochre, burnt sienna, cerulean blue, and ultramarine red to my face mixture and paint the legs and arms, which usually have a more golden or brown tone. I go over the little girl's dress with titanium white mixed with a bit of yellow ochre to warm and tone down the white. I also add touches of cerulean blue and cadmium red light to gray it down. As the paint begins to dry, I soften the background by "tickling" it with my No. 16 brush and smoothing out the edges with a 3-inch brush. Tickling means just lightly touching the paint so that the edges are knocked down.

## Artist's Tip

I intertwine color throughout a painting like patchwork in a quilt. Use my instruction to direct you but remember that there is no perfect formula for mixing and using color. I am always pulling from one of my pools of paint to another pool of color. Don't be afraid to experiment!

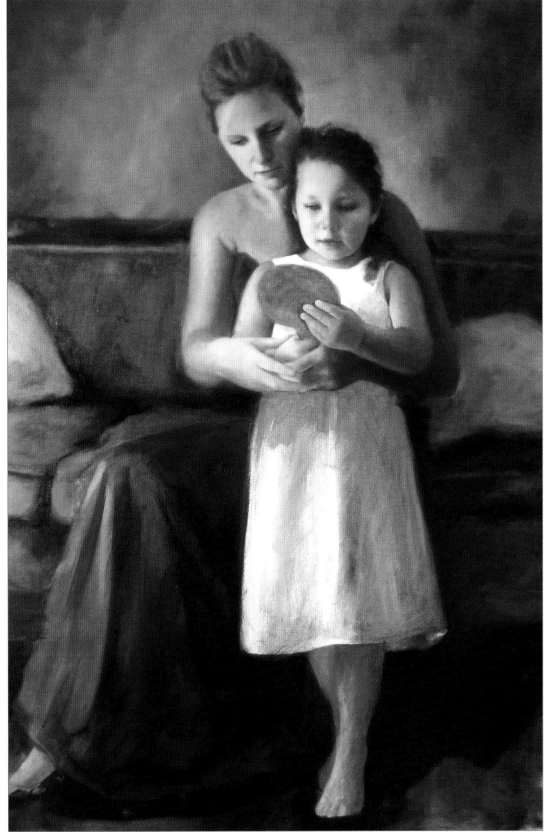

**6.** Next I begin to add detail, moving from one part of the painting to the next. Note that skin is not a solid color; there isn't one color that is skin tone. Be careful not to put too much white in your skin colors, as it can turn pasty. Start by mixing yellow ochre and cadmium red light (or cadmium scarlet) with a gradation of white and a tiny drop of transparent Indian yellow. I like to use a lot of pure colors grayed down with their complementary color. I seldom use brown colors in the face, but instead mix yellow with white, always pulling from my existing pool of colors and mixes. For the shadows, think of complementary colors. You can mix viridian green and cadmium red light for a nice skin tone, or sap green with alizarin crimson, yellow ochre, and bits of titanium white to create gradations of color. I use a crosshatch pattern to paint, thinking of a mosaic and using my finger to blend and polish the skin to make it look natural. Flesh tones are generally cooler across the forehead and rosier across the cheeks and nose. I add a drop more blue or green to my skin mix for cool areas like the forehead and around the mouth.

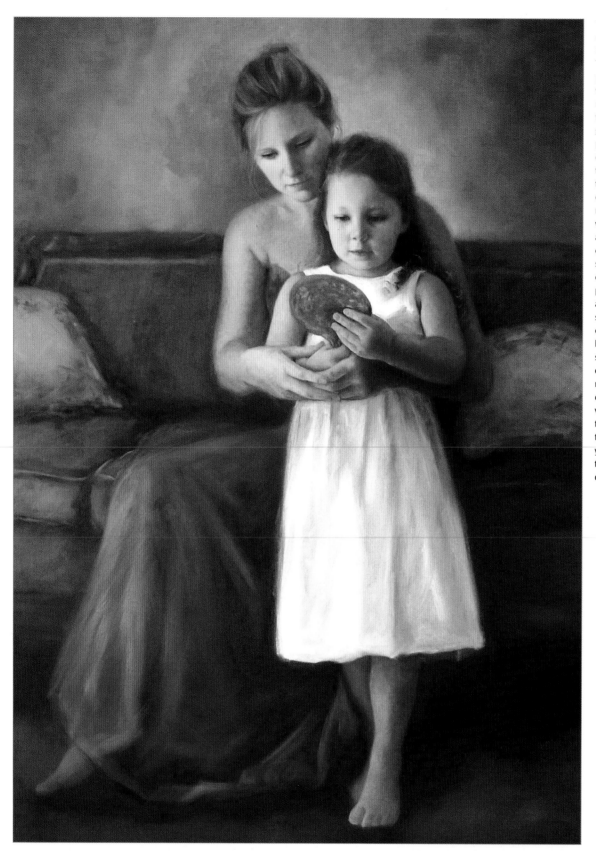

**7.** I refine the details by darkening the darks and lightening the highlights. To darken the darks I paint over the layers with transparent colors, mixing ultramarine blue, transparent red oxide, sap green, alizarin crimson, phthalo turquoise, and dioxazine purple. I mix them two or three at a time to see what colors emerge. For example, I mix transparent red oxide with ultramarine blue and add the tiniest amount of phthalo turquoise to slightly brighten. Using the darker transparent colors, I paint the folds of the dress and then go back with some of the original dress color and work up to the highlights, using cadmium scarlet. For the shadows on the little girl's dress I mix cadmium red light with cerulean blue and a little viridian green. To lighten the mix I start adding titanium white with a little yellow ochre and build on the colors until I get to my desired strength of white.

## Artist's Tip

Part of the adventure of painting is playing with your colors. Try adding the smallest amount of white into the mixes on your palette to see what transparent colors it creates.

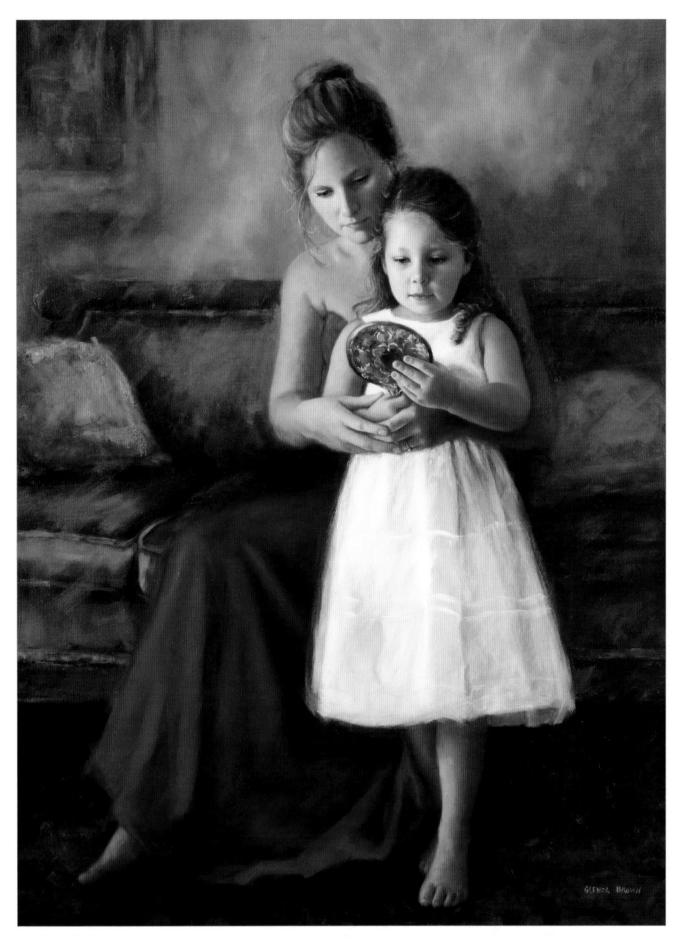

**8.** As I polish off the portrait I add more highlights, using titanium white with a bit of cadmium red light and the tiniest dot of phthalo turquoise or cerulean blue. Some of the warmer highlights call for yellow ochre. Pay very close attention to your reference photos to see where and how the masses of highlights lay and take it slowly, one section at a time. This is also where the importance of working from life comes into play.

# Painting from Life

Nothing takes the place of working from life. Photos can capture a fleeting moment of a person or event, but drawing or painting from life stays in the mind. Learning to draw correctly is extremely important. If you'd like to paint portraits, I suggest you start with master copies—copies of art by masters of the medium. You can purchase these online or bookstores. Tape your master copy to a board and your paper right next to it. Begin drawing. This is called the "sight-size approach."

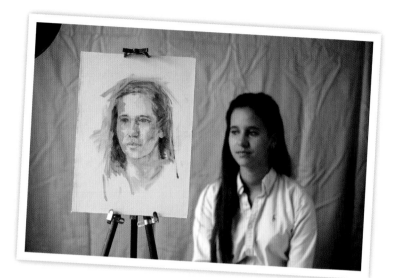

When I paint from life I use the sight-size approach by putting myself in a location where I can look at the model and my canvas at the same size.

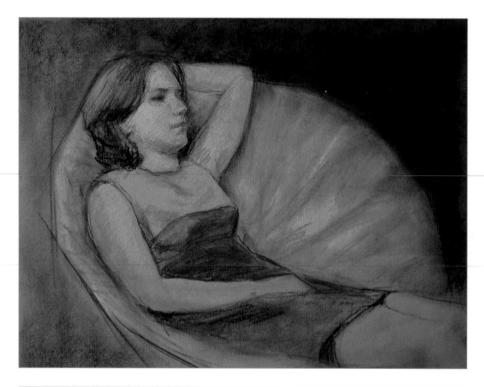

Start with vine charcoal on charcoal paper when you begin drawing people from life. Vine charcoal is easy to erase and perfect for getting comfortable with drawing.

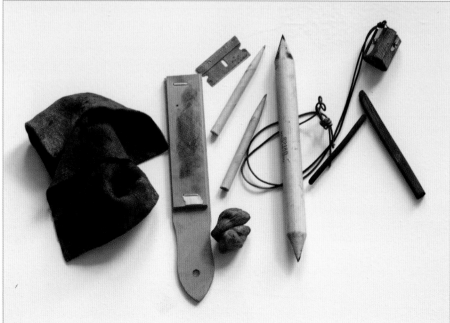

Other items you'll need for working with vine charcoal include: a razor (for custom sharpening), sharpener, a sandpaper block (for sharpening), a kneaded eraser, blending stumps, a chamois cloth to remove/dust charcoal, and charcoal paper. Once you're comfortable with the charcoal process, you'll be ready to dive into the wonderful world of painting from life.

## Chelsea

Chelsea showed up to my studio in blue jeans, a button-down pinstripe shirt, and a baseball cap over her long, dark hair. It took about 45 minutes to set up my model, lighting, and paint. I set the light at a 45-degree angle. Painting from life is a moment-by-moment learning experience. Study the facial features and the body and really get to know your model.

### Palette

alizarin crimson • burnt sienna • cadmium red • cadmium red light
cerulean blue • perylene red • titanium white • transparent red oxide
ultramarine blue • viridian green • yellow ochre

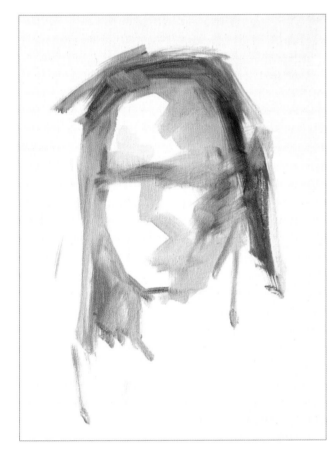

**1.** I start by blocking in the values, using ultramarine blue and burnt sienna mixed with a bit of turpentine. Look for the masses of dark, middle, and light values. I'm not trying to create an exact image, but paint in an abstract form. I wipe off any excess paint with a soft cloth.

### Artist's Tip

I'm painting this portrait fat-over-lean—I only use turpentine for the underpainting and work with no medium.

### Artist's Tip

Purchase a cast head to practice with. Draw the cast head with vine charcoal, and paint a value study in black and white or gray. Try directing a light on the cast head at different angles and draw or paint it. Pay careful attention for the different highlights on the planes of the head.

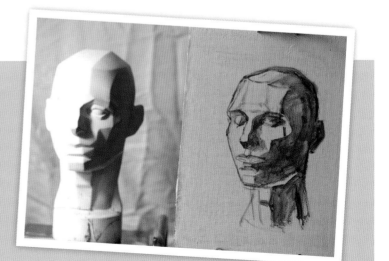

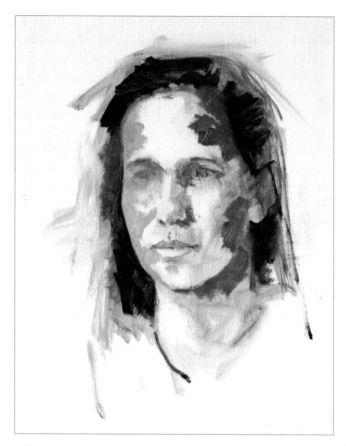

**2.** Next I start mixing yellow ochre and cadmium red with titanium white, creating different piles of skin tone colors. I add burnt sienna and a little viridian green to some piles for darker tones and begin painting in the skin values on the face and blocking in the dark hair.

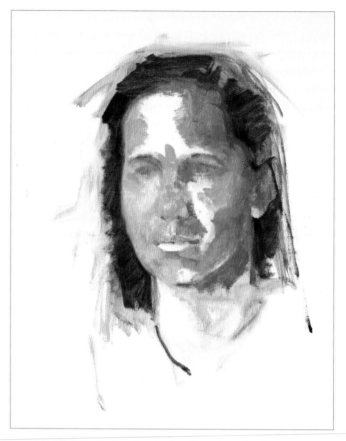

**3.** I continue painting the face, keeping the edges soft to allow for any necessary adjustments. I soften any noticeable hard edges by gently swiping them with a soft, clean brush.

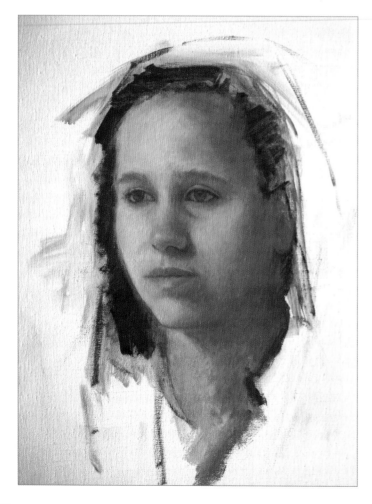

## Artist's Tip

As I work on each area, I constantly return to other areas of the painting to adjust darks, lights, cools, warms, etc. I am always looking to improve my paintings and color choices. Painting is a never-ending battle for balance, and there is always room for improvement.

**4.** I begin blending my lights and darks to create form and smooth skin texture. I mix titanium white, cadmium red light, yellow ochre, and a touch of transparent red oxide for the cheeks, nose, and ears. Cheeks are usually slightly rosy, but cooler in color than the nose or ears. To slightly gray the mix for the cheeks, I add viridian green. When I paint dark hair or eyes I start with a mixed brown that I can adjust to be lighter or darker as needed. I start the eyes with a brown mix of ultramarine blue, transparent red oxide, and alizarin crimson.

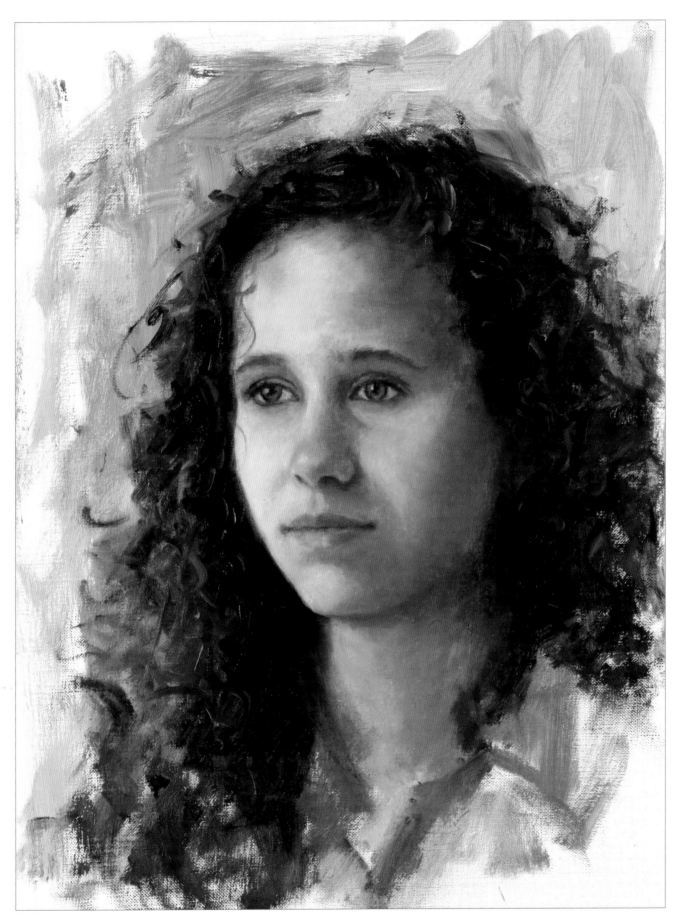

**5.** I start blocking in the dark hair with the same mix I used on the eyes in step 4. Then I lighten the mixture with yellow ochre, a touch of cadmium red light, and cerulean blue to paint lighter values in the hair. Curly hair is simple—just an abstract pattern of darks and lights and a few defined curls. Don't try to place each individual curl. Instead, look for masses of color and apply squiggles of paint to suggest curly locks. I add a few very light strokes with a mix of yellow ochre and a bit of titanium white. Chelsea has beautiful hazel eyes. To get the greenish amber color of the iris I mix yellow ochre and viridian green. I add a bit of my original brown eye mixture to this to paint the shadowed parts of the iris. Then I paint the whites of the eyes, using cerulean blue mixed with cadmium red light and a touch of titanium white. I add a couple pure white highlights. I use the same skin mixture for the lips that I used in step 4, but add perylene red. For the shadow areas I add a touch of viridian green. I create a rough background with broad strokes of yellow ochre mixed with titanium white.

# Formal Portrait

I was first commissioned to paint a portrait of Mr. Bob's wife, Jennie. After starting our photographic session, she also wanted a portrait of her husband. To photograph Mr. Bob I used two lights to create a three-dimensional effect. When using lights, I never use the flash on my camera. Instead, I use a flash on the side to create a Rembrandt appearance.

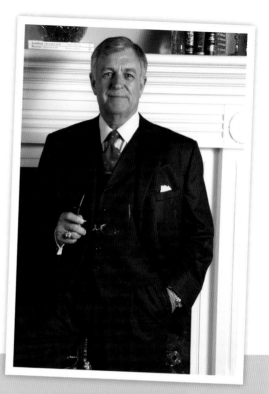

## Palette

alizarin crimson • burnt sienna • burnt umber • cadmium red light
cerulean blue • raw sienna • sap green • titanium white
ultramarine blue • viridian green • yellow ochre

## Artist's Tip

"Fat over lean" refers to the principle in oil painting of applying paint with a higher oil-to-pigment ratio (fat) over paint with a lower oil-to-pigment ratio (lean) to ensure a stable paint film, since the paint with the higher oil content remains more flexible.

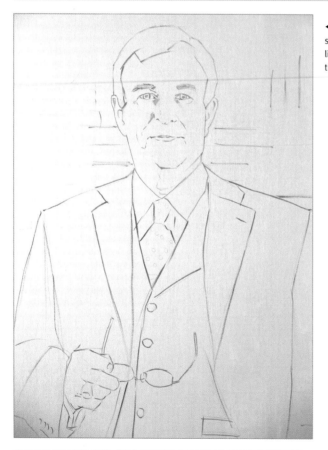

◄ **1.** When beginning a commissioned portrait, I always draw sketches and create a color study so I can work out any problems before beginning. After this process, I transfer the drawing to my linen canvas for placement. I use india ink thinned with alcohol to go over the pencil lines. Once the outline dries, I clean my canvas with turpentine to eliminate any residue before painting.

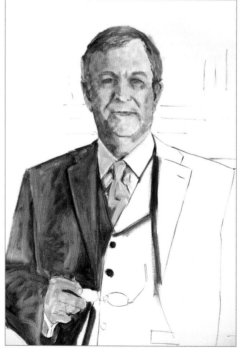

◄ **2.** I begin by painting his face with a warm, thin wash of burnt umber, using the drybrush technique and English distilled turpentine. I mix the paint and turpentine on my palette until I have a slightly diluted mixture. In the lighter areas I use very thin paint, and in the darker areas I use more paint with less turpentine. I don't use pure paint in the beginning because I prefer to build up layers. I keep it light and don't go too heavy with the paint. This process is called "fat over lean," and helps make a painting more durable.

## Artist's Tip

To start a portrait you can place a line drawing on your canvas by using the grid method, transferring a sketch with graphic paper, or you can just begin painting! Use the process that best suits your personality and style.

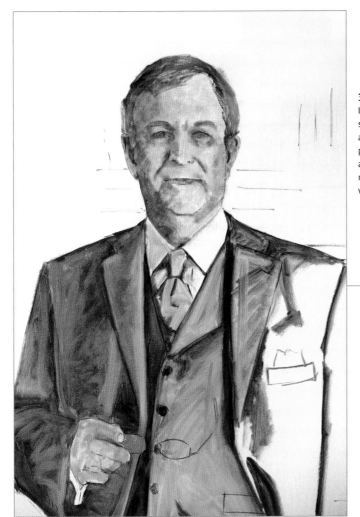

**3.** I paint more of Mr. Bob's suit. Then I use a cotton cloth to rub off paint in spots that need to be lighter. I darken as needed with a brush. This is also a process of toning my canvas as I get a feel for my subject. At this time I am not concerned about accuracy—only values and placement.

### Artist's Tip

I never think my way of painting is the only way; there are so many different approaches to painting, you will eventually find what works for you. Painting is an exciting journey to many wonderful adventures. Enjoy the process!

**4.** I begin to go a little darker by adding ultramarine blue to the burnt umber in the darker areas. I also begin to tone the background to reduce the white of the canvas.

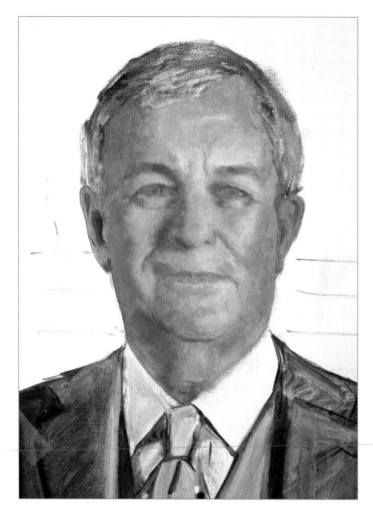

**5.** When my block-in is dry to the touch I start building up flesh colors in the face. I start mixing colors on my palette with a palette knife. For the lighter skin tones I use yellow ochre, cadmium red light mixed with titanium white, and a mix of raw sienna, cadmium red light, and titanium white. I mix the darker skin tones with sap green, viridian green, alizarin crimson, and yellow ochre. In some areas I carefully mix a little titanium white with the darker skin colors. Be careful when doing so, because the color can become pasty or muddy.

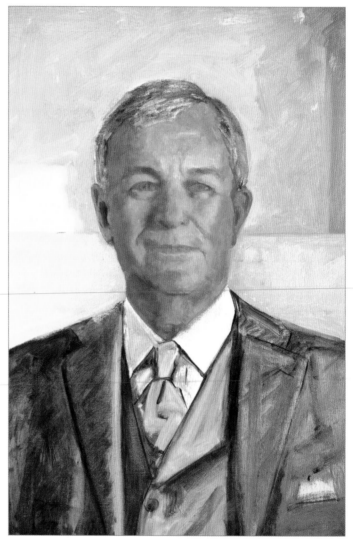

**6.** I begin to paint the back wall with yellow ochre and the white fireplace mantel with titanium white, yellow ochre, raw sienna, and bits of my blues.

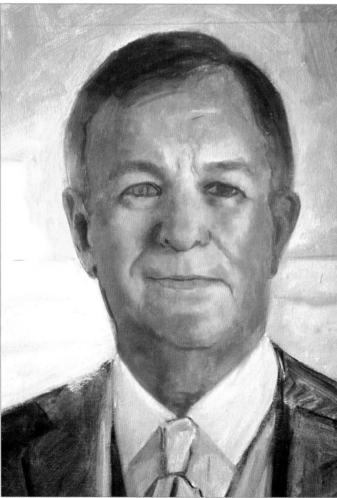

**7.** I go back in to darken the shadow areas with viridian green, raw sienna, alizarin crimson, yellow ochre, and a touch of cerulean blue. I look for the masses at this point and am not concerned with detail.

## Artist's Tip

Even when using photography as a tool, a beautiful portrait takes a lot of acquired skill and years of practice painting from life. Keep at it, and you'll see your painting improve with every portrait.

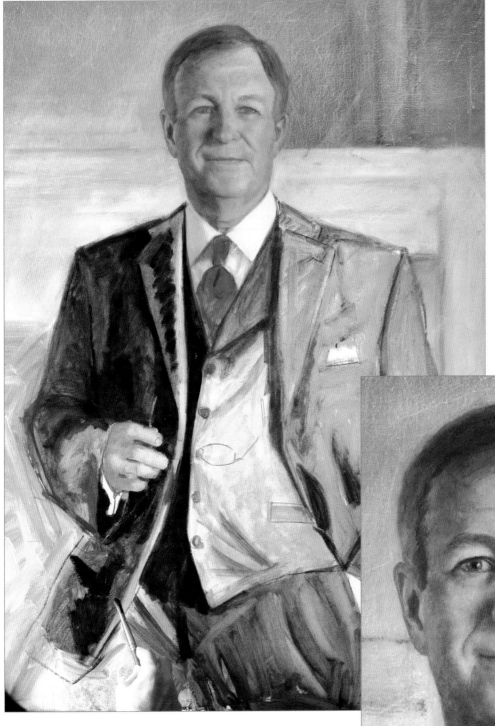

◀ **8.** I begin to work on the suit and tie, using filbert bristle brushes and no medium. For the suit I mix a blue-gray color, using ultramarine blue with a touch of cadmium red light and burnt umber. I add a little titanium white to the mixture for the highlights. I paint the tie with cadmium red light, adding a little alizarin crimson for the shadows.

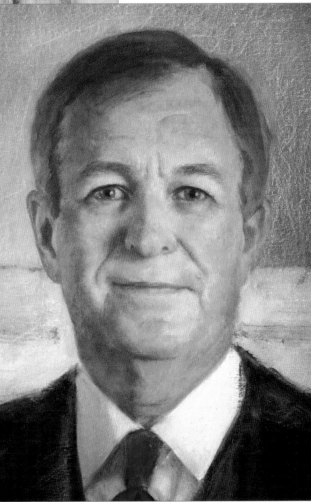

▶ **9.** I return to the face and begin to pull out the details. I paint the whites of the eyes with titanium white mixed with cerulean blue and cadmium red light. I glaze back in the cheeks and nose with a mix of cadmium red light and yellow ochre. Next I start to use a blending and glazing medium thinned with English distilled turpentine (about 1/4 medium to 3/4 turpentine).

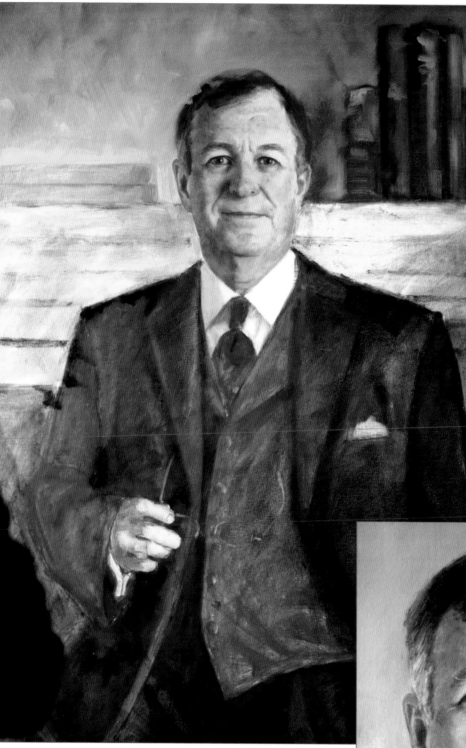

**Artist's Tip**

Using too much medium makes your painting too slick and hard to work. I just barely dip my brush in the medium. Use sparingly!

◀ **10.** I reinforce my darks across the canvas and pay attention to where I need details. I begin work on the books on the mantle, using viridian green and a blue mixture with a touch of cadmium red light to tone down the colors.

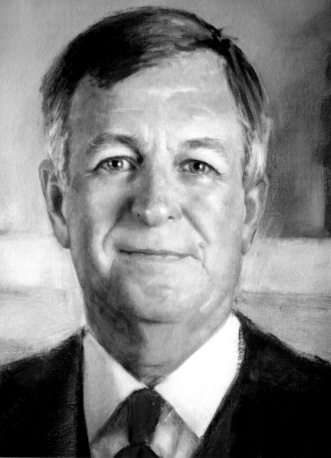

▶ **11.** I continue to work all over the canvas. A portrait has to be unified, and this is difficult to achieve by finishing one spot at time. I work on the face more, bringing up the highlights in the skin and adjusting the color in the hair. I use No. 4, No. 6, and No. 8 silver cat's tongue mongoose-hair brushes to paint the details.

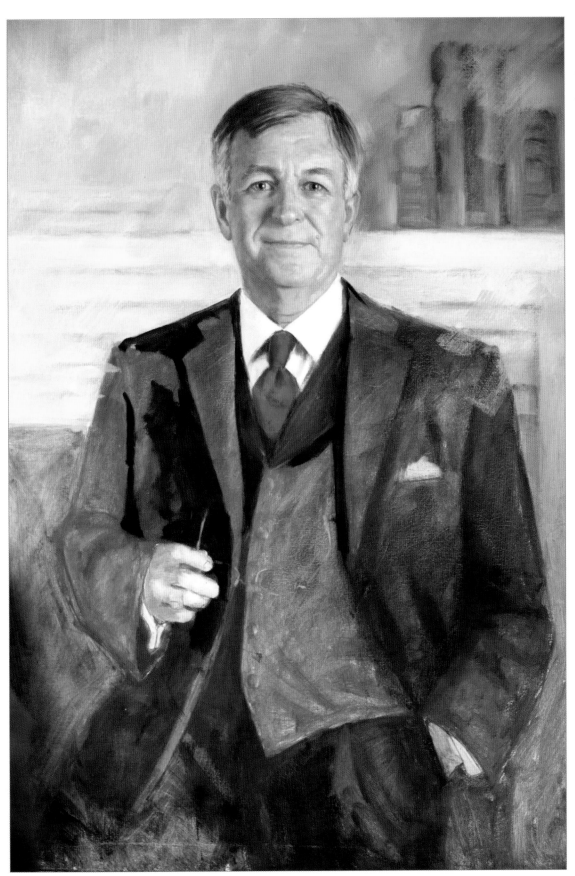

**12.** I continue working on the background and the suit, with a push-and-pull method—notice how I have painted over the suit with the background in places to help unify and avoid hard edges. This method works my edges into the painting for smooth transitions. I begin to darken the values in areas where needed, and I define the darkest values in the suit using the transparent colors of ultramarine blue, alizarin crimson, and sap green.

## Artist's Tip

I check and recheck my work throughout the entire painting process. A great way to check your work is to take a good, high-quality photograph when you think you're finished and study the values and colors. Then hold up your photograph in front of a mirror to see if everything still works in reverse.

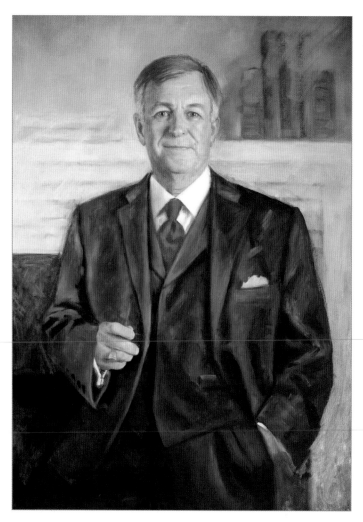

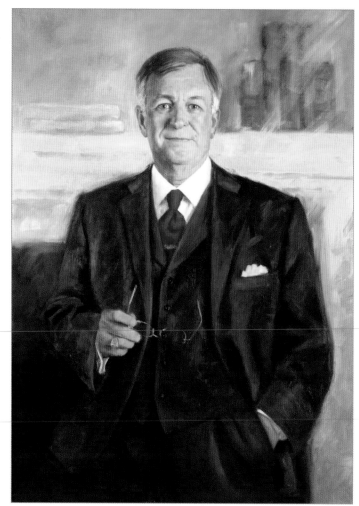

**13.** Now I work on the lighter values in the suit, using a base of cerulean blue, ultramarine blue, and a little cadmium red light and titanium white. The cadmium red light tones down the intensity of the blue, making it more of a gray-blue navy.

**14.** I continue to build up my dark and light values in the suit. I also begin to add the glasses and work on the details of the hand. I use the same colors for the hand as I did for the face, but a little darker in value because of the way the light falls on the subject. I work some more on the mantel and books in the background. I want this area to be visible, but blended into the background, so I don't add too much detail.

I make the fingers come forward by making the forefingers lighter in value. For the glasses I use burnt sienna, raw sienna, titanium white, and yellow ochre. For the highlights I use a mixture of titanium white, cerulean blue, and cadmium red light. I paint his ring using the same colors.

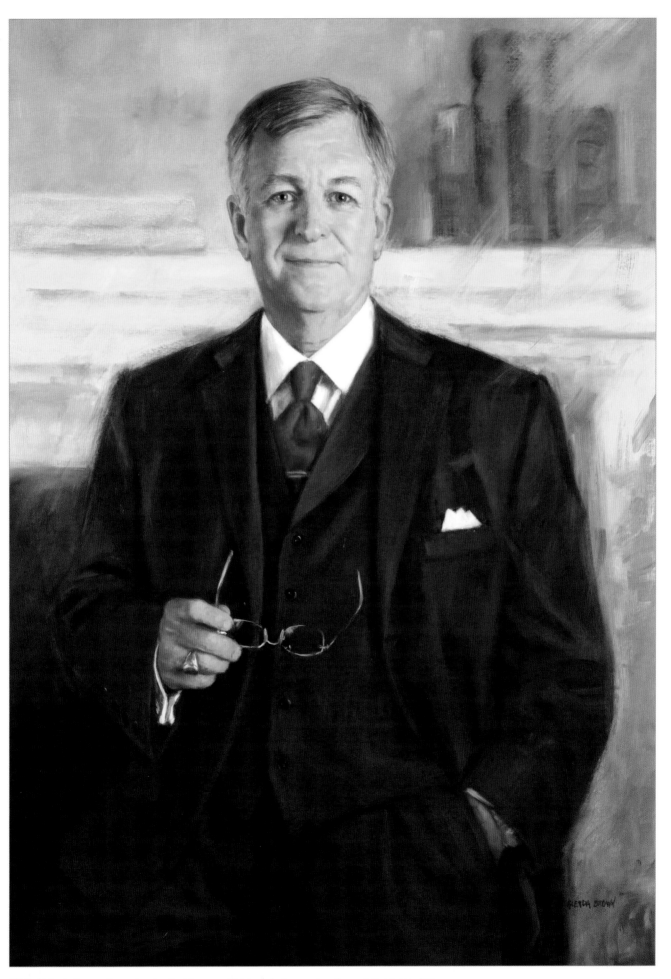

**15.** I add the buttons on the vest and recheck for areas I think can be improved, and my painting is complete.

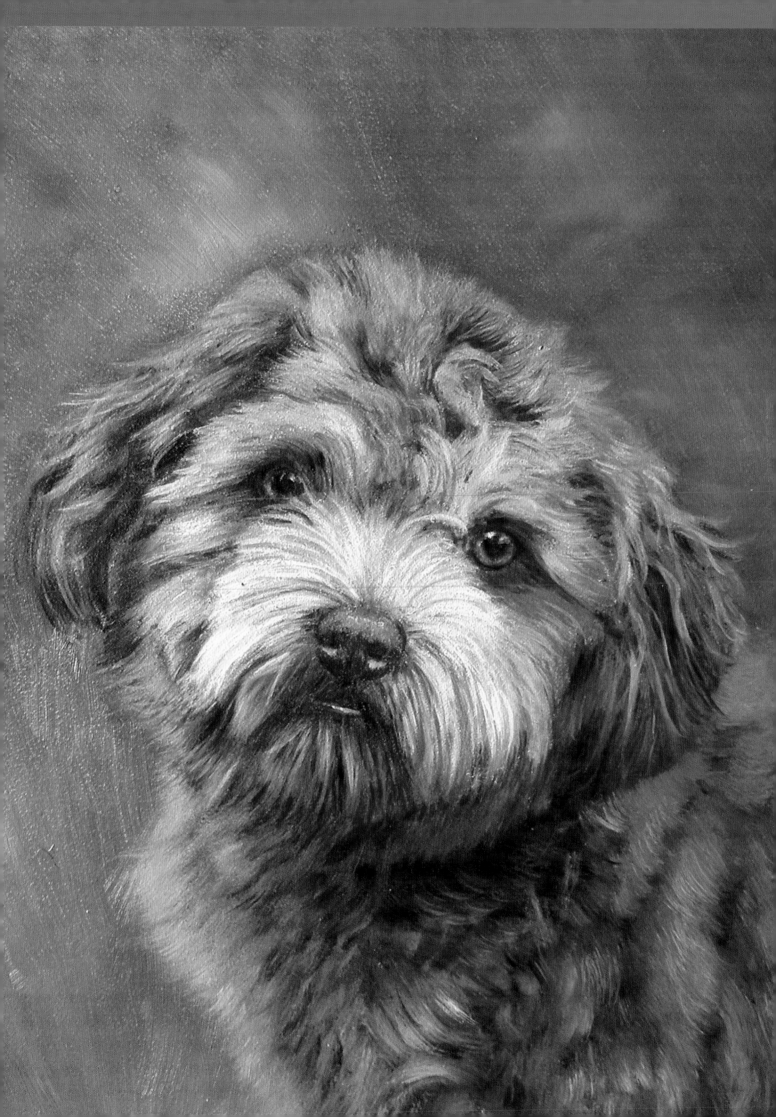

# Chapter 3
# Painting Animals

## with Lorraine Gray and Jason Morgan

Oil is a wonderful medium for creating realistic animal portraits. In this chapter you'll find a step-by-step guide to rendering texture, plus six step-by-step portrait projects for both domestic and wild animals. You'll even find tips on painting eyes, noses, ears, and whiskers. As you paint, enjoy learning how to blend lovely, rich colors and create transparent glazes. If you have trouble achieving a desired effect, take a little break. Stand back and observe your piece; you'll find it easier to see where you need to alter things. Practice constantly, and soon you'll be a master at painting lifelike animals.

# Rendering Fur

## with Lorraine Gray

Here I demonstrate two techniques for fur texture—one for long fur and one for short fur. Practice these techniques on a small canvas board before you begin a large project.

## Short Hair Fur Texture: Tabby Cat

**1.** First mix a small amount of burnt umber and ultramarine for the black fur, keeping the paint thin. Brush the paint onto the canvas from left to right in the direction the fur grows. Practice on a piece of white paper to make sure you don't have too much paint on your brush and to check your color. Dab off excess paint with a cloth if your brush is too loaded with paint.

**2.** While the paint is wet, mix a bit of thinned burnt sienna and raw sienna. Paint in the direction of the fur near the black strokes. Thin the black mix a bit, and dab off excess paint from your brush. Then use the drybrush technique to blend the two colors. Next mix white and a little burnt umber and raw sienna, and add cream fur texture with a small round brush. Let dry a few hours or up to a day. To test, lightly touch with your finger. If the paint is sticky let it dry longer.

**3.** Once dry, add another layer of the black mix. Then mix more of the cream color, and add more cream fur texture. With a clean, dry bush, lightly blend the fur to soften.

**4.** Lastly, apply some white paint to highlight the fur. You can do this while the paint is still wet and blend in slightly, or you can wait until dry and flick on some highlights as a finishing touch.

### Artist's Tip

Always paint fur in the direction it grows.

## Long Hair Fur Texture: Tortoiseshell Cat

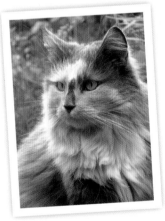   

**1.** Using a round brush, paint the darker fur with a mix of burnt umber, burnt sienna, and a bit of ultramarine to darken. Keep your paint fairly thin. Then mix a thin amount of white with a bit of burnt umber to create a cream color. Brush long fur strokes under the darker color and blend the colors together. This is the undercolor for the long fur. Let the paint dry.

**2.** Once dry, slightly darken the top shadow with a thin layer of burnt umber and burnt sienna. Then mix white and a dab of raw sienna and burnt umber to create a warmer cream, keeping the mix thin. Use long brush stokes to paint the fur, and then blend the lighter fur stokes with the darker fur. Let this layer dry.

**3.** Add another layer of the darker fur. Then mix white and a tiny bit of burnt umber for the lightest fur color. Using a No. 4 round for the larger fur stokes and a No. 10/0 and 2/0 for the thinner fur, brush in the light fur stokes. With a clean, dry brush, blend the two colors together slightly to get the look of soft fur. If you want to lighten the fur more, flick in some highlights using just white paint.

### Artist's Tip

When layering on top of wet paint, your new layer must be thicker than the first. If you use a thinner layer over wet paint, it starts to lift off the canvas. If this happens, let the paint dry, or make the paint on your brush a little thicker.

# Ears, Eyes & Noses

## with Lorraine Gray

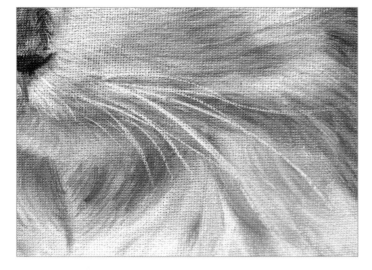

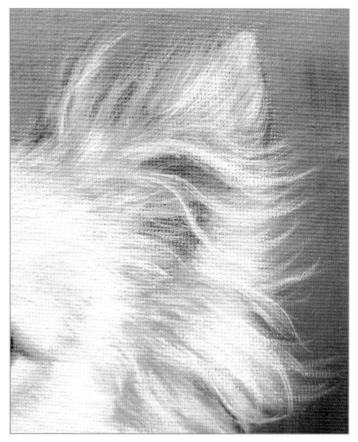

**Whiskers** To create whiskers, use a fine brush (size 10/0). Dilute white paint to a thin consistency and then, starting at the base of the whisker, quickly sweep the brush in the direction of the whisker, lifting the brush at the end.

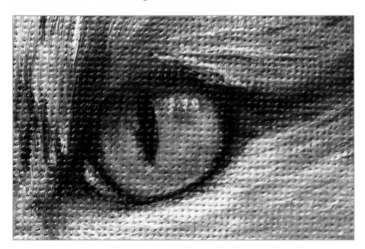

▲ **Cat Eyes** Cats' eyes have some lovely colors. Start by drawing the shape of the eye and the pupil with a round brush, using a burnt umber and ultramarine blue mix. While this is wet, mix cadmium yellow and ultramarine blue for the green, and paint around the inner edge of the eye.

For the midtone yellow mix lemon yellow with a bit of cadmium yellow and blend slightly into the green. Eyes reflect color from their surroundings, so highlights are not pure white. I like to mix a bit of ultramarine blue or cobalt blue into white and flick highlights near the top of the eye. If there's too much, simply lift some off with your thumb. When the eye is dry, put a dab of white at the edge of the blue highlight. To soften the outer edge of the eye, paint a thin wash of burn sienna and burnt umber along the bottom.

▶ **Cat Noses** Mix burnt umber and ultramarine and paint the dark bridge and tip of the nose. Then make a diluted mix of cadmium red with a little bit of alizarin crimson and white for the pink color on the lower nose. While wet, mix more white into the color mix and paint the lighter pink color. Doing so while the paint is still wet blends the colors, avoiding hard edges.

Once dry use a round brush to add the fur texture on the bridge of the nose with a mix of burnt umber and a little white. Paint little brushstrokes down the nose to create the fur texture. Then clean the brush and mix the highlight color with a little ultramarine blue and some white. I dilute the paint so it is thin enough to glide easily off the brush without leaving thick paint on the canvas.

**Ears** First paint a thin layer of a burnt sienna and burnt umber mix with a filbert brush for the darker ear color. For the center of the ear, use a thin mixture of cadmium red and a little alizarin crimson. When dry, paint a thin layer of burnt umber over the pink to tone it down. Once dry, start the next layer. Using a round brush, mix burnt umber with some white to create beige. Paint in the direction the fur grows, and flick some fur texture on the ear. Clean the brush and mix raw sienna and some white for a cream. Using the same brushstrokes, flick on more fur texture. The beige color is still wet so the cream blends in slightly for a soft, fluffy look. Do the same technique with some white paint, and then let the painting dry. Add more white highlights where needed. To get a soft, fluffy look, be careful not to use paint that is too thick.

# Horse

## with Lorraine Gray

I couldn't resist painting this beautiful horse. He makes a great model for learning to paint and blend a wispy mane. Remember that you don't always have to paint dark to light. In this painting I paint the lighter burnt sienna first and tone it down with a thin wash of darker color to allow the warm tones in the horse's neck to show through.

### Palette

burnt sienna • Naples yellow
olive green • raw sienna • raw umber
ultramarine blue • titanium white

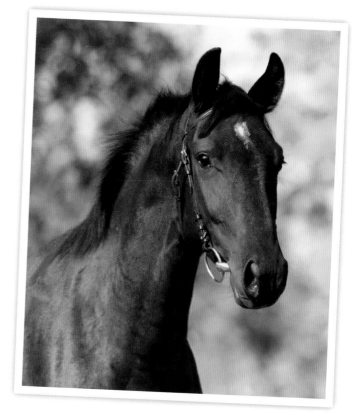

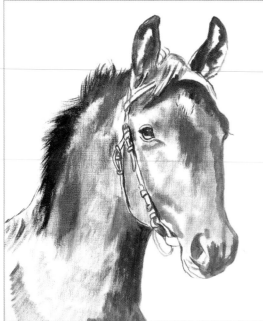

**1.** I sketch my horse with an HB pencil. Once happy with the likeness, I thin raw umber and use a small thin brush to draw in the outline of the horse. Then I use a larger brush to roughly put in my dark areas. I use just a little paint on the brush so I can "scrub" these areas without putting too much paint down.

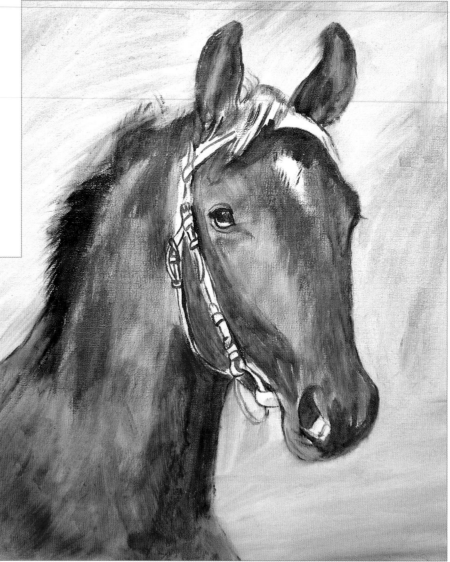

**2.** Once dry, I mix a very thin wash of olive green and roughly put in the undercolor for my background, using a flat hog brush. With the same brush, I apply a slightly thicker wash of burnt sienna for the strong undercolor of my horse. I let the painting dry.

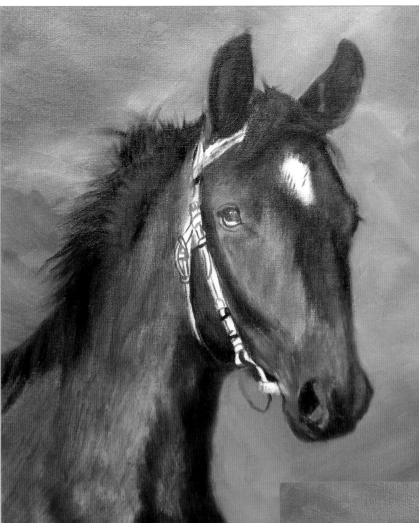

**3.** Once my painting is completely dry, I paint a thicker layer for my background, using a flat brush and a thicker wash of olive green. I roughly brush my green background and, while the paint is wet, brush in some Naples yellow. I then softly blend the two colors together for a mottled-looking background. While the background is wet, I mix some raw umber and ultramarine blue and put in the dark ears, mane, neck, and nose areas, using a round brush. The mane blends into the wet background, giving a real hair look. While the paint is still wet, I put another layer of burnt sienna over my horse. I let the painting dry.

▶ **4.** I mix raw umber and ultramarine blue and go over the dark areas again with a round brush. Then I thin the paint and put a thin coat over the whole face with a flat brush. The warm burnt sienna undercolor shows through. While the paint is wet, I mix a highlight color of ultramarine blue, burnt umber, and titanium white. With a round brush I start to blend the highlight areas in the face. Notice how the highlights melt into the undercolors. To fill in the eye I use a mix of burnt sienna and raw sienna.

## Artist's Tip

To eliminate brushstrokes in your background, gently brush over it with a clean, dry brush.

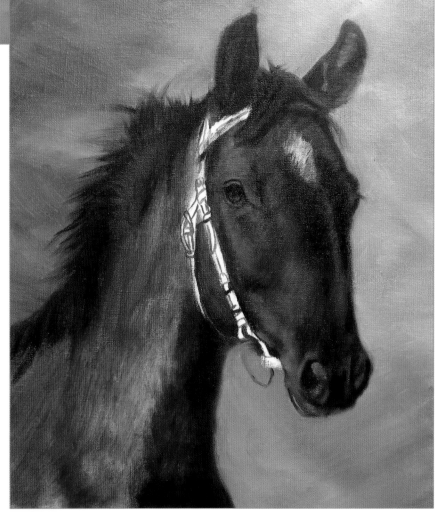

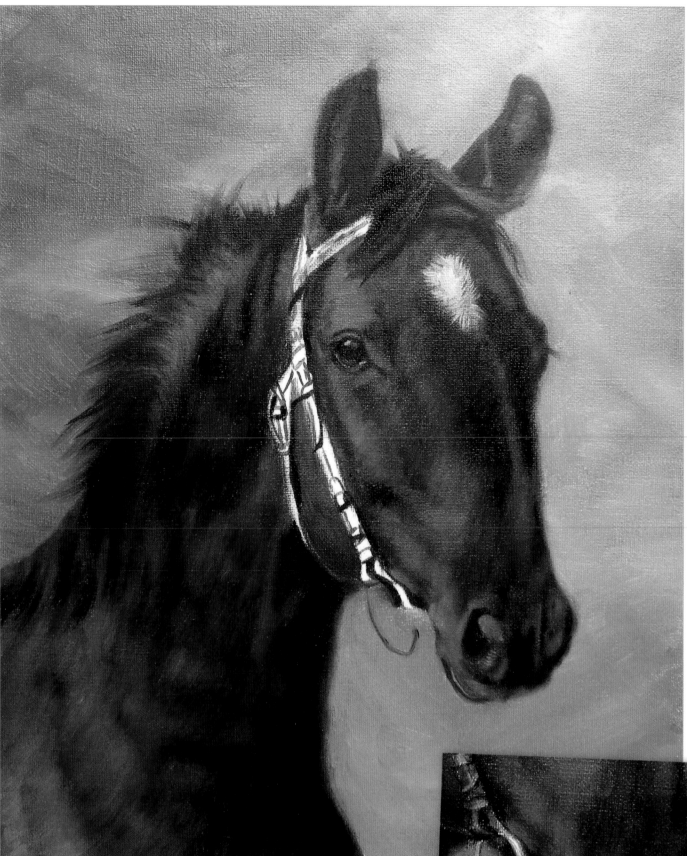

**5.** I use the same raw umber and ultramarine blue mix from step 4 to paint the neck and follow it with a thinned layer of the same color. Then I load several brushes to paint the left side of the neck. I load a No. 4 round brush with the dark raw umber and ultramarine blue mix. I also load a No. 1 brush with a cream mix of raw sienna, burnt sienna, and titanium white. I load a second No. 1 brush with a light highlight color mix of ultramarine blue, raw sienna, and titanium white. I paint over the left side of the neck, switching between the three brushes. I put some highlights in the fringe area too. Then, using a small round brush, I put in the eye detail. I use burnt sienna and raw umber for the main eye color and raw sienna at the bottom of the eye. I add highlights with a mix of ultramarine blue and a tiny bit of titanium white. For the bit in the mouth, I apply a base color of raw sienna mixed with a little burnt sienna.

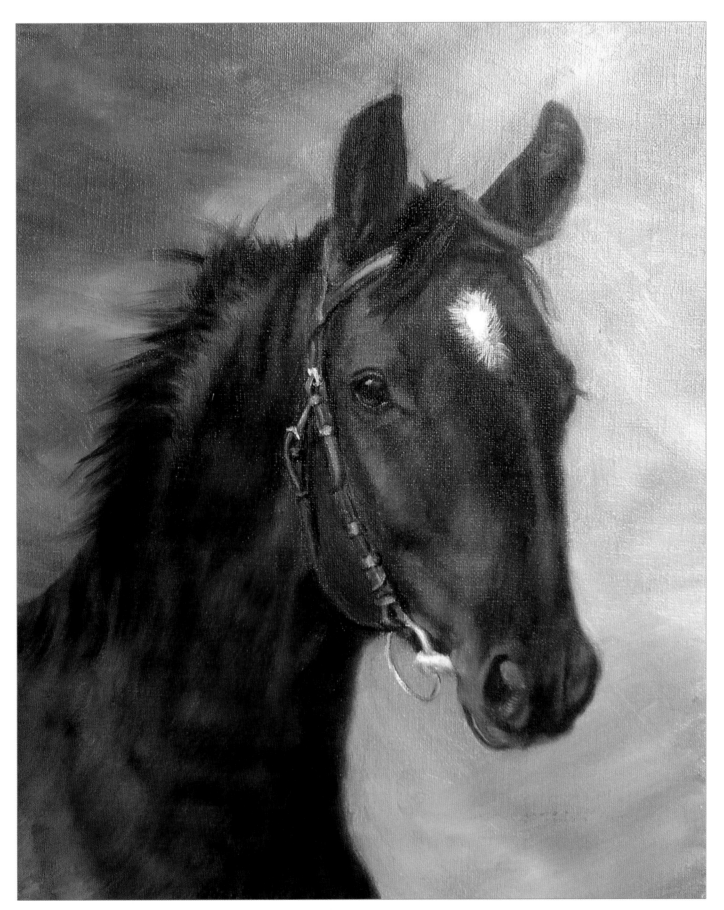

**6.** Finally it's time to add the reins. I mix a gray for the base color, using raw umber and ultramarine blue, and paint the reins with a small round brush. I blend a little gray mix at the bottom of the bit while the paint is wet. I add some titanium white at the top and blend. I do the same for the silver ring. For the highlights on the reins, I add more titanium white to my gray mix and gently stroke in the highlights. I let my painting dry before any final tweaks.

# Tabby Cat

## with Lorraine Gray

I love this photo of a relaxing tabby. This is a great project to experiment how to achieve soft, out-of-focus fur texture in the background and crisp focus and texture in the face.

## Palette

burnt sienna • cadmium red • cadmium yellow
Naples yellow • olive green • raw umber
ultramarine blue • titanium white

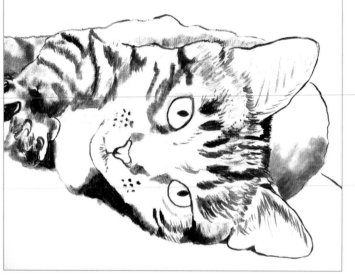

◄ **1.** First I sketch the cat with an HB pencil. Then I use a small round brush and a thin mix of raw umber to draw the outline of the cat. I roughly brush in the dark areas and allow the painting to dry.

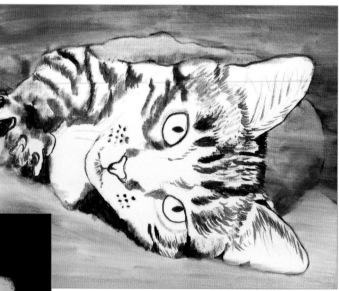

**2.** Using a flat brush, I paint a thin wash of burnt sienna in the background behind the cat. I dilute the burnt sienna more and paint the foreground undercolor.

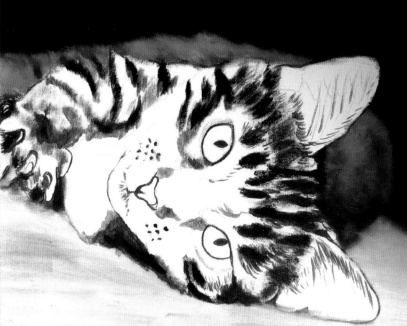

◄ **3.** Next I put a layer of ultramarine blue and raw umber in the background, striving for minimal brushstrokes. While the background is wet, I make a medium-consistency mix of burnt sienna, raw sienna, and titanium white for a sandy cream color. I roughly put in the sandy patches on the cat using a round brush. Then, using a flat brush and a dark color mixed from ultramarine blue and raw umber, I dab in the dark areas. I blend the colors by gently massaging with a finger. Using a clean finger, I very gently blend the edge of the cat into the background for the out-of-focus look. I let the paint dry.

## Artist's Tip
This photo has a shallow depth of field—the front of the cat is in focus, while the back is blurred.
To achieve the soft look of the cat's body, you must paint wet-into-wet.

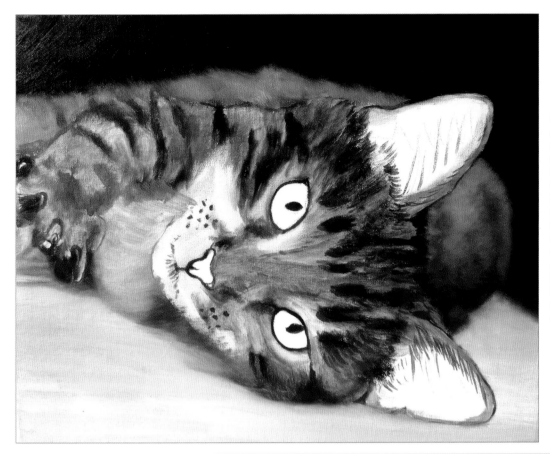

**4.** Using a small round brush, I add another layer of raw umber on the stripes, paws, and eye outline. I mix burnt sienna and raw sienna to create a ginger color and roughly brush in the gingery fur with a flat brush. With the same brush, I put a very thin layer of raw umber over the rest of the fur where white canvas shows. Next I mix a cream color from titanium white, raw sienna, and a bit of raw umber. While the cat is still wet, I softly blend the edges into the floor, using a flat brush and my cream mix. I let the painting dry.

▶ **5.** Then I mix white and raw sienna to make a new cream. I mix a second, lighter cream using more titanium white than raw sienna. With three small brushes, I flick in short fur texture, changing between the brushes and the cream mixes to achieve variety in shade and fur texture. The result makes the fur look soft, rather than like a hedgehog! I mix a thin wash of cadmium red and a bit of burnt sienna for the inside of the ears. I add the lighter pink spots with a mix of cadmium red and white. For the pale fur texture at the base and inside the ear, I use my two cream mixes and my thinnest brush.

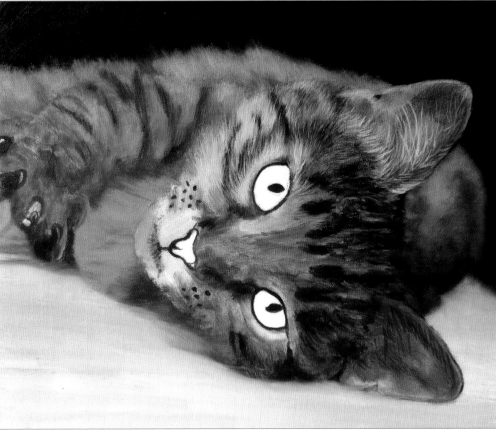

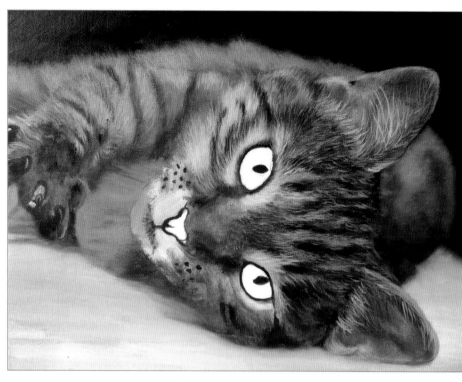

**6.** I continue adding in cream fur texture with the small brushes and two cream mixes. As needed, I dab occasionally with my finger to soften the fur strokes, especially in places like the leg.

▼ **7.** Next I put a thin wash of burn sienna over the eye. Then I make a slightly thicker mix of ultramarine blue and cadmium yellow, using more blue than yellow to create a bluish green. I dab in the green area around the pupil with a small round brush. While the paint is wet, I put a small amount of cadmium yellow in the eye, followed by small amounts of burnt sienna. Then, using the same brushes and cream mixes from step 6, I put in more fur texture over the rest of the cat, dabbing with my finger to blend so it doesn't look prickly. Using a flat brush and a thicker mix of raw sienna and white, I roughly brush in the foreground color. For the pink base color on the nose, I use a thin mix of cadmium red and burnt sienna. I add fur texture on the other ear. I let my painting dry before moving to the final step.

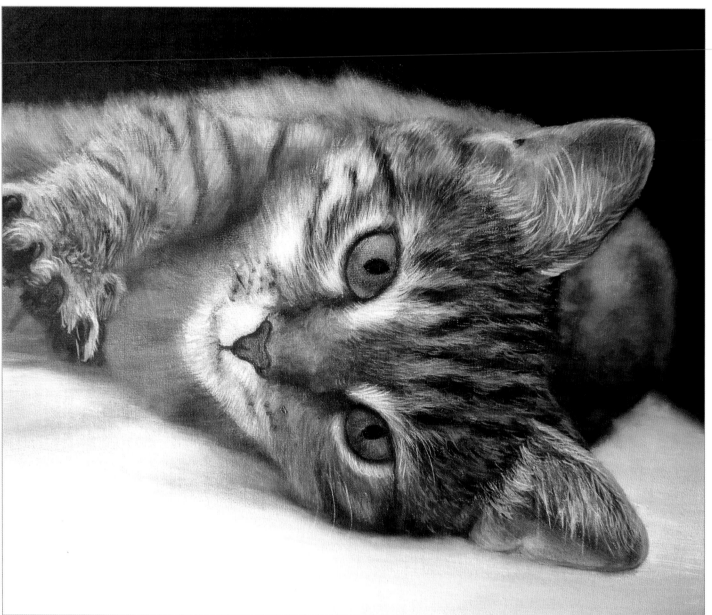

**8.** For the final touches, I put a thin layer of raw umber over the nose to tone down the pink. While the paint is wet, I add small dabs of a mix of ultramarine blue and white for the shine. To create the highlight in the eyes, I use a small round brush and thinned titanium white that lets the undercolors show. I dab thicker paint in the middle of the highlight and use a thin brush to create small white flecks. I brush in wispy fur texture on the chin, around the mouth, and on the paw with a very light cream and a thin brush. I put a thin layer of ultramarine blue on the claws and add thin white highlights. You should still see the pinkish undercolor coming through. Lastly I paint the whiskers with a thin rigger brush and very thin titanium white paint.

# Lhasa Poo Mix

## with Lorraine Gray

What a cute little dog! He has two lovely fur textures—
long fur on the ears and muzzle and short wavy fur on the
forehead. The two different textures make for an interesting
and compelling portrait.

## Palette

alizarin crimson • burnt umber • burnt sienna
cadmium red • Naples yellow • olive green
ultramarine blue • titanium white • yellow ochre

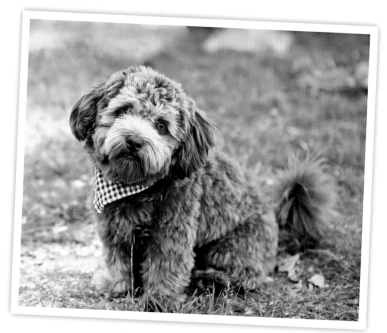

◀ **1.** I sketch the dog with an HB pencil.
When I am happy with the likeness, I mix
a thin wash of burnt umber and paint the
outline with a small round brush. Then I
roughly paint in the dark areas of the dog
with the same color. I let the painting dry.

▶ **2.** After the paint dries I mix a thin
wash of olive green and paint the
first background layer. You can use
any color for your background. While
the background dries, I start on the
undercolor for the dog. I mix titanium
white with some burnt umber and
ultramarine blue and put down a gray
undercolor on the face. I also paint a
thin wash of burnt sienna in the ears
and eyes. For the pink nose I mix some
cadmium red with a little alizarin
crimson and titanium white.

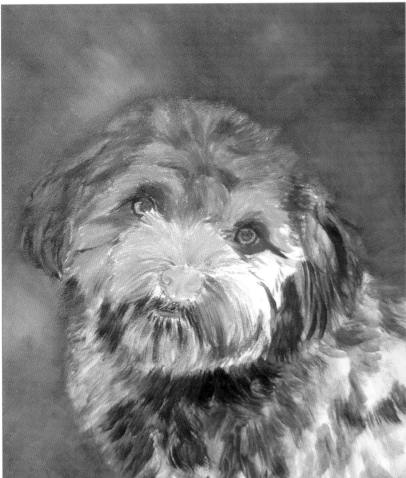

**3.** When the background is dry, I make a thicker mix of olive green and Naples yellow and use a flat brush to paint the background. I use thicker paint so it will be wet when I work on the dog and I can blend the fur into it.

**4.** I mix titanium white, burnt umber, and ultramarine blue for more gray. While the background is wet I use two small (No. 3 and No. 2) round brushes to start brushing in fur texture. The dark undercolor shows through. My paint is thicker now and I'm working into wet paint, but I am careful not to get the paint too thick and overwork it. I add more darks where needed.

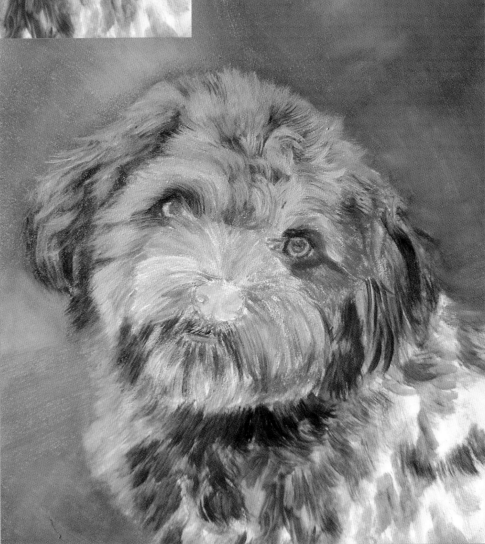

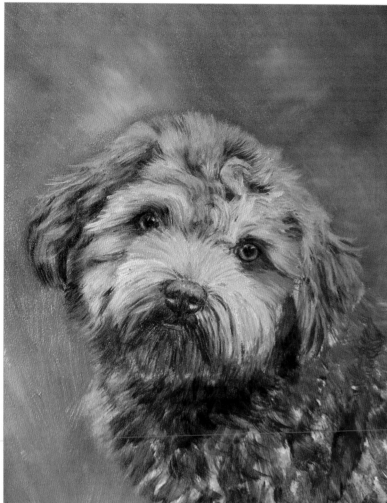

**5.** Next I work on the eyes. I use burnt sienna for the undercolor and darken the pupils with a mix of burnt umber and ultramarine blue. I add highlights with a mix of ultramarine blue and titanium white and add a small speck of pure white. I paint a bit of yellow ochre around the edge of the pupil. Then I add more fur texture on the face and ears with my gray mix from step 4. I add a thin layer of burnt umber to the nose to tone it down. Next I mix some black and use a small round brush to define the nostrils. With the same brush I dab some light blue highlights on the nose with a mix of ultramarine blue and white and press with my thumb to add texture. I repeat with a light pink mix of cadmium red and titanium white. I let the painting dry before the next stage.

**6.** With a round brush, I paint more dark areas of the fur, including the ears and chest, with a burnt umber and ultramarine blue mix. I mix a light gray of burnt umber, ultramarine blue, and titanium white and flick it into the dark fur, using three different sizes of round brushes for variety. While the paint is wet, I mix some yellow ochre and burnt sienna into the color to add variety to the shades of fur. Be careful not to use too much paint on your brush. I wipe the paint from the brush and then gently blend the paint for a soft, fluffy finish.

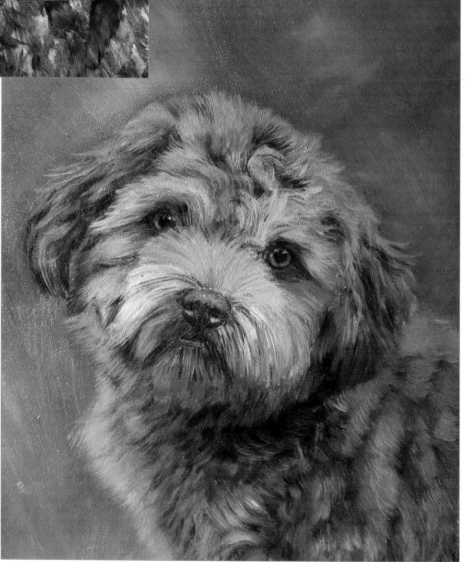

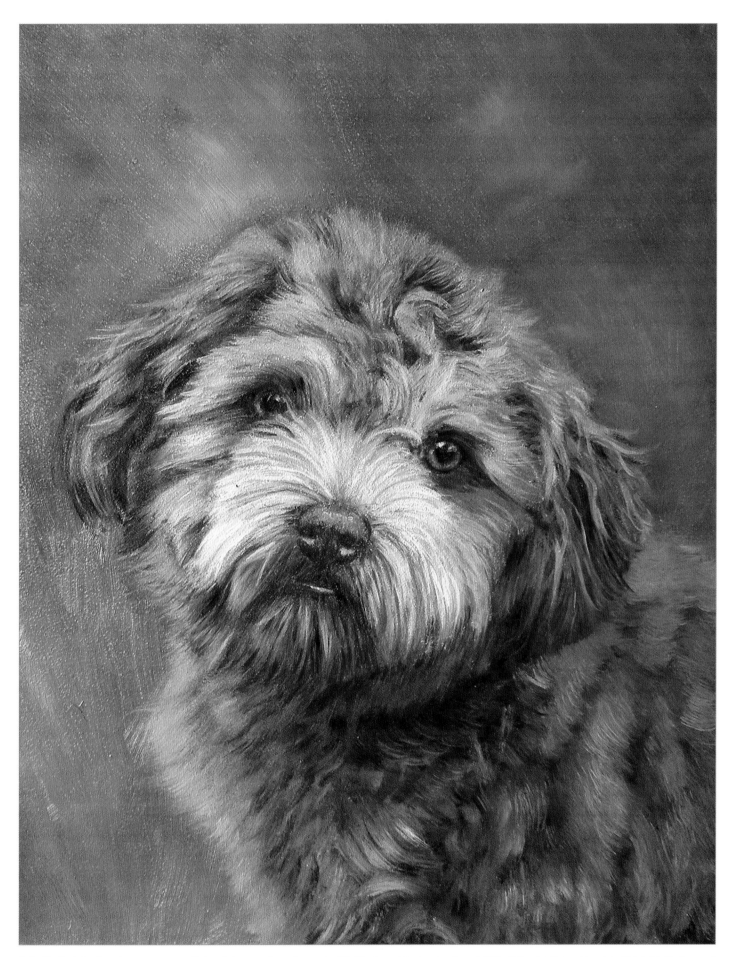

**7.** For the final step I create a warm cream with burnt sienna, yellow ochre, and a little titanium white, keeping the paint thin. With a small round brush I add detail in the face and ears. I paint smooth fine lines in the fur on the ears and around the nose. Then I mix a lighter cream of yellow ochre and titanium white for the highlights. I paint a thin wash of burnt umber over the pink mouth, and then mix some pale pink highlights and put a thin line on the lip. I add a few final touches to the nose with some pale blue highlights.

# Snow Leopard Cub

## with Jason Morgan

A snow leopard is a great subject to begin with when first starting to paint wildlife, as you need a limited number of colors, and most of them are opaque. Therefore, not many layers are needed to really build depth in the fur.

### Palette

burnt sienna • burnt umber • titanium white
ultramarine blue • Winsor yellow

▶ **1.** I sketch the snow leopard cub with a regular HB pencil onto an 8" x 10" acid-free primed gesso board, and then seal the drawing with a light spray of permanent pencil fixative. The fixative will prevent the drawing from being erased as I begin to apply paint.

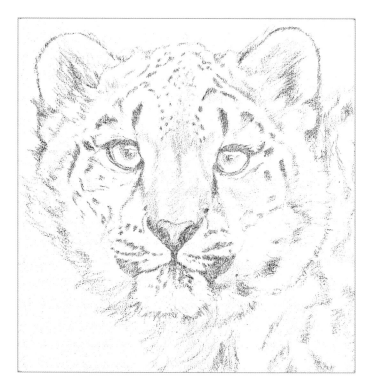

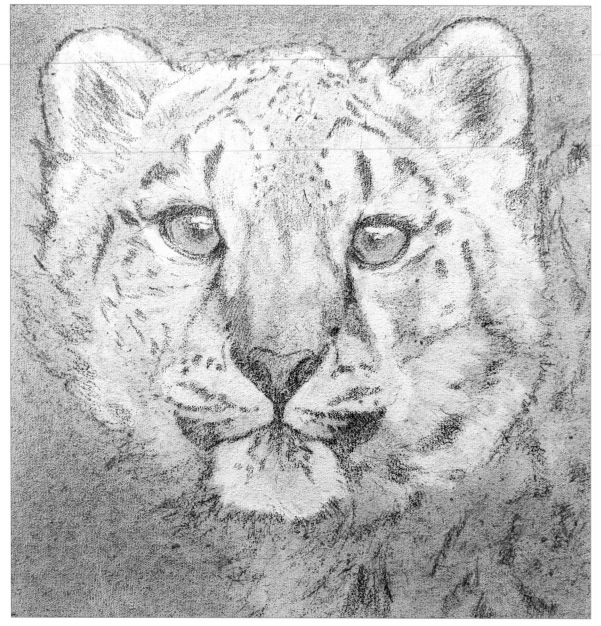

**2.** A tonal underpainting is a great way to simplify the subject and provides a map to follow with succeeding layers of paint. I paint on a watery mix of burnt sienna acrylic and, while it is still wet, lift out the areas that will be light in the finished painting with a paper towel. I use acrylic paint for this underpainting because it dries quickly, but you can use oil as well. I allow the paint to dry completely before I continue.

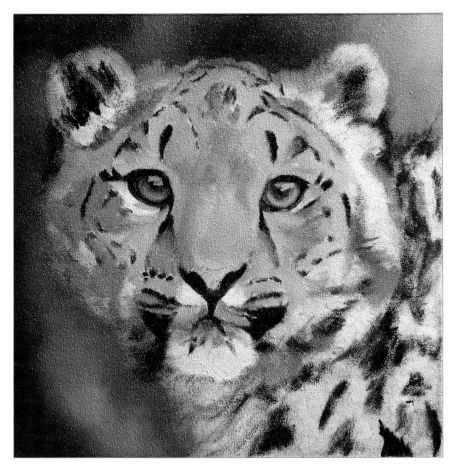

**3.** I begin blocking in by painting a simple background, using a No. 6 flat bristle brush and various mixes of ultramarine blue, burnt umber, and titanium white, blending with a soft touch to give a subtle lighting effect. I then move to the cat's face and begin to lay in some of the darkest areas around the eyes and the spots with a smaller No. 1 flat bristle brush. Then I start blocking in the fur with a No. 4 flat brush, using mixes of titanium white, ultramarine blue, and burnt umber again. I block in the eyes with the same fur mix, plus a little Winsor yellow to give them a slightly green tint.

## Artist's Tip

I paint the fur that is farthest away on the animal first and then overlap the fur strokes as I move toward the eyes and nose.

**4.** I continue blocking in with the same colors until all of the cub's fur is covered. I'm still using the large No. 4 brush, as it is important not to get too detailed at this early stage. All I need to achieve in this step is a solid underpainting on top of which I can add fur texture. This stage generally takes about two to three hours to complete. I let my painting dry overnight.

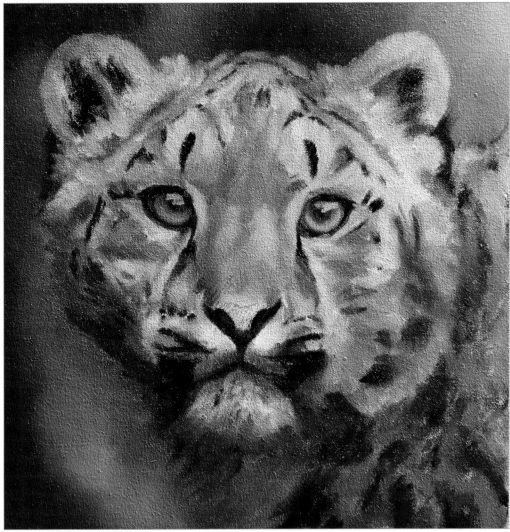

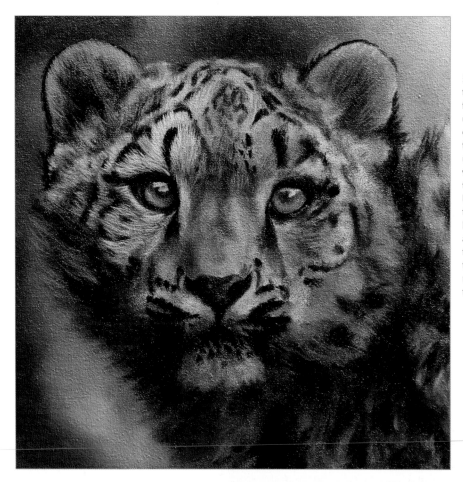

**5.** This is the beginning of the texture and detail stage. In order for the details to show up, the underpainting must be dark enough. My underpainting needs to be even darker, so I mix burnt umber and ultramarine blue with alkyd medium to create a transparent mix. Then I scrub it lightly over the areas that I need to darken. While this is still wet, I begin to paint the fur texture with a No. 1 flat bristle brush, ensuring that my brushstrokes follow the direction of the fur. I also re-establish the dark markings at the same time.

**6.** I continue adding fur details until the whole cat is brought up to the same level of completion. While this layer is still wet, I begin to refine the details and the fur texture with a No. 4 bristle rigger brush. I thin my paint mix with a little bit of odorless thinner to allow the paint to flow more easily. If an area needs to have a softer look, I brush over the fur (in the same direction as the fur), using a very soft, flat synthetic brush.

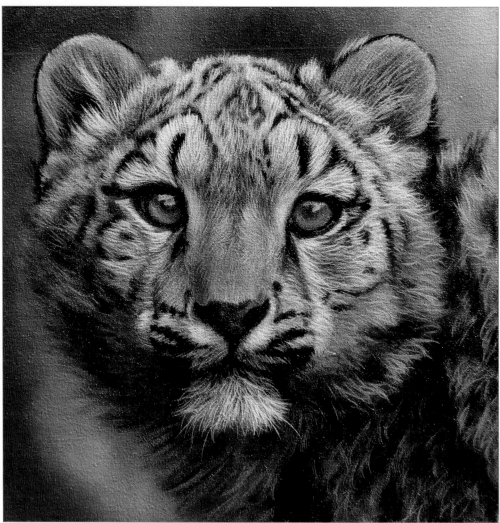

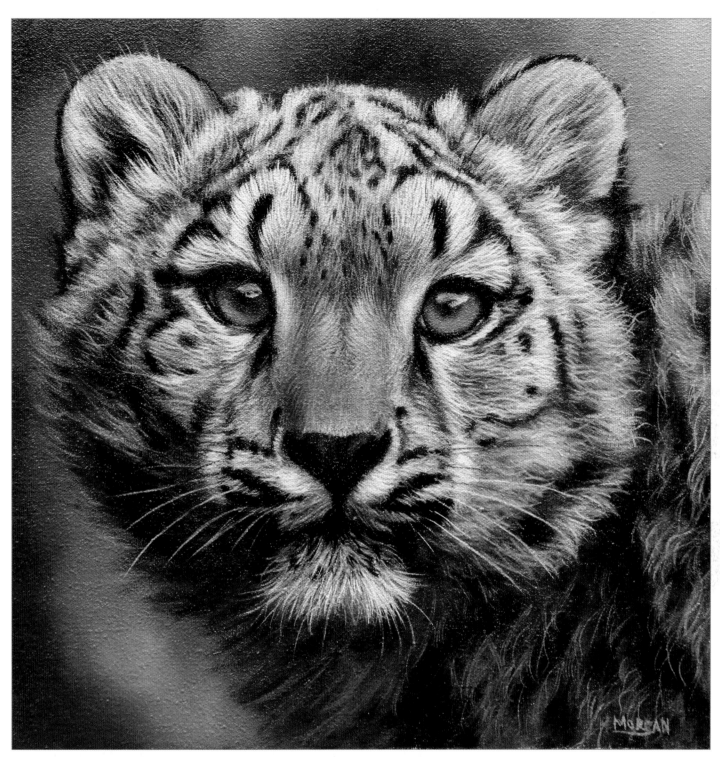

**7.** The final step is one of refinement, and it is at this stage that I normally apply some glaze, which is just paint thinned with alkyd medium to make it very transparent. I use very small amounts of burnt sienna, ultramarine blue, Winsor yellow, and burnt umber to warm some areas of the fur. While it is still wet, I paint the lightest highlights once again with a No. 1 rigger brush.

# Tiger
## with Jason Morgan

Tigers are probably the most popular wildlife subjects, but they can also be one of the most difficult, as most of the colors can be quite transparent. In this painting we will build layers of paint to create the appearance of luxurious, thick fur.

## Palette

burnt sienna • burnt umber • cadmium orange
cadmium yellow deep • Naples yellow
titanium white • ultramarine blue • Winsor yellow

**1.** I draw the tiger on the canvas and seal it with a light spray of fixative. When it is fully dry I paint over the whole canvas with a watered-down mix of burnt sienna acrylic paint, lifting out the highlighted areas with some kitchen tissue. You can also use oil paint. I allow this to dry fully before continuing.

**2.** The background foliage is quite complicated, but I want the tiger to be the center of interest. I simplify it to just the main shapes and begin to paint in the leaves and stems, concentrating on the shadows, midtones, and highlights and ignoring any details.

**3.** I refine the main foliage areas further before beginning to block in the tiger's face, using a small flat bristle brush (No. 4) and various mixes of cadmium orange, cadmium yellow, burnt sienna, and Naples yellow to paint the orange fur. I use a mix of burnt umber and ultramarine blue for the dark stripes.

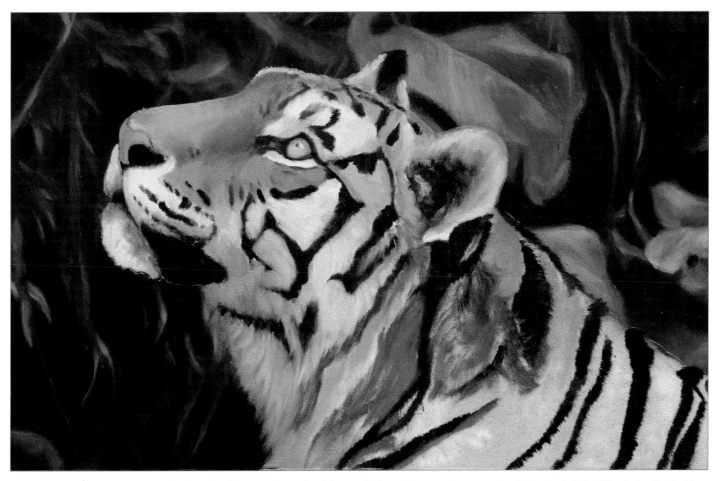

**4.** I continue to work my way over the whole tiger using the same colors and techniques as in the previous step, always ensuring that my brushstrokes follow in the direction the fur lays. I let the paint dry overnight.

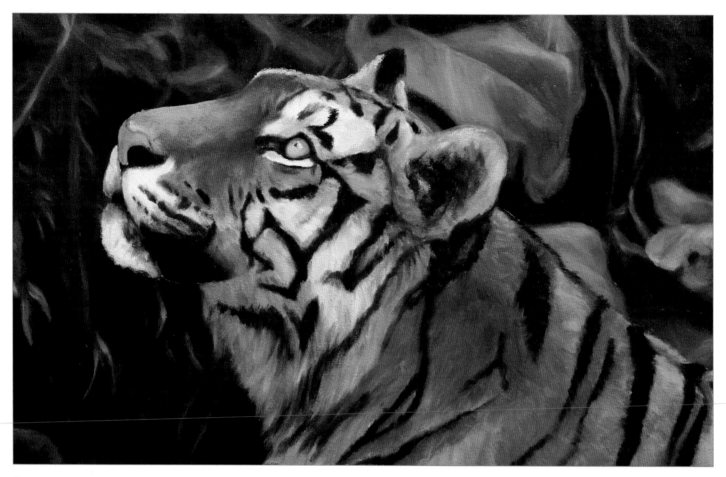

**5.** My painting technique is a process of refining and building upon each preceding layer, and applying a glaze is a great, quick way to do just that. I apply a glaze of burnt sienna and burnt umber mixed with ultramarine blue and thinned with medium to darken areas of the orange fur. I use a glaze of ultramarine blue and burnt umber to darken the white areas under the neck.

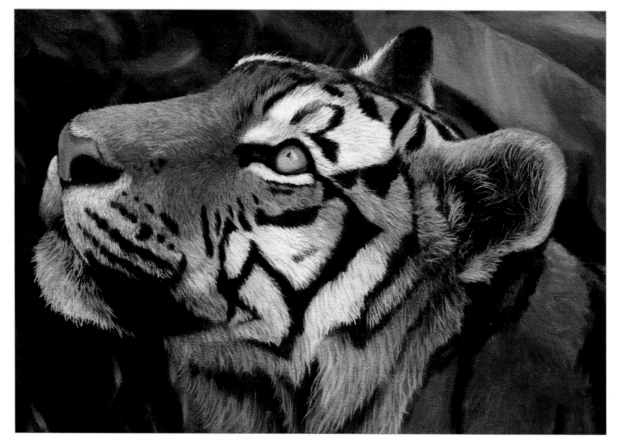

**6.** I start to add the first layer of fur detail on the tiger, beginning with the face and using a No 4. bristle rigger brush. I paint in the fur furthest away first and then overlap the brushstrokes as I paint the fur closest to the viewer.

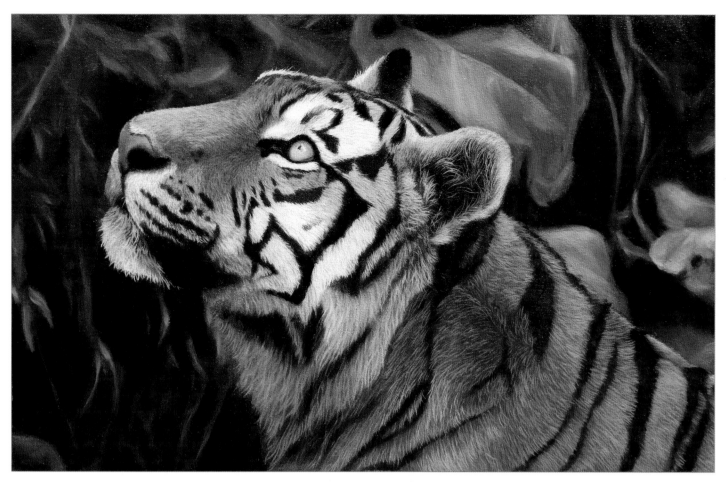

**7.** I continue to detail the whole tiger, constantly checking the reference photo to ensure that I am following the direction of fur growth.

## Detail

Some areas, such as the shoulder, have very complicated fur direction, as the fur can grow in swirls. I let my painting dry overnight.

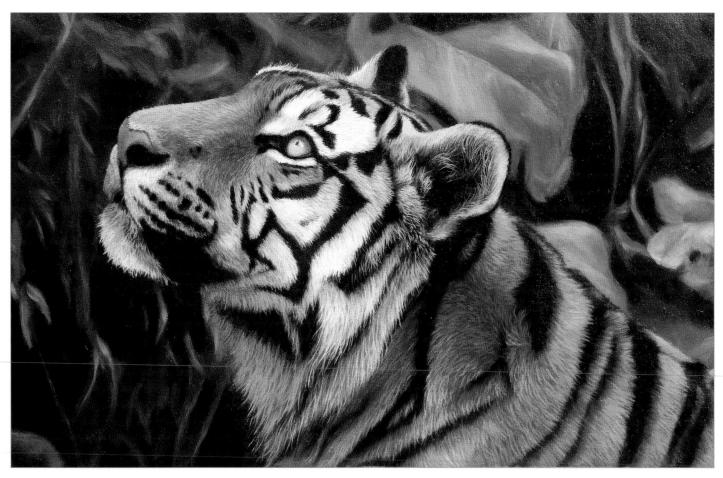

**8.** I apply a second layer of glaze to the areas that require further color adjustment or darkening, using the same colors as the first glazes.

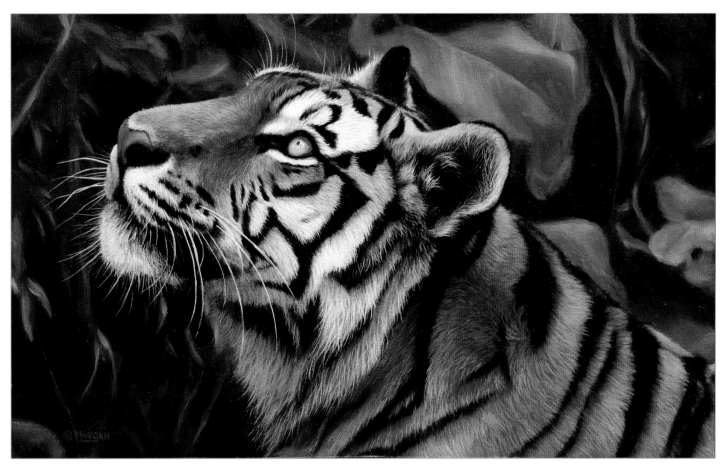

**9.** The last detail is the whiskers. To paint whiskers I thin the paint with odorless paint thinners to the consistency of ink. Then, after loading my brush with paint, I use a slow confident stroke, starting at the base of the whisker and lifting off pressure as I come to the tip.

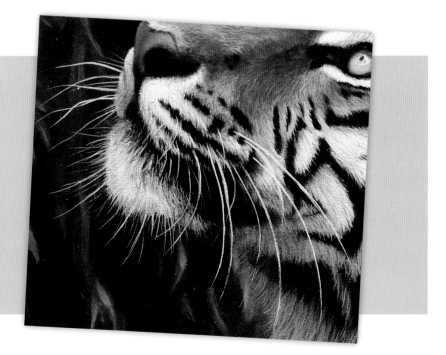

## Detail

Whiskers can be challenging for beginners because the paint can't be too thick or too thin. Try painting whiskers on a practice canvas first to test the consistency of your paint and get a feel for the motion.

# Black Leopard

## with Jason Morgan

Painting a black subject is really an exercise in studying the color you can *really* see, not what you expect to see. For example, a black leopard is really more of a very dark brown than a pure black. This is also an exercise in applying highlights, which give the subject its shape and form.

### Palette

alizarin crimson • black acrylic paint • burnt sienna
burnt umber • cadmium orange • cadmium yellow deep
Naples yellow • titanium white • ultramarine blue
Winsor yellow

*Note: You can use black oil paint instead of acrylic.*

**1.** To ensure that my drawing is accurate on the canvas, I like to draw my subject on paper first. This makes it much easier to correct any mistakes. I then transfer the drawing to canvas using transfer paper and seal it with a light spray of permanent fixative, which I allow to dry fully before continuing.

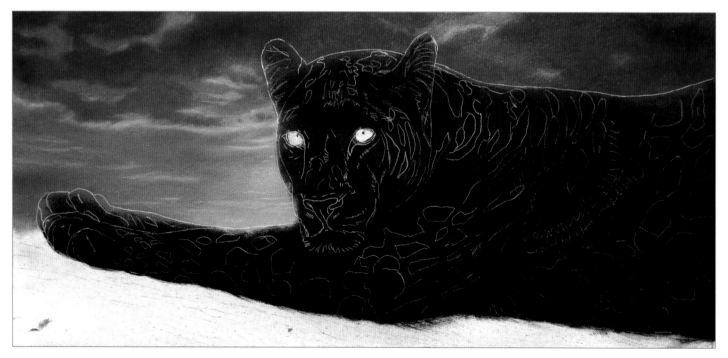

**2.** I block in the leopard with black acrylic paint, just to get a dark base to paint over later. I use acrylic paint because it dries quickly, but you can use oil paint as well. When the black paint is dry, I paint in the background of distant clouds, using various mixes of cadmium yellow deep, cadmium orange, Naples yellow, Winsor yellow, alizarin crimson, and ultramarine blue. I let my background dry overnight. Then I re-establish the leopard's markings by once again tracing over my drawing, using white transfer paper instead of the standard black so that it shows up easily.

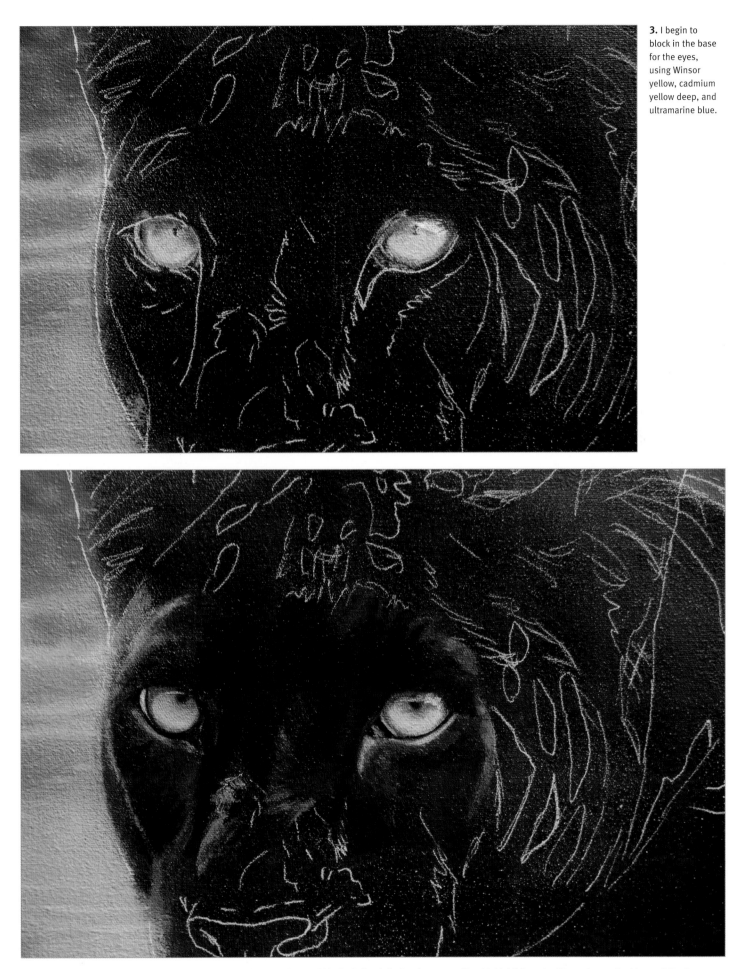

**3.** I begin to block in the base for the eyes, using Winsor yellow, cadmium yellow deep, and ultramarine blue.

**4.** I add depth to the eyes by adding darks—burnt sienna, burnt umber, and black—before bringing the eyes to life with highlights mixed from ultramarine blue and titanium white. I lay the highlights on top of the darks using a small round brush and a very light touch. I then start to work out from the eyes, painting the fur with a small flat bristle No. 4 brush. I follow the direction of the fur growth with my strokes and use a mixture of burnt umber, burnt sienna, ultramarine blue, and a little black.

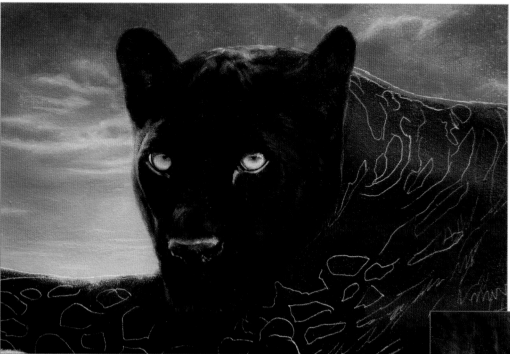

**5.** I continue to work outward as I block in the whole head, using the same No. 4 flat brush. It is important not to begin using small detail brushes too soon, as it can give a tight, unrealistic look to the fur texture.

**6.** It can be easy to lose your place when you are painting complex fur markings, especially on a dark subject like this leopard. To help keep my place, I like to paint in the suggestions of the highlights and lighter fur areas as I complete each small section at a time.

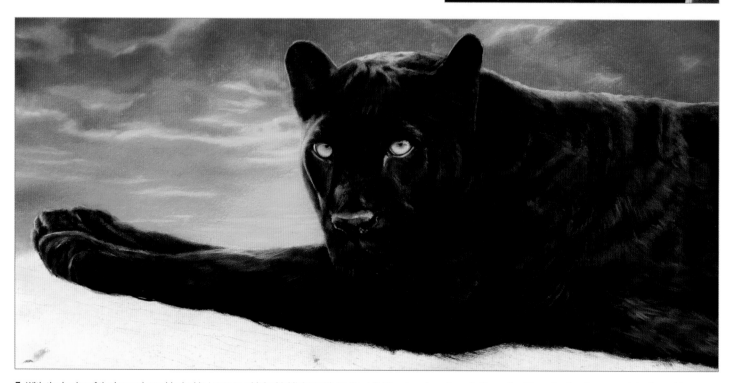

**7.** With the basics of the leopard now blocked in I start to add the highlights with my No. 4 flat brush, using mixes of ultramarine blue, alizarin crimson, and titanium white. This is what really makes the fur look glossy and realistic. It is absolutely essential to follow the shape and form of the animal at this stage.

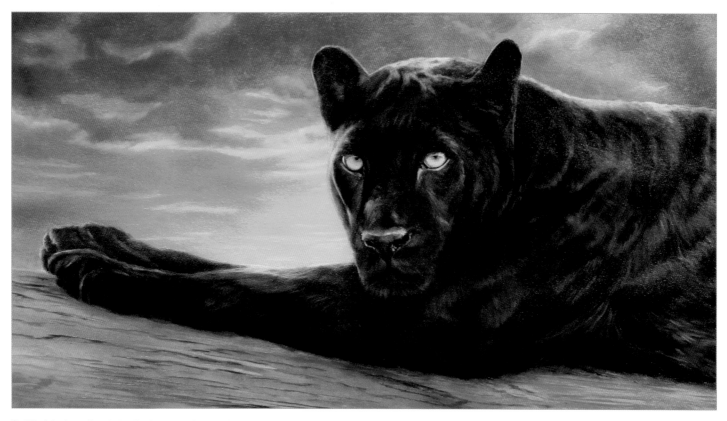

**8.** I block in the underpainting for the tree with a mix of ultramarine blue, burnt sienna, cadmium yellow deep, burnt umber, and Naples yellow, using horizontal brushstrokes.

## Artist's Tip

When you finish a painting, try putting it out of sight for a few days. You almost always see something to adjust when you look at it again with fresh eyes.

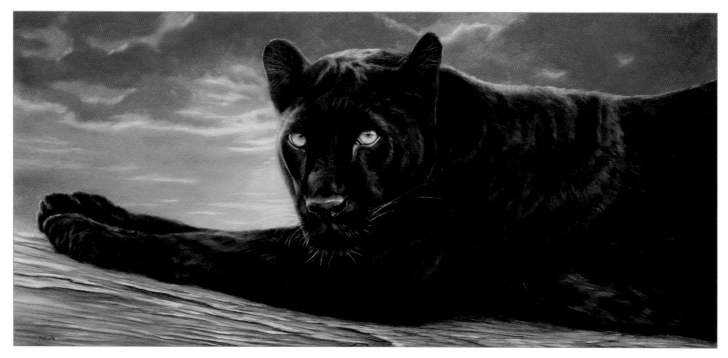

**9.** With the whole canvas now covered with paint, and detailed in most areas, I apply some glazes (paint thinned with alkyd medium) to make fine adjustments where required, such as darkening some areas of the body. I also paint in a few more details on the log to give an appearance of raised bark before calling the painting complete.

# Chapter 4
# Painting Landscapes & Seascapes

**with Varvara Harmon and Jim McConlogue**

It only takes some canvas and a few colors of paint
to create beautiful, vibrant landscapes and seascapes.
In this chapter, expert artists Varvara Harmon and
Jim McConlogue guide you through step-by-step instructions
for five breathtaking scenes, including a tropical bay, a vineyard,
and a snow-capped mountain. You'll explore how to
suggest mood, create dimension, and render textures
such as sand, water, and bark.

# Hanalei Bay

## with Jim McConlogue

For this painting of Hanalei Bay in Kauai, Hawaii, I compiled several reference photos and chose elements that appealed to me most from each. As an artist, you shouldn't feel constrained to replicate exactly from reference photos—if you want to change or add something you should. The freedom is yours.

## Palette

alizarin crimson • cadmium orange • cadmium red medium • cadmium yellow light • dioxazine purple sap green • titanium white • ultramarine blue yellow ochre

**1.** I start by toning my canvas with thinned yellow ochre. I prefer linen canvas mounted to hard board (Gator Board). On larger paintings like this, I sometimes draw grid lines to help me paint more accurately. Working with a thinned mixture of alizarin crimson and sap green, I sketch out a basic drawing of the mountains and bay, using a No. 6 filbert brush. I establish a horizon line and pay close attention to perspective, depth, and placement of the visual elements. Figures tend to draw the attention of the viewer, so I take my time drawing them and try to add character and movement to their poses.

## Artist's Tip

A filbert brush gives you the versatility of a thin-line, calligraphic, or broad stroke, depending on how you turn it in your hand.

**2.** Once I'm happy with my line drawing, I begin to block in some of the shadowed areas of the painting and the shapes of the background mountains, using the same thinned mixture from step 1. I also work on the volume of the forms and setting the angle of the light. This thin blocked-in stage is a good time to check that the painting works in a limited value range. You should also ask yourself if your eye moves from element to element, or if there are any compositional issues or areas of weakness. Now is the time to make those changes; simply wipe off the paint with a paper towel or rag and adjust your drawing.

## Artist's Tip

Paint the larger shapes first and redefine the image using smaller shapes once you are nearing the finish.

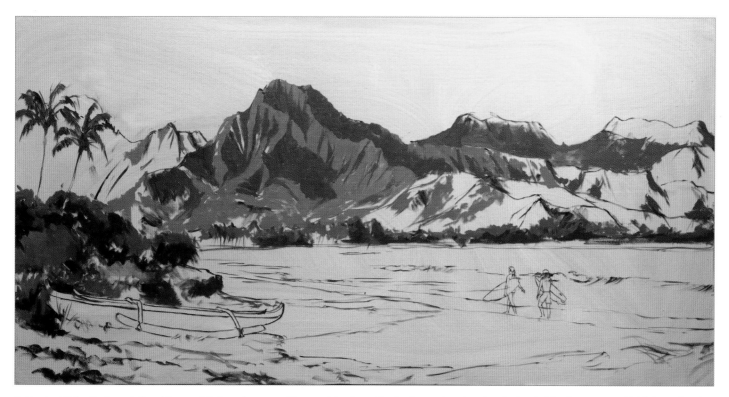

**3.** I begin defining the forms in the midtone and darker-value areas of the mountains. I pay attention to my color mixes, keeping in mind that I want warmer highlights and cooler shadows. Small areas of oranges and warm yellows combined with mixes of warm and cool greens help define objects and transitions in the background hills. I mix yellow ochre, ultramarine blue, and cadmium orange in various amounts for the green areas. I combine ultramarine blue, alizarin crimson, and titanium white with my mix from steps 1 and 2 for the cooler shadows. I often use a "mud" color—usually a mixture of leftover paint from the previous day's work—to tone down an overly saturated color mixture.

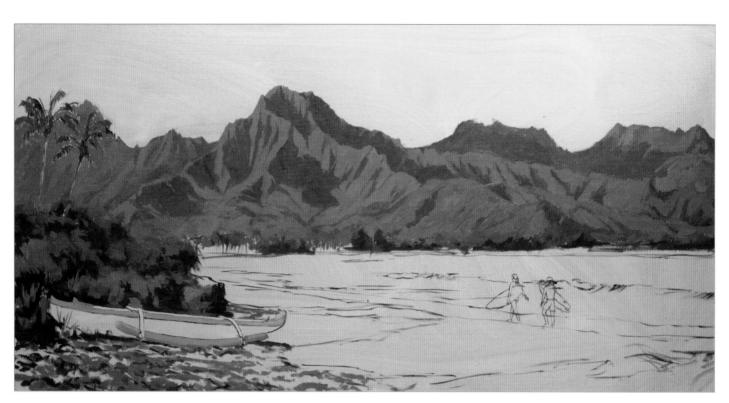

**4.** When working on larger paintings like this one (24" x 48"), I tend to work in an isolated area and then move on to the next. Ideally you should try to get the canvas covered first with approximate colors and then adjust the painting overall. Here I continue to define shapes and begin working color into the foreground bushes and outrigger canoe. Try to vary your color notes within the bushes to create life and form. I use cadmium orange and various warm and cool green combinations to give a bit more character and form to the foliage. For the dark green I use a combination of alizarin crimson, sap green, ultramarine blue, and dioxazine purple.

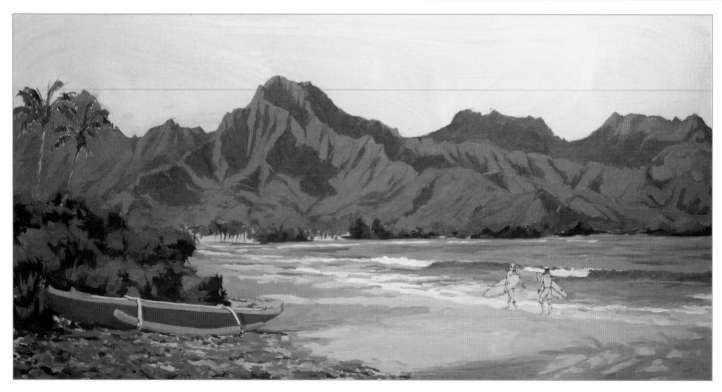

**5.** Have some fun at this stage and design a pattern of shadows on the beach! For the sand I use a combination of yellow ochre, titanium white, cadmium orange, and just the smallest touch of my mud color. Turn and roll your brush over in your fingers as you confidently place brushstrokes in the beach and ocean areas. In the foreground ice plant, and parts of the sand and ocean, I twirl my brush as I pull it horizontally to apply paint with a slightly haphazard look. Let there be peaks and valleys and thick brush marks in the application of your paint! I add a bit of dioxazine purple to the lighter sand color for the shadowed areas. I paint in some shadows and midtone colors in the outrigger canoe. Note how the placement of the canoe points the eye toward the surfers.

## Artist's Tip

When painting the water, create a few horizontal ridges by applying thicker paint.
Once dry, these areas catch the light and create a sparkle effect.

## Artist's Tip

Remember that high-contrast values and hard edges bring attention to an area. We want to make sure some areas of the painting recede while other areas pop forward. Apply paint with a variety of edges—harder edges where you would like to emphasize an area, and softer edges where the forms nearly blend together. The proper combination and use of value and edges are usually the most important aspects of a successful painting.

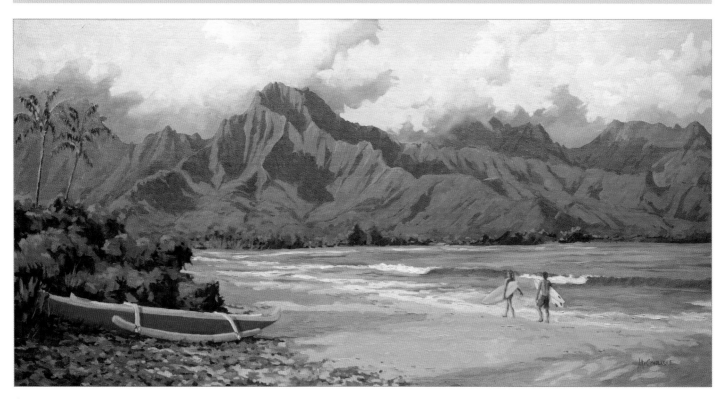

**6.** Study the way reflective light can illuminate clouds, and paint the sky with your own signature style. Allow your imagination to run and your brush to dance when painting clouds. Note that these clouds are a combination of reflective surfaces combined with translucent edges that melt into each other and the background sky color. Be careful not to paint a sky that is too blue. I always add a number of subtle colors to a combination of ultramarine blue and titanium white. With a No. 10 flat brush in each hand, I paint into some of the clouds with my sky color, and then I paint cloud colors into my sky in a back-and-forth motion until I'm satisfied. If something doesn't work for you, simply wipe it off and try again. I adjust some of the lighter values in the background and add thicker paint on the ocean and sand in some spots to "catch" the light. Finally I work on the highlights and shadows on the two surfers and continue to refine edges, values, and little details.

## Details

# Catalina Island

## with Jim McConlogue

I love this photo I took of a small bay on Catalina Island. I especially like the warmth of the afternoon light. To make the painting even more dynamic, I decide to add a couple eucalyptus trees to frame the left side of the painting and bring the eye back to the small island in the middle.

### Palette

alizarin crimson • cadmium orange • cadmium red medium
cadmium yellow light • dioxazine purple • sap green
titanium white • ultramarine blue • yellow ochre

**1.** After toning my linen-mounted canvas with a very thin wash of yellow ochre, I lightly sketch in a basic outline. Once the sketch is done I use spray fixative or a re-touch varnish to seal in the drawing. This gives me the opportunity to wipe off any passages of paint that are not working and still have my initial drawing underneath.

**2.** I begin to establish some of the darker darks by painting with a combination of alizarin crimson and sap green. I add a touch of dioxazine purple to the mix, in varying amounts, for some of the shadows. I keep this dark mixture thin by adding solvent or medium, as I don't want my shadow areas to be too thick. Some of these first strokes will show through in the finished painting, but I will adjust others to be warmer or cooler, depending on how the painting proceeds. I also begin to establish a darker mid-value shadow across the middle ground of the painting and begin to indicate some bush and tree forms in the background.

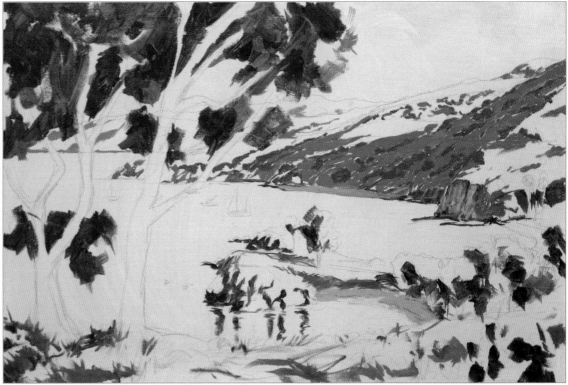

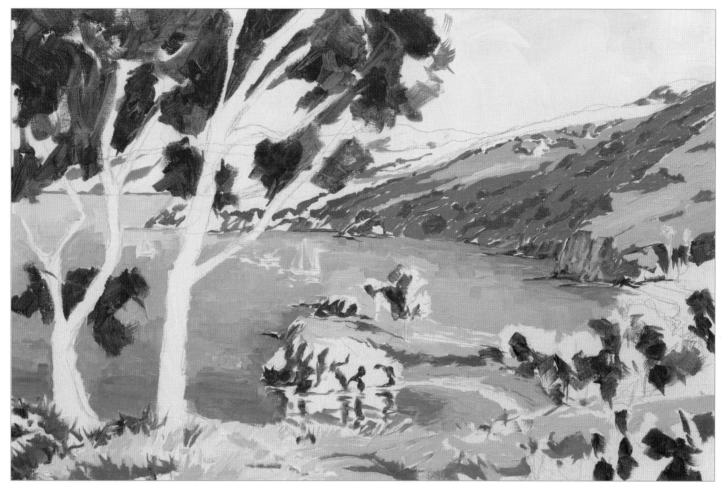

**3.** I jump into the lighter warm highlights with a combination of yellow ochre, cadmium orange, cadmium red medium, and titanium white. I also loosely block in the ocean with ultramarine blue, cerulean blue, and titanium white near the horizon and a combination of ultramarine blue with a touch of cadmium red medium near the bottom. I try to cover a majority of the painting surface with approximate colors so I can study its progress and make adjustments as necessary. You will often need to adjust color temperature and values until you are satisfied with the results.

## Artist's Tip

In this painting I jump around from spot to spot, instead of taking a more systematic approach—background, foreground, sky, etc. You can mix up your approach from painting to painting depending on complexity and subject matter, or just to keep it interesting!

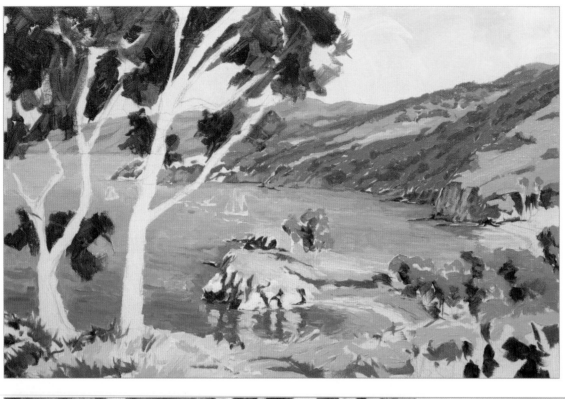

**4.** Now most of the values are established, so I begin to concentrate on temperature and making the entire painting appear bathed in the warm afternoon light. I add warm, middle, and light foliage to the grove of trees near the beach with combinations of yellow ochre, cadmium orange, and ultramarine blue, and I adjust some of the shallow water with cerulean blue, cadmium yellow light, and titanium white. I constantly analyze what needs to be adjusted and how each area is working separately, while also stepping back to view the painting as a whole. Often when I step back or squint my eyes to blur the painting, I am able to better see what areas need adjustments. I also start to think about what my sky might look like. In the reference photographs I took and my memory of the scene, the sky was cloudless, but I think I'll change that up a bit.

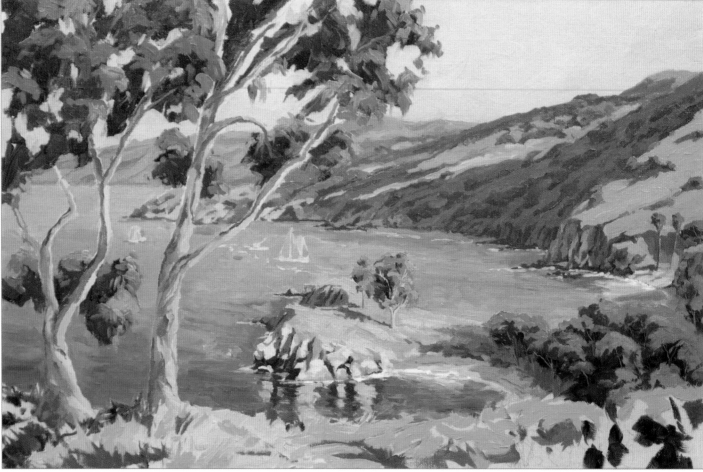

**5.** I paint the blue sky with a mixture of titanium white and ultramarine blue, but I also add a bit of my warm highlight color from the landscape. Skies are typically warmer near the horizon, and I often mix my mud color or add a dab of orange to knock back and gray down the sky color. I want another element to reflect the warm light, so I decide to paint in some light clouds in the upper right. I also begin painting the foreground eucalyptus trees. The bark of these trees is colorful and exciting to paint. You can't go wrong when painting them—each has its own distinctive markings.

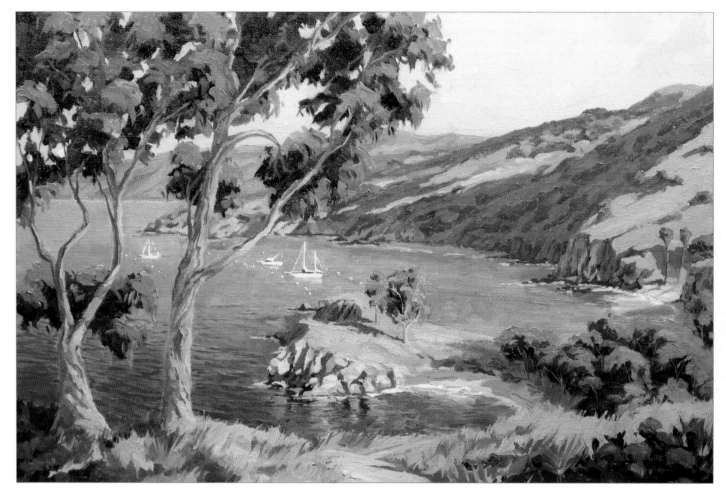

**6.** I paint in some low-lying bushes in the right corner to solidify that area. I want to define the grass shapes a bit, so I pull them up into the darker middle ground trees and down into the foreground bushes. I add boats and buoys with a bit of warmed-up white and a few accent colors to help give them shape. Remember to add a bit of a boat hull reflecting in the water, but don't overdo it. Light colors reflect slightly darker and darker colors reflect lighter. As a last addition I add in some water details with darker accents of ultramarine blue and alizarin crimson and break up the rock reflection in the foreground.

# Napa Vineyard

## with Jim McConlogue

This 30" x 40" vineyard painting is a combination of reference photos from a trip I took recently to Napa Valley, California. I used one photo for the sky, another for the vineyard, a third for the background hills, and a few more for the buildings.

### Palette

alizarin crimson • cadmium orange
cadmium red light • cadmium red
medium • cadmium yellow
dioxazine purple • sap green
titanium white • ultramarine blue
yellow ochre

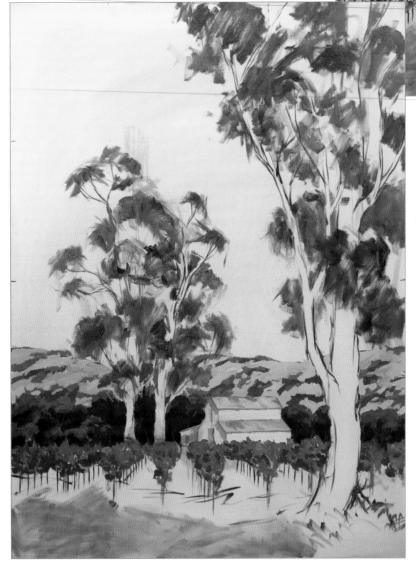

▲ **1.** I begin by toning the canvas with yellow ochre and cadmium orange. Then I take my time and sketch with paint, using a No. 4 bright brush and a warm brown mix of dioxazine purple, alizarin crimson, and cadmium orange. Depending on its complexity, I sometimes prefer starting a painting without a pencil sketch. Drawing with a brush gives a much more expressive line quality. Oil paint is a wonderfully forgiving medium, and you shouldn't be afraid to simply wipe off passages that are not quite right. I block in larger dark areas with a No. 8 flat bristle brush.

◄ **2.** I begin blocking in some general color notes and value relationships around the sunlit barn. I want to establish a starting point around the main center of interest that I can base the rest of the painting upon. The darker green is a combination of yellow ochre, ultramarine blue, sap green, and alizarin crimson. I add more yellow ochre and a touch of cadmium orange for a nice middle-value green. Since I've used quite a bit of "artistic license" with this composition and combined many pieces of reference material, I know that I'll need to constantly reassess and adjust as I paint.

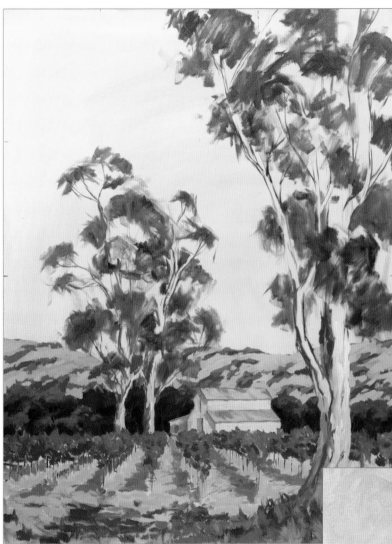

**3.** Next I begin to roughly establish the foreground plane and play with the color and shape of the shadowed portions of the eucalyptus tree. The vineyard soil is quite a bit redder than that of the surrounding hills. I combine yellow ochre, cadmium red medium, and titanium white and paint a basic tone that I will adjust once I develop the rest of the painting. It's good to get some paint down and begin the process, knowing that you can add highlights and accents to achieve your desired outcome. I mix blue and purple shadow colors for the eucalyptus by adding ultramarine blue, titanium white, and alizarin crimson to the initial brown mix I started with.

**4.** I paint in the sky and clouds, moving more quickly and trying to let the brush bounce and dance. I use ultramarine blue and titanium white with a tiny bit of my foreground dirt color to paint the sky—the brown knocks down the brightness. I add more white and a touch of cerulean blue to paint the light sky near the horizon. For the clouds I use a mixture of titanium white and yellow ochre. Pay attention to the edges of your clouds. I like mine to melt into the sky in places and be sharper in others. I like clouds with a bit more personality, not ones that look like cotton balls! I add a bit of cadmium red light to my cloud mixture to paint the shadowed clouds.

## Artist's Tip

Save enough of your sky color to paint in "sky holes" in the tree foliage when your painting nears completion.

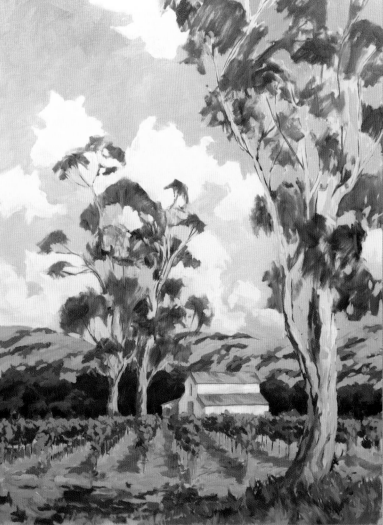

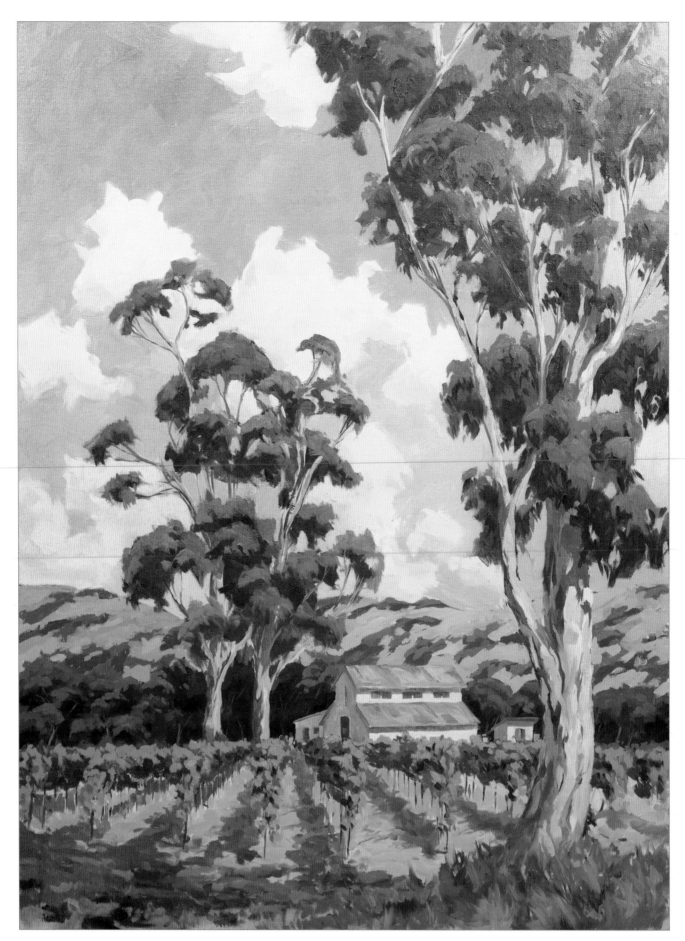

**5.** At this stage, I am about 90% finished. After looking it over, I decide to repaint the barn. I adjust the perspective a bit and add in additional features, buildings, and equipment. I also drop the roofline slightly and add more vineyard leaves to the foreground to help sink the barn into the landscape more. I work more on the foliage of the eucalyptus trees and add highlights, using a bit of cadmium orange and yellow ochre to give the trees a warmer feel.

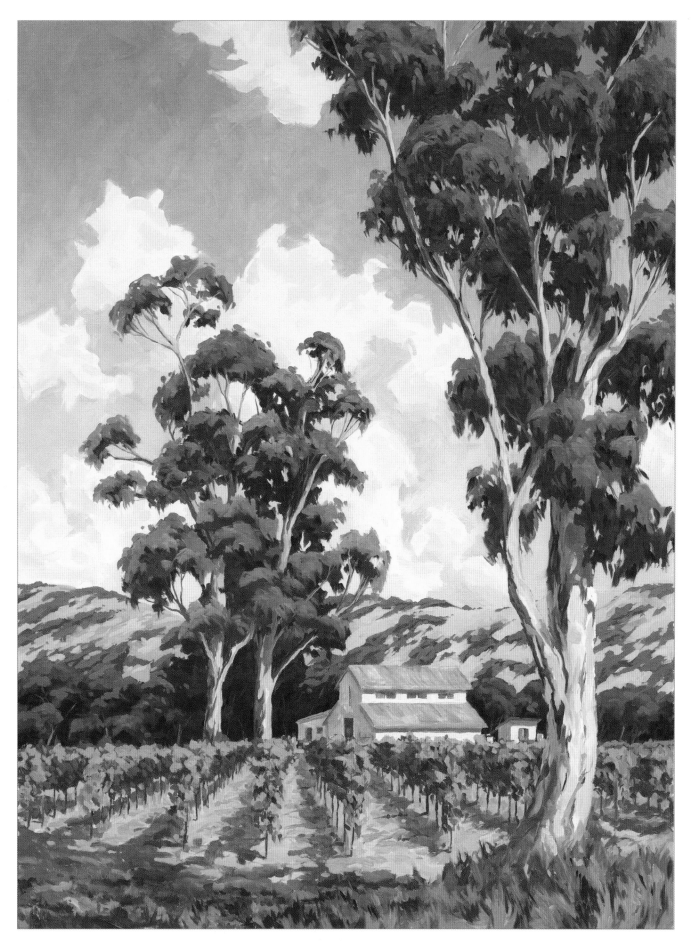

**6.** I rework the background hills by graying down the trees and adding subtle shifts in color to the warm ochre grasses—adding a bit more red and white in various places to give it some life. I also lighten the vineyard leaves and brighten them a bit by adding cadmium yellow and a touch of titanium white to my green mixture. I add highlights to the foreground grasses and a few dark accents to the foreground eucalyptus. I also do a bit of negative painting to add in sky color to the foliage in spots where the sky peeks through the leaves. I do the same on the foreground tree shadow with a bit of the ground color peeking through. I finish with a bit of lighter low-key green highlights on the middle-ground trees.

# Beach Path

## with Varvara Harmon

This lovely beach path painting is a great project for rendering different textures and gives you an opportunity to try using your palette knife. I like to work my way from back to front when I paint landscapes, starting with the sky and ending with the foreground focal point.

### Palette

alizarin crimson • burnt sienna
cadmium yellow deep hue • cerulean blue
phthalo blue • sap green • titanium white
ultramarine blue • yellow ochre

**1.** Because this is a simple composition, I do not need a detailed sketch before I start painting. I put down a few lines for the major breaks of the horizon, the beach path, and the railing. Without focusing on details, I place the clouds, using cadmium yellow, alizarin crimson, and ultramarine blue mixed with titanium white. Lighter areas of the clouds will have warmer tones, while areas in shadow and the cloud bottoms will be a bit cooler (by adding more blue) and darker. I also place a couple strokes of these warm and cool colors on areas of the path and beach that consist of wet sand.

**2.** I use titanium white with a little bit of cerulean blue for the sky closer to the horizon, and then I add more phthalo blue to the mixture as I move up away from the horizon toward the top of the canvas.

**3.** I work on refining the shapes of the clouds and the sky, making smoother transitions from the lighter shades of blue to the darker ones. Next I place the underpainting for the ocean on the canvas, using phthalo blue and titanium white. I add a little bit of alizarin crimson for the ocean closer to the horizon, where it reflects the sky. I also mix in sap green to paint the ocean closer to the shoreline, where the water is shallow. With a few more strokes I add waves. Those far away are smaller and have less contrast. The waves along the shore are larger and show more white foam. Notice that I paint the ocean mostly in the middle portion of the canvas, because I know that water on both sides of the path will be hidden behind grasses.

**4.** For the sandy path I use yellow ochre, burnt sienna, and ultramarine blue mixed with titanium white. Areas of the path where the sand is dry are much lighter than the wet sand along the shoreline. For the wet part of the path and beach, I add more ultramarine blue mixed with burnt sienna.

**5.** I finish painting the path to the beach by adding footsteps in the sand, as well as the shadows from the grass and fence railings on the right side. I use a similar color palette for both the footsteps and the shadows; however, I add more ultramarine blue before painting the shadows.

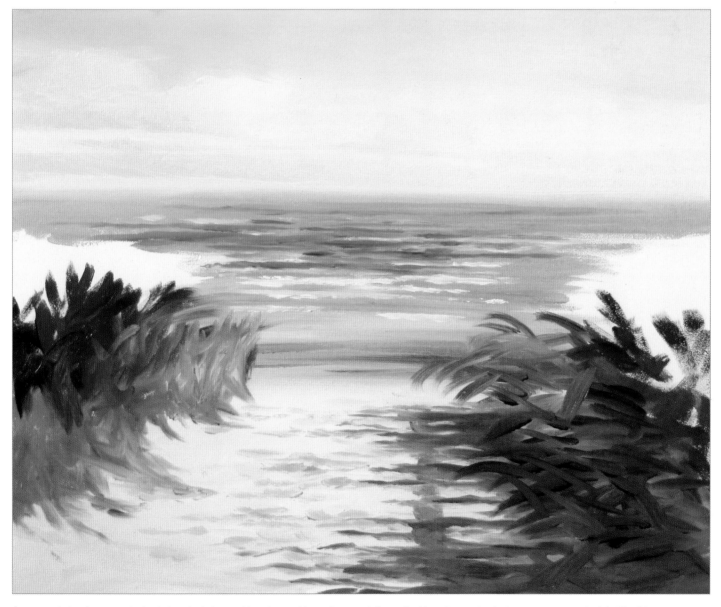

**6.** I start painting the grasses in the darker, shaded area with a mixture of burnt sienna and ultramarine blue. Then I paint the dry grassy areas on the left side of the path, using a combination of yellow ochre and burnt sienna.

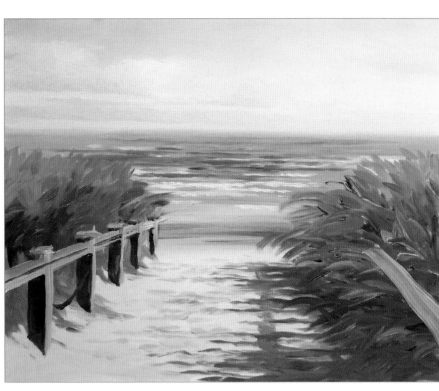

**7.** I continue working on the grassy areas by painting in live, sunlit grass with very loose, heavy strokes, using a mixture of sap green, burnt sienna, cadmium yellow, and yellow ochre. Mix these colors in different ratios to achieve natural-looking grasses with a wide variety of color combinations. I also paint in parts of the fence railings, since some of the grass will overlap the fence. I use a combination of burnt sienna, ultramarine blue, and titanium white to create the grayish tones of weathered wood. I recommend adding more bluish colors in the shaded areas to create cool temperature effects.

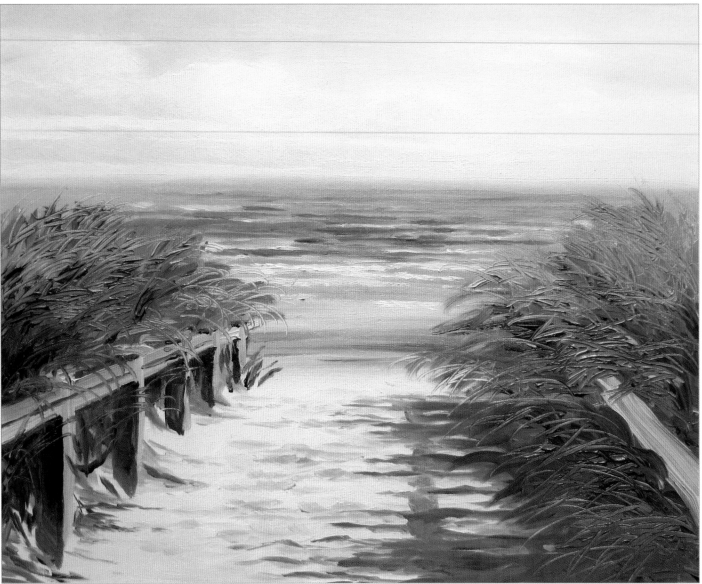

**8.** Painting with heavy strokes sets up a nice base for adding texture and depth. I create grass details with a palette knife.

## Artist's Tip

Grass-blades can be painted in different ways. In this painting, I use a palette knife technique to create a three-dimensional effect. Using a knife, I scrape the paint away, which creates natural looking, thin grass-blades. During this process you can add many different colors and keep using the knife to shape up the grass.

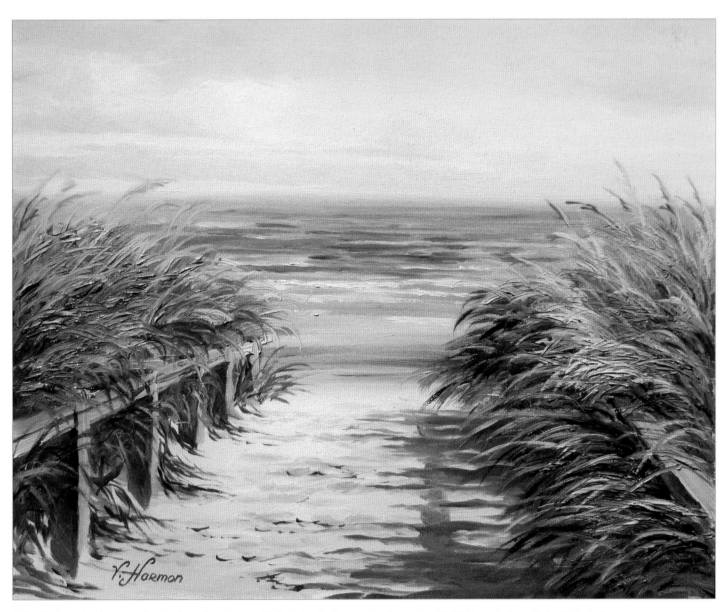

**9.** As a final step I add some smaller details, such as dry grass-blades below the fence and on the sand and highlights on the tops of taller blades in the grassy areas, as well as some dark strokes in shaded areas.

# Mountain

## with Varvara Harmon

In this painting I'll demonstrate how to paint trees and flowers with just a few simple strokes to suggest natural foliage that doesn't distract from the beautiful, distant mountain. Notice how the flowers and trees pull the eye back, leading it to the snowy peak.

## Palette

cadmium yellow deep • cerulean blue
permanent magenta • phthalo blue • sap green
titanium white • ultramarine blue

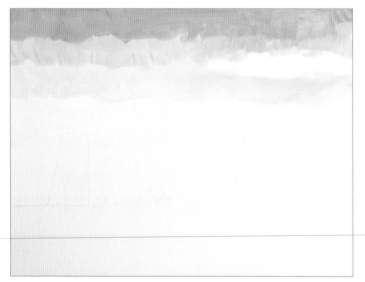

**1.** I use a pencil to outline my composition on a 12" x 16" acid-free, primed gesso board. I block in the color of the sky with a 1-inch flat brush. I use titanium white with a little bit of cerulean blue for the sky closer to the horizon. Then I add more phthalo blue to the mixture as I move away from the horizon.

**2.** I blend the color blocks to create smoother transitions between the lighter and darker shades of blue, using the same flat brush and moving it in different directions. I also add some clouds, using a very light mixture of titanium white and permanent magenta, using slightly darker shades on the bottom of the clouds.

## Artist's Tip

Placing your brushstrokes in different directions will provide a consistent look, will help to avoid any lines forming on the painting, and will also reduce glare when the painting is finished.

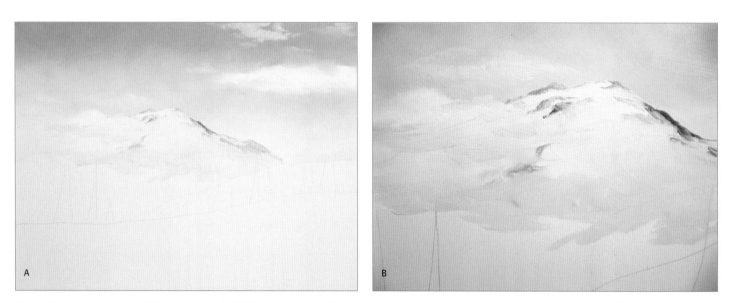

**3.** I add low clouds near the top of the mountain and paint the snow-covered peak, using a mixture of titanium white, permanent magenta, and cerulean blue (A). For the exposed rock details I use a darker mixture of titanium white, permanent magenta, and ultramarine blue (B).

**4.** I continue blocking in the major colors of the mountains below the tree line, using a titanium white, permanent magenta, and ultramarine blue mixture on the higher elevations. Then I add more phthalo blue to the mixture to paint the base of the central mountain and part of the slope of the mountain on the right. I fill in the smaller details and shape up the mountain by adding different blue, green, and purple shades.

**5.** I put down the base color for the meadow grass in the foreground. I use a mixture of sap green, cadmium yellow deep, and titanium white for the lighter greens, and a sap green mixed with ultramarine blue for the darker areas. I start to work on this area with a bigger flat brush, laying down the major colors first and then adding in the details with a smaller brush.

**6.** I decide where to put the trees and add lines for the future tree trunks.

**7.** To fill in the shapes of the trees, I mix sap green, permanent magenta, and ultramarine blue. This combination can produce a variety of colors—from a cool dark purple to a warm green. I recommend mixing the paints in different ratios of the base colors in order to achieve a wide variety of color combinations.

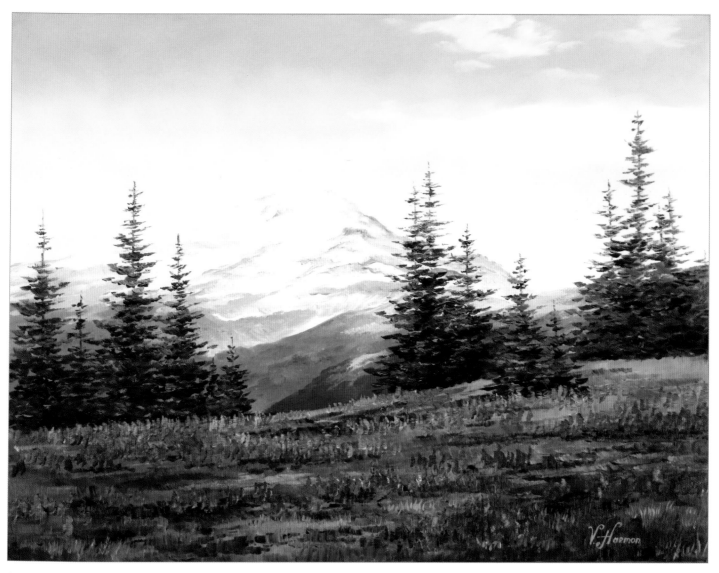

**8.** I finish painting the trees by adding light branches to create a three-dimensional effect. Then I add flowers to the meadow. Remember that the size of the flowers closer to the horizon will be much smaller and look like a "flower blanket." Conversely, the flowers closer to the foreground will be larger and stand by themselves. I use a combination of three colors for the flowers: permanent magenta, cerulean blue, and titanium white. Use darker and lighter combinations of this color mixture to create an interesting effect with the flowers and reflect the color variations seen in nature.

# About the Artists

**Marcia Baldwin** is an award-winning contemporary fine artist, born and raised in Louisiana. Marcia is the owner of M. Baldwin Fine Art Originals. After 37 years of professional growth, Marcia continues to challenge herself creatively by approaching each new painting as a journey, an exploration, and a moment to discover something new and wonderful. Visit www.mbaldwinfineart.com to learn more.

**Glenda Brown** is a member of the Portrait Society of America, Portrait Society of Atlanta, and the American Impressionist Society. She has won awards with the Portrait Society of America, including Top Ten in Tennessee and Peoples' Choice Award. In March 2012, Glenda was awarded First Place and Members Choice Award at the Portrait Society of Atlanta. She is represented by Artreach Gallery in Germantown, Tennessee; Gallery 202 in Franklin, Tennessee; Portraits, Inc. in New York, New York; and Portraits South in Raleigh, North Carolina. To learn more about Glenda, visit www.glendabrown.com.

**Lorraine Gray** is a pet portrait artist who works in pastels, oil, and acrylic in Berkshire, England. Lorraine's love for art and animals started as a young girl, when she spent many hours painting her beloved pet dog and cat. After graduating from school Lorraine worked as a secretary for a local business and pursued her hobby through local commissions and creating pet portraits for her friends and family. Since launching her website, Lorraine has fulfilled commissioned paintings from all around the world. Lorraine's work has been featured in the Kennel Club Exhibition in Picadilly, London (2006); on program broadcasting live with BB1TV from Battersea Dogs and Cats home, where she painted a portrait of the featured dog (2007); and in the magazine *Your Cat* (2011). To learn more, visit www.pastelpetportraits.co.uk.

**Varvara Harmon** is an award-winning multimedia artist who works in oil, acrylic, watercolor, silk paintings, and ink and pencil drawing. Her work has been juried into national and international exhibitions, is in private collections around the world, and has been published in *International Artist* and *American Artist* magazines, as well as in *The Best of America Oil Artists* book in 2009 and *The Best of World Landscape Artists* in 2012. She is a member of the International Guild of Realism, Oil Painters of America and Landscape Artists International. Varvara is currently represented at several galleries across the Northeast and teaches workshops and classes in acrylic, watercolor, and oil. Visit www.varvaraharmon.com to learn more.

**Jim McConlogue** is a professional fine artist from Encinitas, California. He paints with oil, both plein air and at his home studio. His paintings have been published in fine-art and instructional books, and he has been featured in numerous magazine and newspaper articles. Jim studied life drawing, painting, and illustration through the Corcoran School of Art and University of California—San Diego extension courses, The Athenaeum School of the Arts, St. Mary's College, and a number of plein-air workshops. Jim currently works on commissioned paintings, and his original oils and giclée prints are displayed at galleries in Leucadia and La Jolla, California. Visit www.jimmcconlogue.com to learn more.

**Jason Morgan** is a professional wildlife artist who specializes in big cats and African animals. Jason is heavily involved in conservation through the Cheetah Conservation Fund, the Snow Leopard Conservancy, and the Dian Fossey Gorilla Fund and has been featured in *Artists & Illustrators*. A signature member of Artists for Conservation, Jason strives to paint wildlife as accurately as he can by studying animals in their natural environment. Visit www.onlineartdemos.co.uk to learn more about Jason.

**Vanessa Rothe** is a former graphic designer/art director who has worked with Disney Press, Walter Foster Publishing, and Sony. Today Vanessa is a professional artist with a more traditional palette: oil paints. Vanessa is a Signature member of the American Impressionist Society, the California Art Club, Oil Painters of America, and Laguna Plein Air Painters Association. Vanessa is also honored to be the California Editor of the nationally acclaimed art collector magazine *Fine Art Connoisseur,* as well as a long time contributing writer for *Plein Air* magazine. Visit www.vanessarothe.com to learn more.

**James Sulkowski** is a classical artist who paints in the tradition of the Old Masters, giving his work timeless and luminous qualities. James studied at the Pennsylvania Academy of the Fine Arts, Carnegie Mellon University in Pittsburgh, and the Art Students League of New York with Frank Mason and Robert Beverly Hale. He has attracted private, corporate, and public collectors worldwide, including presidents, kings, universities, hospitals, banking institutions, and museums. James is also listed in *Who's Who in American Art.* For more information, visit www.jamessulkowski.com.

# Index